The Renaissance I

Illustration on title-page:

Giovanni Bellini
Venice *ca* 1430-1515
Madonna and Child
Oils on wood 77 × 60 cm
Venice, Accademia

Illustration on cover:

Piero della Francesca
Borgo San Sepolcro, 1410/1420-92
The Flagellation
Wood 81.3 × 58 cm.
Urbino, Palazzo Ducale

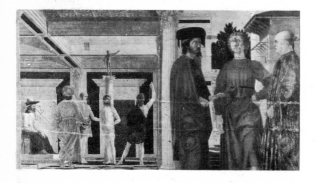

Impressionism

Post-Impressionism

The Renaissance I

The Renaissance II

The Renaissance III

The XVIIth Century I

The XVIIth Century II

The XVIIIth Century

Cubism

Romanticism

American Painting

Futurism and Dadaism

Gothic Painting I

Gothic Painting II

Romanesque Painting

Expressionism

Greek and Etruscan Painting

Surrealism

Egyptian Painting and the Ancient East

Great Masters of Modern Painting

Roman and Palaeochristian Painting

Abstract Painting

Prehistoric Painting

Byzantine and Russian Painting

Chinese Painting

Japanese Painting

Islamic and Indian Painting

The Renaissance I

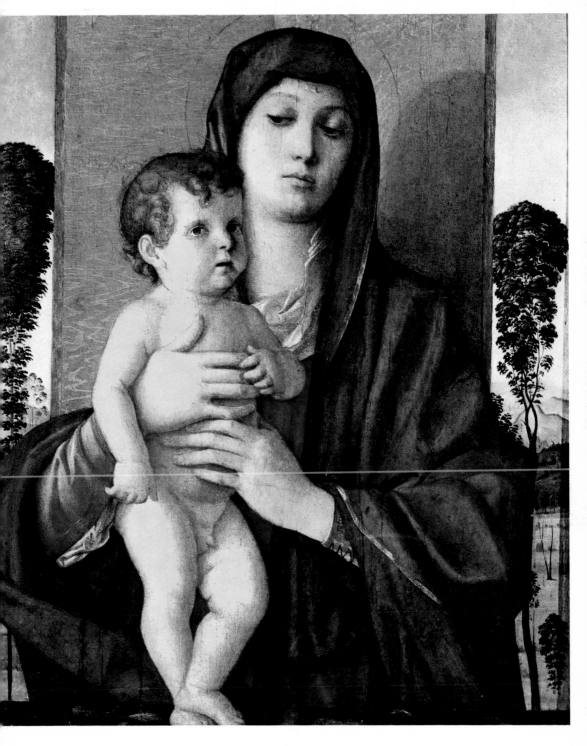

ie-Charles Flamand

Heron Books, London

Series edited by Claude Schaeffner
Artistic advisor:
Jean-Clarence Lambert
Illustrations chosen by Claude Schaeffner
Assistant: Martine Caputo
Cartographer: Gilbert Martin

Translated by Joan White

Colour prints for the illustration of the first half
have been provided by:
Giraudon, Paris: pages 3, 6, 9, 13, 14, 16, 17, 18,
21, 23, 28, 35, 37, 38-39, 43, 44, 45, 46, 48, 55, 56,
65, 68, 69, 73, 74, 75, 76, 79, 85, 86, 87, 91 and 94;
André Held, Lausanne: pages 10, 22, 24, 25, 27, 33,
40, 50, 51, 52, 53, 54, 58, 62, 63, 66, 67, 70, 72, 80,
82 and 88;
Scala, Florence: page 81.

The black-and-white illustrations in the dictionary
have been provided by:
Anderson-Giraudon, Paris: pages 149 left, 155, 167,
170, 171, 187, 191, 193, 194, 196, 197, 200 and 201;
André Held, Lausanne: pages 146, 149 right, 150,
177, 186 and 203;
Giraudon, Paris: pages 151, 169, 185, 192 and 199;
Alinari-Giraudon, Paris: pages 174, 175, 178, 188
and 189;
Brogi-Giraudon, Paris: pages 156, 158 and 182;
Bulloz, Paris: pages 161, 163 and 174;
Roger-Viollet, Paris: pages 148, 165 and 166;
Anderson, Paris: page 147.

Contents

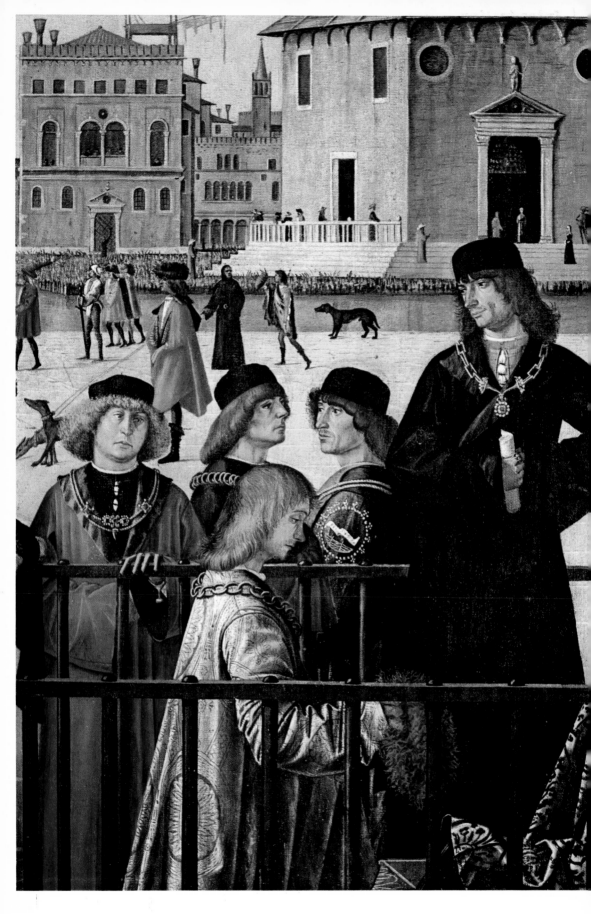

Vittore Carpaccio, Venice 1455-1526
Legend of St Ursula
Arrival of the Ambassadors
From 1490 to 1496
Oils on canvas, Venice, Accademia

Introduction

The term "Renaissance" which is used to indicate the transformation which started in Europe with the developments in art and culture in 15th-century Italy can only too easily take on the same vagueness of meaning as so many other generalised terms—the "Gothic period" or the "Dark Ages" for instance. Its meaning can of course be limited to the "Renaissance of classical antiquity", a period on which the Middle Ages entertained the wildest ideas, but this meaning is too restrictive and does not adequately convey the significance of the term. It is true that the Italians of the Quattrocento sought to justify the audacity of their achievements by constant reference to examples from classical Greece and Rome where they found what they considered true perfection. Moreover, they insisted that they were only copying, a not very convincing gesture of humility which deceived no-one! What happened on the Italian peninsula from the 14th century onwards was more than a "return to classical antiquity" and much more than a "rebirth". It was in fact both a "new birth" and an "incarnation"—of man in his total humanity, in the full unity of his being.

This is particularly well illustrated for us by painting, which at last restored to our eyes the treasure lost from sight with the gods of Greece and Rome and held in anathema by popes and doctors of Holy Church—the human body!

The sudden reappearance of the body typifies the new approach to the problem of man's attitude to the world as well as to the world's attitude to man. It has been said over and over again that the Italian Renaissance symbolises the springtime of Europe. (But what is the present time, five centuries later, supposed to represent? Summertime? Hardly . . . Autumn, the sear, the yellow leaf?) It is true nevertheless that it was a young *artist who was the first to paint—and, so one might say, also to understand—man in all his individuality, and before he died at the age of twenty-seven gave us an unforgettable portrait: this artist was Masaccio and the paintings his frescoes in the Brancacci chapel in the Carmine in Florence. One of these frescoes in particular seems to be the visual representation of the "new birth" of man, snatched dramatically from a known world and cast out from the bosom of the universal Mother, the Holy Catholic Church, alone in the face of individual conscience and intoxicating liberty. This is the portrait of Adam and Eve standing noble and naked on the threshold of their new world, a world where man is supreme—waiting to step into a whole new era—that of humanism—on the brink of modern civilisation!*

And meanwhile in the North, far away from Italy, on the windswept walls of a mountain abbey in lands where the Middle Ages still held sway, a French artist drew one by one the dreadful grinning skeletons and the grim cadavers of the Dance of Death*: here in the Chaise-Dieu, man the human being was still scorned, despised, rejected. In Florence, though, it was spring and the early blossom hung on the trees.*

It was no small thing, handing back the human body to its rightful owner. It meant countering the idea of imperfection with the idea of beauty, it meant commending man in his outward appearance instead of accepting his inward damnation. Even the greatest of mediaeval beauties was basically ethereal, a calm gaze held fascinated by distant unreachable horizons, perhaps by heaven itself: in the choir of Naumburg cathedral stands Countess Uta, a face and nothing more. Not for a moment can we conceive of her without her long cloak with its high close collar or without the smooth bandeau framing her face. Who knows

what terrors of Hell lay in wait for this frail beauty? Two centuries later in Florence, Botticelli revealed her in her full glory and magnificence: she is one of the Graces attendant on Primavera in her transparent veil: she is Venus, lissom and naked, rising from the sea. Hell can wait! (Though the pyres smouldered red for Savonarola.)

To the sadness and despair of Charles d'Orléans, winter poet and prince in exile in a world on the wane, Lorenzo the Magnificent offered the reply:

> Quant'è bella giovinezza
> Che si fugge tutta via!
> Chi vuol esser lieto, sia!

The ghostly gibbets of François Villon loom darkly in the mist and start to fade from view; in their place comes a shimmering procession, Gozzoli's glittering Journey of the Magi. *Glory, like beauty, was a major passion and a deep preoccupation of the Quattrocento. It found its greatest interpreters in the painters of the time: Ghirlandaio, Mantegna, Gentile Bellini, Carpaccio, Pinturicchio. Every feature of daily life, from dawn to dusk, and even night itself—no longer an ever-repeated symbol of death—was now a work of art. Solemn ceremonies, consecrations and coronations, triumphal entries, tournaments, carnivals, masques and balls, chariot races, banquets, the chase, the feast, the fireworks—no one could keep count of the festivities where princes sought to outdo themselves and one another in celebrating their princely state.*

Another passion was the thirst for knowledge, a thirst which for some—Uccello, for instance—was totally absorbing, limitless, unrestrained and intoxicating. In the Middle Ages, the image-maker worked in a spirit of humble deference which even now manages to awake a pang of nostalgia in the heart; the Renaissance artist on the other hand worked in a terrifying spirit of intellectual arrogance: is there anything more icily regular than some of Piero della Francesca's geometrical expositions, all mind and no heart? And what about Uccello's fanatical passion for perspective, an obsession finding confident expression in his abstract battle scenes? The world of imagery in 15th-century Italy had ceased to be an obscure forest of symbols like the "dark wood" where Dante sought the true faith. Henceforward, there was nothing that was not within man's grasp and in due course everything proved to be under his dominion. The geographical discoveries, the physical conquest of new territories, came at the end of the Quattrocento, but the mental *conquest came much earlier in the century with Uccello's fresco of the Universal Deluge in the Green Cloister of Santa Maria Novella. Perspective was—or so they thought—the proper scientific, humanist reply to the mediaeval concept of universal allegory. The Euclidean notion of space guided Brunelleschi in the completion of the great Duomo in Florence and then took on the force of dogma: it provided the artist with the intellectual means to impose order and organisation on the new world which dazzled and delighted his admiring eyes. This is what "realism" means to the Renaissance. It gave artists a system to work by for the next three centuries and kept its importance right up to the dawn of Impressionism.*

Jean-Clarence Lambert

9

Filippino Lippi
The Assumption
(Detail: apostles)
Rome, Santa Ma
Minerva

The Quattrocento

The Italian word "Quattrocento" refers to the fifteenth century, that is to the years "one thousand and four hundred" (mille quattrocento). This century witnessed the beginning of that extraordinary artistic revolution which Vasari called a *rinascita* as early as 1550. It was to establish all the traditions and accepted standards for the plastic arts in Europe right up to the middle of the 19th century.

It was a period of dedicated and fervent research and of fruitful discovery: it became a vast melting-pot of ideas and customs. In time it rocked Europe to its foundations, but first of all it rocked Italy. It was a turning-point in history; liberty of thought began the destruction of scholasticism, the experimental method shattered the established authority of the sciences and reason began its quiet opposition to faith. The beginning of the 15th century saw the entire field of human knowledge opened to question and revision; the first practical applications of this new attitude came with the work (still marked by somewhat restrained boldness) of those painters, sculptors and architects who go by the name of the Quattrocentists. Their works are full of violent contrast, due to the prevailing spirit of the period, for this was a time when paradoxes came into uneasy confrontation without any real prospect of harmony. The contrast, however, held promise for the future. It exalted the power of human thought and sent man travelling in an entirely new direction, one which led ultimately to the modern mind, a change which Paul Valéry defined superbly: "At the very right moment, there occurred in Italy a ferment of life and ideas where there was a wild mingling of absolutism and anarchy, wealth and piety, a longing for the Eternal and a passion for sensuality, delicacy and violence, the greatest simplicity and the boldest intellectual ambition—a fusion of almost every extreme of physical and mental energy."

The Renaissance started with a strong revival of interest in the art of classical antiquity, in literature and architecture as well as in sculpture and painting. Of course, antiquity and examples of the art of classical times had always been at hand in Italy; there were even traces deep in the Byzantine and Gothic concepts which reigned supreme in art until the 15th century. It was, however, a confused and fragmentary sort of classicism, scattered haphazardly here and there. The Quattrocentists wanted to draw up a systematic inventory of their classical heritage, especially that of ancient Rome whose broken traces were still readily visible. The past was to come to the help of the future. For example: in about 1407, the architect Brunelleschi* and the sculptor Donatello* gave a tremendous impulse to the movement by going to Rome and digging in the ruins. Their enthusiasm rose with every building they uncovered and every relief that they copied.

It was necessarily a rather timid sort of archaeology, for they lacked the means and methods available in the 18th century when the excavations of Herculaneum, Pompeii and the Roman Forum were started.

The artists of the 15th century felt a bond linking them across a thousand years with the overgrown, half-ruined reliefs of the triumphal arches of Titus, Septimus Severus

11

and Constantine, with the columns of Trajan and Marcus Aurelius. All of a sudden, the artists of Florence looked with new eyes at the sarcophagi and the Venus, later owned by the Medici, which stood for no particular reason in front of the Baptistery. At the same time, the first private collections of antiquities were started: the privileged few sent their representatives to comb the countryside for statues, coins, odd bits and pieces of the past brought in by peasants ploughing their fields and labourers clearing building sites.

This passionate pilgrimage towards antiquity was carried on into the literary field: humanist scholars disinterred from dusty libraries a few essential masterpieces of Greek and Roman literature whilst a new and fruitful impulse to study the classics came when the fall of Constantinople drove hundreds of Byzantine scholars and writers towards the universities of the West.

The first consequence of this rediscovery of classical tradition was a reawakening of interest in nature, always admired by the ancients. The Quattrocentists sought to translate this into reality by breaking the restraint of Gothic conventions. No more gold backgrounds or rigid hieratic figures or stereotyped ornaments. The scope of painting widened: the study of physiognomy allowed artists to seize the varying expressions of the human face, the knowledge of anatomy brought a greater awareness of the proportions and movements of the body. The nude reappeared in art. Contemporary dress appeared in paintings instead of clothes that were indefinable in terms of age. Where landscapes had been artificial and stylised, they now became real and recognisable views of Italy as she really was. In the field of technique, Brunelleschi (soon to find his own imitators) rediscovered the Greek method of using geometry to draw a series of planes on a flat surface to show objects as they appear when seen from a distance and in a particular position. This application of the rules of linear perspective* had tremendous importance in Quattrocento art, equalled only by the first steps in the use of chiaroscuro.*

As in every real revolution, there was much that was not new: a hundred years before, Giotto and his followers had turned against the tyranny of the Byzantine style in favour of a more naturalistic presentation. They aimed at a greater humanity of expression, a greater reality of form. Fra Angelico* had succeeded in reconciling a strictly mystical inspiration with a deep love of nature and an acute sense of observation. This first wave of realism ended in the revolutionary creations of Masaccio. As the Renaissance swept irresistibly onwards, this movement towards natural forms became general, thanks to a social and economic situation which favoured these artistic innovators.

A nebula of artists

In the 15th century, Italy was a scattering of independent states or "republics" run by the local aristocracy. Recurrent outbreaks of small-scale wars did not have any serious effect on the economic expansion of the country as a whole, thanks to the development of maritime commerce and of banking. This prosperity was accompanied by the rise of the rich patron: the *fautori dell'arte*. There was constant competition between princes,

Thomas Masaccio
Florence 1401-28
St Peter enthroned
Florence, Santa Maria del Carmine

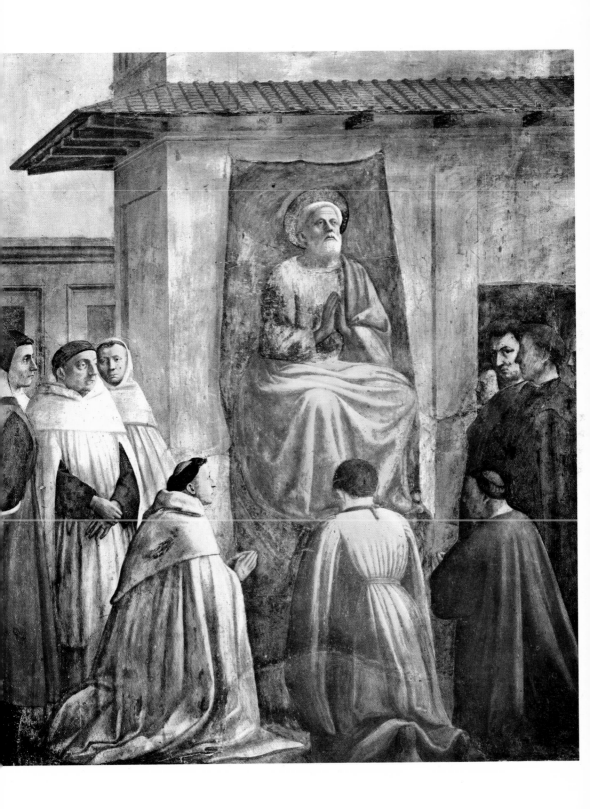

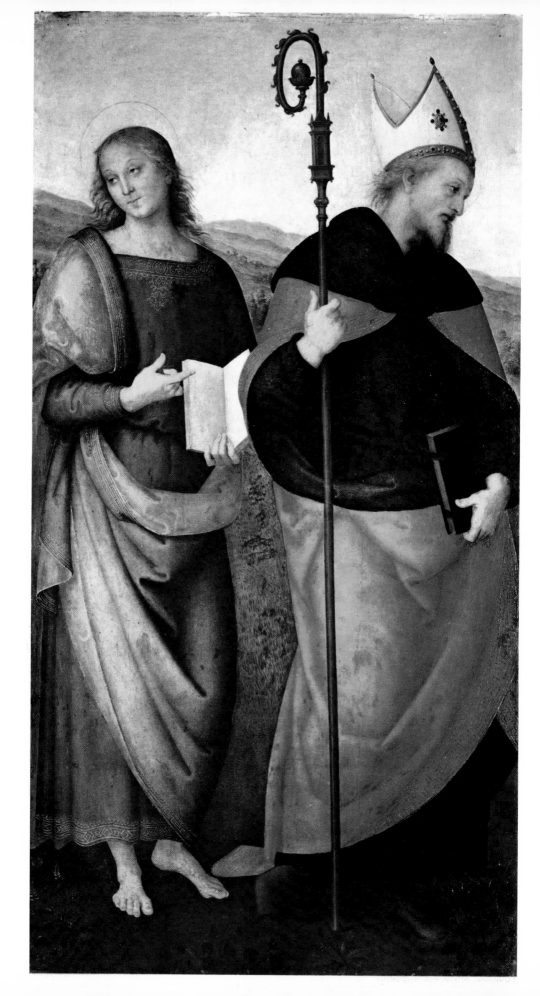

14

city corporations and wealthy merchants, all seeking as a matter of personal pride to outdo one another in the encouragement of art and literature providing that a proportion of the finished product came their way. This was to help the great artists not only to have a means of livelihood but also to break new ground.

In Florence, the Medici* family, who were the most influential people in the city as well as the main bankers for the whole of Italy, gave lavish encouragement to the new artistic trends and at the same time gathered together a splendid collection of antiques. Cosimo de' Medici, who had banks throughout Europe and agencies in the Middle East, had his palaces built by Brunelleschi and subsidised Uccello, Filippo Lippi and Andrea del Castagno. And his son Lorenzo, who was called the Magnificent, more than deserved that name for his encouragement of Ghirlandaio, the Pollaiuolo brothers, Botticelli and Filippino Lippi, as well as for his early appreciation of the growing genius of Leonardo da Vinci and Michelangelo.

In Rome, the Popes by no means lagged behind. Nicholas V* commissioned Fra Angelico, Benozzo Gozzoli and Piero della Francesca to undertake a series of frescoes in the Vatican. Sixtus IV gave his name to the famous Sistine chapel because he increased its beauty immeasurably by commissioning work for it from such artists as Pinturicchio, Perugino, Botticello, Piero di Cosimo and Ghirlandaio.

An old one-eyed soldier reigned over the small state of Urbino—Federigo of Montefeltro, who was given the title of Duke by the Pope. Curiously enough, he had a passion for books and paintings. He had thirty clerks in constant employment copying every rare manuscript he could find. He commissioned his own and his wife's portrait from Piero della Francesca.

In Rimini, there lived the Malatesta family, fierce in so far as sheer brute fighting was concerned, but no less great for all that as patrons of the arts. Sigismondo Malatesta, a fighter of grim reputation, adapted a christian church as a splendid temple to his mistress, the lovely intelligent Isotta; it was full of pagan allusions and the remains of the great humanists replaced the relics of the saints. Piero della Francesca decorated it with a series of paintings based on the signs of the Zodiac and other allegories.

In Mantua, Lodovico Gonzaga listened without complaint to the endless arguments of his perpetually angry friend Mantegna because he believed that all artists were "gente fantastica".

Ferrara trembled in the power of the d'Este* family—but the Palazzo Schifanoia had frescoes by Cosimo Tura and Francesco Cossa.

Milan was not much happier under the Sforza. The worst of them, Lodovico il Moro, seized power by having his nephew poisoned. But he it was who became one of Leonardo's first and greatest protectors...

Hardly better than craftsmen

One slight qualification: the patrons were very much men of their time and their sense of social prejudice led them to consider artists somewhat inferior to scholars and 15

Perugino (Vannucci Pietro)
Castello della Pieve 1450-Fontignano 1524
St John the Evangelist and St Augustine
Toulouse, Musée des Augustins

humanists. They were never able to get over the fact that most painters and sculptors sprang from humble backgrounds. Andrea del Castagno and Benozzo Gozzoli were of peasant origin; Uccello's father was a barber; Filippo Lippi's a butcher; the Pollaiuolos' a poultry-seller; Mantegna's a carpenter; Cosimo Tura's a cobbler. They were only seven or eight when they left school and they could barely read or write. Their professional training started when their mothers took them and their few pathetic belongings to start work in the studio of a *maestro* or master. Here they lived and slept and got their keep in return for sweeping the floor, lighting the fire and running errands. Bit by bit, they learned the secrets of the craft, for the *maestro* guarded his knowledge jealously and passed it on to his pupils very slowly. First they were apprentices, then they were journeymen for twelve years and finally they became *maestros* themselves. In his famous *Libro dell' Arte*, Cennino Cennini* described the different stages in an artist's training. "This is how long it takes you to learn. First, a year to study elementary drawing. Then you need a full six years to stay in the studio with the *maestro* and to get to know everything possible about the different branches of the craft, starting first of all by grinding colours, boiling up glue, mixing plaster, then going on to preparing panels, touching them up, polishing them, applying gold leaf, learning how to grain. Then another six years to study the use of colour, the application of mordants, to find out how to paint draperies and folds and how to work in fresco. And all the time, you must practise drawing, each day and every day, work-day and feast-day."

16 Even when they had their own studios, there was no change in their social condition.

Benozzo Gozzoli
Florence 1420-Pistoia 1497
Triumph of St Thomas Aquinas
Paris, Louvre

They were still just craftsmen. Curiously enough, they seem to have lacked any sort of vanity and rarely signed their pictures; they never worked for the sake of fame or reputation. Most often, they worked together as a team and it was not unusual to find a dozen working on the same picture, the *maestro* painting only the really difficult parts. They were willing to undertake quite ordinary commissions: Botticelli and Gentile Bellini illuminated confraternity banners; Ghirlandaio decorated baskets; Pollaiuolo made jewels; other artists painted furniture, frames, *tondi**. They were unsophisticated and innocent and never changed. If they painted masterpieces, they were certainly not aware of it. If you want a true picture of the painters of the Quattrocento, "you must visualise them not in an elegant studio, but in a scruffy workshop where they lived surrounded by the tools of their trade and their apprentices, pots and bottles everywhere. They wore any sort of clothes, old overalls, aprons, anything... Donatello completely forgot to wear a superb red cloak given to him by Cosimo de' Medici and kept his money in a basket hanging from a beam: friends and fellow-workers helped themselves to what they needed... Once Perugino had to sleep in a packing-case in his studio... At midday, the artist's wife would send them a little wine and some bread which they ate as they worked: the wife ate at home." [1] The humanists tended to look down on these people whose work was in their eyes no less than manual labour. As for the patrons, they treated them rather like servants, fed them in the staff quarters and like Nicholas V listed them in their account

[1] Philippe Monnier, *Le Quattrocento*. Paris 1901.

17

Lorenzo Costa
Ferrara 1460-Mantua 1535
Holy Family
Lyons, Musée des Beaux-Arts

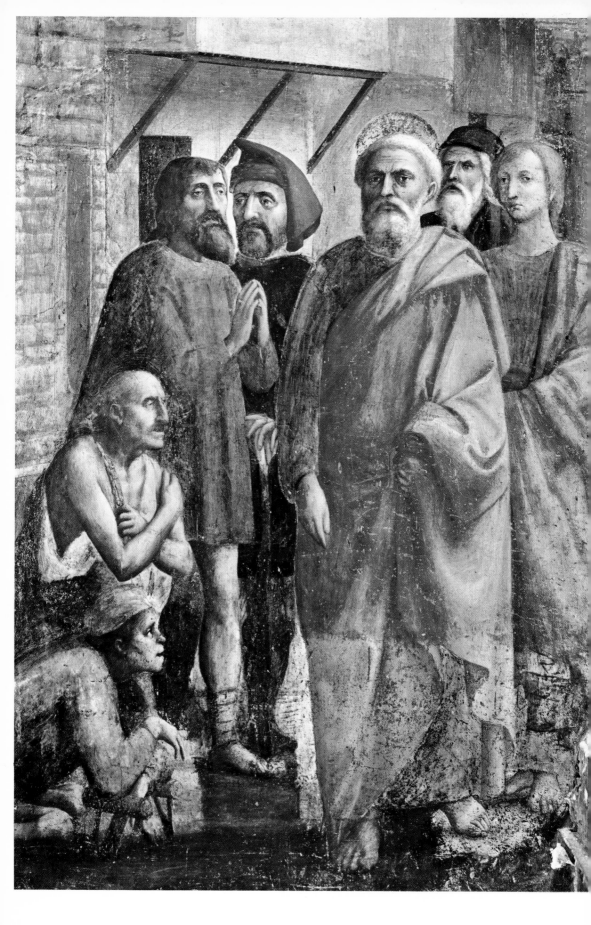

books along with plasterers and pavers. They were paid less than favoured poets and scholars, less than doctors and sometimes even less than ordinary masons. Their monthly wages rarely came to more than seven or eight florins, though sometimes they got their keep as well. Sometimes they were paid by the yard: when Francesco Cossa was commissioned to do some frescoes for Borso d'Este, he was paid ten *bolognesi* per foot. Even if they became famous, they still stayed poor all their lives in most cases, witness for instance the list of grievances in their tax declarations. Often they died in extreme poverty. It was only in the course of the next century that nobles, churchmen and *bourgeoisie* began to treat artists with the same consideration as they treated scholars.

Masaccio: Founder of the new style

The cream of scholars and artists gathered quite naturally in Florence first of all. This aristocratic town of great merchants and diplomats became the main centre of the early Renaissance. The Florentine school of painting, preoccupied particularly with problems of theory such as perspective and anatomy, was always to be distinguished by a certain intellectuality. It was concerned above all with precision and balance and sought to express the intensity of spiritual life by formal perfection and rational construction.

It was the Tuscan painter Masaccio* who laid the foundations of the new style. His originality and the way in which he combined his new ideas with his personal synthesis of the lessons of past masters had the greatest influence on his time and governed all subsequent developments in European art. In addition, his troubled life made him the first "artist in torment" that we know.

Tommaso di Ser Giovanni di Simone was born on the feast of St Thomas in 1401 at Castel San Giovanni, near Florence. His father was an unimportant country notary. The usual shortened form of his Christian name, Maso, soon took on a pejorative suffix, which is why we know him as Masaccio, "Hulking Tom". Vasari*, the principal biographer of the Renaissance artists, wrote that he was "very absent-minded, like someone who is lost to the world because he has every bit of his mind firmly fixed on his paintings and for this reason takes no heed of anything or anybody. Everyone called him Masaccio, not because he was rough or cruel (indeed, he was goodness itself) but because he was so clumsy."

In 1422 Masaccio settled in Florence and became a member of the Corporation of "Speziali", which was composed mainly of doctors and apothecaries but to which all painters who used chemicals and powders had to belong. In 1424 he joined the Guild of St Luke, the confraternity of painters in Florence, where the architect Brunelleschi taught him linear perspective. Vasari says that he was a pupil of Masolino da Panicale*, who was one of the last Giottesque painters, but this does not now seem to be true. Masolino's work is rather uneven in quality, sometimes lively but most often rather lacking in vigour; some of his work, though, has a certain charm, for instance the frescoes in the Baptistery at Castiglione d'Olona near Milan (1435), particularly *St John baptising Christ* and *Salome's Dance*.

It is fascinating to follow Masaccio's progressive development towards a new concept of painting, beginning with his first works which still bore the imprint of traditional Gothic ideals. In the altar-piece of *St Anne, the Virgin and the Child Jesus*, Mary's right knee seems to strain against the cloth and brings a suggestion of dimension set within the flatness of an ornamental surround of conventional angels. In the so-called *Virgin of Humility*, Brunelleschi's theories are put into practice by the high-lighting of those parts of the picture which serve to determine dimension. In 1426, Masaccio painted for the Carmelite church in Pisa a superb polyptych whose central section, a *Virgin with Child*, represents his first masterpiece and is of the greatest importance since it shows the essential features of Masaccio's revolutionary contribution to painting. What is specially typical of it is the rigorous observation of the laws of linear perspective and this imparts to the painting a truly "three-dimensional" aspect. Hollows and reliefs stand out clearly; there is a proper unconfused presentation of successive planes of distance. Where the Gothic artists imbued their paintings with diffused light, in this picture the light comes from a specific point, plays on prominences, casts shadows and brings out the dimensional aspect of the figures. Last but not least, the face of the Virgin shows all the pain and presentiments she feels when she looks at the Child and has none of the stiffly conventional beauty of the Middle Ages. This tendency to impart a proper expression to the people in his paintings occurs elsewhere in the polyptych: in the *Crucifixion* panel, the Madeleine stretches her arms to heaven in a surge of anguish and suffering; this is in direct contrast to the rigid and motionless agony of the Virgin and it brings life to the entire composition.

In these paintings, Masaccio is seen at the height of his powers. A fortunate circumstance suddenly made it possible for him to show just what his talent was: Masolino had to leave an important commission half-finished and entrusted its completion to Masaccio. It was the decoration of the chapel of the Brancacci family in the Carmine church in Florence. In 1423, the wealthy merchant and diplomat Felice Brancacci* asked Masolino to paint some frescoes there on the general theme of the life of St Peter as told in *The Golden Legend*. In 1426, Masolino went to Hungary to join Filippo Scolari, the famous Florentine soldier of fortune who had become King Sigismond's agent. It fell to Masaccio to finish the chapel. Six of the frescoes can be attributed to him with complete certainty and four of them are specially significant:

The Expulsion brings back to art the full beauty and nobility of the nude; the naked bodies of Adam and Eve are superbly lighted and show an advanced knowledge of anatomy. Eve's hands are in a similar position to those of the *Venus pudica* of antiquity. Their attitudes, though, are new in that they express a dramatic intensity of anguish.

The Rendering of the Tribute Money gave Masaccio the opportunity of painting in the character of the toga-clad apostles a whole series of highly individualised human types; he may have painted himself amongst them—see the last disciple on the right of the central group. The figures stand out perfectly in a three-dimensional space where the careful use of linear perspective and chiaroscuro almost convince us that we can feel the movement of the air around them.

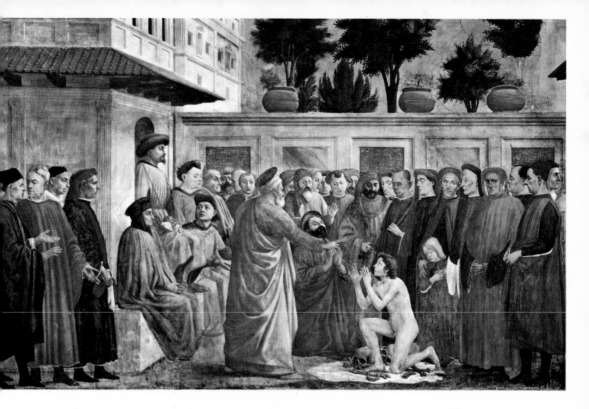

The Baptism of the Neophytes with its naked converts allowed Masaccio to demonstrate his mastery of anatomical subjects in a great variety of poses. One of them in particular, the "trembling neophyte", greatly impressed contemporary artists: a clever use of chiaroscuro makes it appear that one of the nudes is trembling with cold.

St Peter's shadow curing the sick inaugurates a new trend towards simplicity by concentrating the whole of the composition on the figure of St Peter, contrary to the tradition which gave the same importance to every single detail; it also marked the introduction of realism by its uncompromisingly truthful presentation of the group of sick and maimed.

Masaccio's life as he created these masterpieces was a constant struggle against poverty. He lived from hand to mouth in company with his widowed mother and his brother Giovanni, himself a painter but with little talent. Most of his clothes were with pawnbrokers and he could never give regular wages to his assistant, Andrea di Giusti, who took him to law. Could this be why he suddenly went off to Rome in 1428, leaving the last fresco in the Brancacci chapel unfinished? (This was *St Peter raising the son of Theophilus* and Filippino Lippi finished it fifty years later.) Either this, or an urge to get more lucrative commissions. A waste of time: he had hardly arrived in Rome when he died at the age of twenty-seven from some unknown cause. One tradition has it that he was poisoned by a jealous rival, but this rests on no firm foundation.

Masaccio's major surviving works are therefore the frescoes in the Brancacci chapel and a comparison between these and Masolino's show how infinitely superior Masaccio's are. In Masolino's, the use of perspective is still very rudimentary and what relief there is is clumsily done; in Masaccio's paintings we see a coherent solution of the problems of linear perspective, a matchless use of light and chiaroscuro, perfect anatomical drawing and an intense truthfulness of expression. All the painters of the Quattrocento came to the Brancacci chapel to look, appreciate and draw inspiration; even a century later they still came—the great painters of the late Renaissance, Fra Bartolomeo, Michelangelo, Raphael, Andrea del Sarto.

21

The world of Uccello

One of the first people to benefit from Masaccio's example was that curious figure Paolo di Dono, born in 1397, son of a barber-surgeon from Pratovecchio. His nickname, *Uccello**, "bird", seems to have been given to him on account of his love of birds—it is said that he had an aviary full of rare species, but this seems unlikely since he was extremely poor. We first hear of him in 1407 as a *garzone* on the list of apprentices working for the goldsmith Lorenzo Ghiberti*. In this capacity, he must have worked on the bronze doors for the Baptistery.

His first pictorial work dates from 1436: an equestrian portrait of the *condottiere* Sir John Hawkwood*, known in Florence as Giovanni Acuto, commander of the Florentine mercenaries. Already in this painting, Uccello shows himself firmly in control of the means provided by perspective for the illusion of dimension: the portrait is intended to be a *trompe-l'œil* and creates the illusion of a free-standing equestrian statue. According to Vasari, Uccello gave up his entire youth to the study of perspective under the influence of Brunelleschi and the mathematician Antonio Manetti. Uccello's wife said that when she called him to bed, he would always reply: "How fair a thing is this perspective!"

Uccello's next commission was the decoration of the cloister of San Miniato al Monte*; his frescoes were a marvel of colour and depicted scenes from the lives of the saints. Unfortunately they are now extremely faded. In the year 1440, he continued his animal studies—which absorbed him more and more—by painting two versions of *St George and the Dragon*. Shortly afterwards he went to Padua with his friend Donatello and whilst there painted on a wall of the Vitaliani house a series of figures which were much admired by Mantegna and which had some influence on the Padua school: pictures of giants in a greenish monochrome. They have now completely disappeared.

These are transition works and in 1445 he was back in Florence painting his famous *Flood* in the cloister of Santa Maria Novella* where fourteen years previously he had painted some Creation scenes. This painting of the Flood is also in greenish monochrome but has been seriously damaged by bad weather; it is truly a visionary work. The ark is built in the shape of an enormous box and appears on both sides of the com-

Paolo Uccello
Predella: Miracle of the Sacrament
Execution of the woman
Urbino, Palazzo Ducale

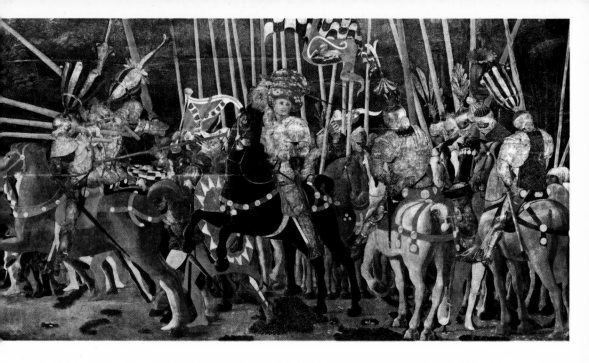

position. This double row of straight lines stretching away to infinity creates a dizzy feeling of space in which the figures are crowded together to emphasise the intensely dramatic feeling of the work. The painting quickly became famous and every painter in Florence hastened to Santa Maria Novella to see it: the cloister soon became known as the Green Cloister. A few years later, Uccello painted his own portrait as part of a long panel portraying his favourite artists: Giotto, Donatello, Manetti, Brunelleschi. Their faces are obviously idealised but in spite of this are painted with a deep regard for psychological truth and understanding. In the portrait, Uccello painted himself as an old man with a white beard. It was, however, the period in which he was at his very best and when he was engaged in painting that major Renaissance work *The Battle of San Romano*, a three-part painting now divided between the Louvre, the Uffizi and the National Gallery. Painting as an eye-witness reporter, Uccello described a recent event: in 1432, the Florentines gave a sound beating to the Sienese troops and the Medici decided to celebrate the occasion by decorating a room in one of their palaces with a picture showing the three main episodes of the battle. In this picture Uccello succeeded in reaching the very essence of form by synthesising his researches and his previous work. The elements of the picture are reduced to their geometric equivalents and by this means are simplified and rhythmically organised. The long straight lines of the lances form triangles in contrast to the blocks of horsemen and horses. Here for the first time Uccello approached the realm of fantasy which was to delight him more and more and which makes him from many points of view a precursor of the surrealists. All the elements of a dream world are present in this triptych: the heraldic devices, the suits of armour articulated like some curious crustacean carapace, the cascading plumes which hide and dehumanise the combatants, the darkness which pervades the whole picture with a gold-splashed glow of red.

The same element of the unexpected appears in another important work by Uccello—the *Miracle of the Sacrament* painted for the Urbino confraternity of the Corpus Domini when he was seventy-one. This was a predella, i.e. a small strip of paintings which forms the lower edge of a large altar-piece. This particular one shows the six main episodes in a mediaeval legend which illustrates the fierce antisemitism prevailing in the minds of his contemporaries: a Jew buys a consecrated wafer from a woman in order

23

Paolo Uccello
Battle of San Romano 1456-57
Oils on wood 180 × 316 cm.
Paris, Louvre

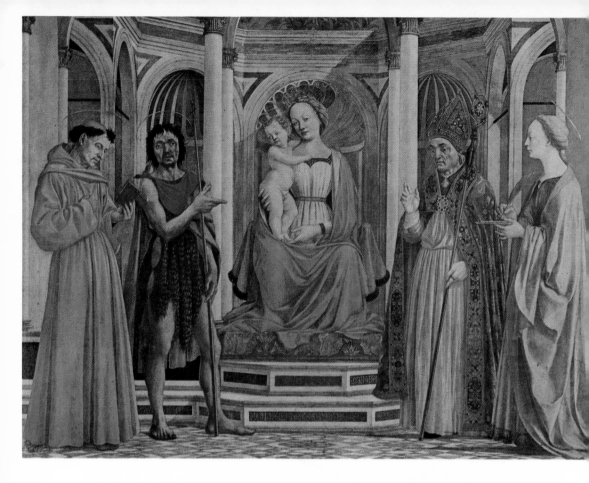

to profane it; the wafer bleeds miraculously; the woman, the Jew and his family are all burnt at the stake. The unpleasant story itself does not interest Uccello, whose mind is totally absorbed in the interplay of colours and the interposing of unexpected details: the shields decorating the Jew's fireplace bear scorpions, black stars and Moors' heaas. The chequerboard floor-tiles and the background landscape all echo the unreal. Story-content is no more than a pretext: what matters is the opportunity to spend more and more time on the exploration of Uccello's marvellous interior world where a kind of magical geometry is sovereign ruler.

All these elements appear in his last known work: *The Hunt*. Are these hunters or are they ghosts? Does the forest, dark, strange, disturbing, belong to the real world or to dreams? But the unusual never works to the detriment of formal necessity: the trees in the foreground divide the composition into four equal parts and even the dogs are formed into a triangle with the hunted stag as apex. When Uccello painted *The Hunt*, he was already a forgotten artist. He spent more and more time on his researches, in so far as his meagre resources would allow. In 1469 he wrote on his tax return: "I am old, infirm and unemployed, and my wife is ill."

He died in 1475. A lonely, tormented artist, long unrecognised, Uccello was unique in the history of the Quattrocento. Unique for a variety of reasons. First, because of his passion for perspective which led him to take its geometric applications so far that he reduced real objects to abstractions. Next, because of his extraordinary mental processes and his conquest of new ideals. Finally, because the basic features of his observation served only one main purpose—the creation of a fabulous dream world. The importance of his message was not fully appreciated until the appearance of cubism, surrealism and abstract art over four hundred years later.

24

Domenico Veneziano
Virgin and Child with Saints
Florence, Uffizi

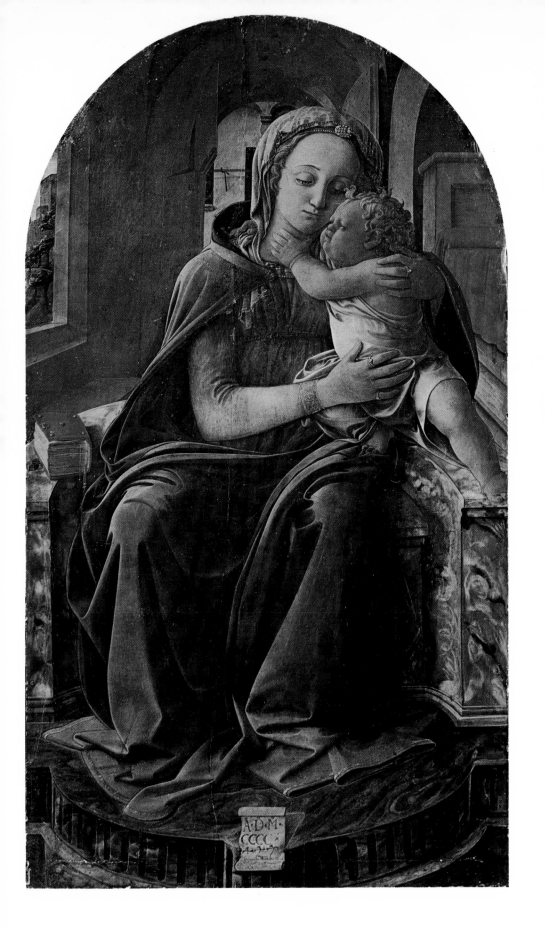

25

Fra Filippo Lippi
Virgin and Child
Rome, Galleria Nazionale d'Arte Antica

The short life of Andrea del Castagno

Andrea del Castagno, another spiritual heir of Masaccio, stayed—unlike Uccello—firmly within the precincts of naturalism. His life was almost as short as his master's: born in 1423, he died of plague in 1457 at the age of thirty-four. He was a woodcutter's son and his name comes from that of a tiny village in the Mugello valley where he spent his youth. He came to Florence early and in 1444 joined the Speziali. He was already well known and his work was admired because a few years earlier the Medici family had given him a very peculiar commission: that of drawing in the form of hanged men the leaders of a rebellion who had been formally exiled from Florence. This won him the nickname of Andreino degli Impiccati (of the hanged men).

His first really outstanding work was the decoration of the refectory of Sant'Apollonia* with the main events in the Passion of Christ. Andrea del Castagno set his *Last Supper* in the dining-room of a Renaissance palace and his use of perspective is so singularly well defined that the room almost seems to open out of the wall. Another striking feature is the dramatic intensity of the different characters, caught in a fraction of a second at the very moment when Christ tells the disciples that one of them will betray him. Even more than in the paintings of Masaccio, the different characters appear as individuals, and the wide range of expressions, the strength of the profiles and their fierce gravity are the expression of a deeply passionate artist seeking above all to give form to spiritual emotion.

Above the *Last Supper*, he painted *The Crucifixion*, *The Entombment* and *The Resurrection*, linked by a calm landscape of small hills; the same emotional force is common to all these frescoes. At the same time, the very confident use of light and shade indicates the influence of Donatello, who inspired Andrea del Castagno's *Christ Crucified*, a painting which is very similar to the Santa Croce crucifix. The same influence is seen in a later work: Andrea del Castagno's frescoes painted in 1451 for the old villa Carducci on the outskirts of Soffiano, now in the Sant'Apollonia cloister (the Castagno Museum). He painted these murals in the form of statues and they represent *Famous Men and Women*, amongst them the Cumaean Sybil, Esther, Dante, Petrarch and Boccaccio as well as other more contemporary figures less well known to us: each portrait conveys a tremendous impression of concentrated energy. It is sometimes said that these portraits imprison the living soul. But the soul calls to us even so and makes us instantly aware of its presence.

The secret of Domenico Veneziano

A story put about by Vasari states quite baldly that Andrea del Castagno murdered Domenico di Bartolomeo, known as Domenico Veneziano, in order to rob him of the secret of oil painting which Domenico had brought from Flanders. Modern scholarship has shown this to be sheer slander by proving that Veneziano did not die till four years after his alleged murderer, that is in 1461. Moreover, Veneziano never painted in oils,

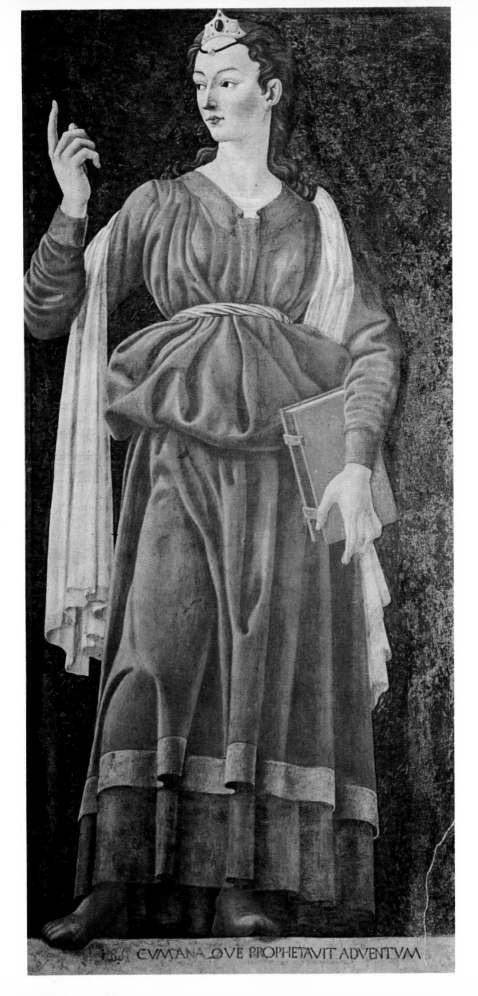

CVMANA QVE PROPHETAVIT ADVENTVM

27

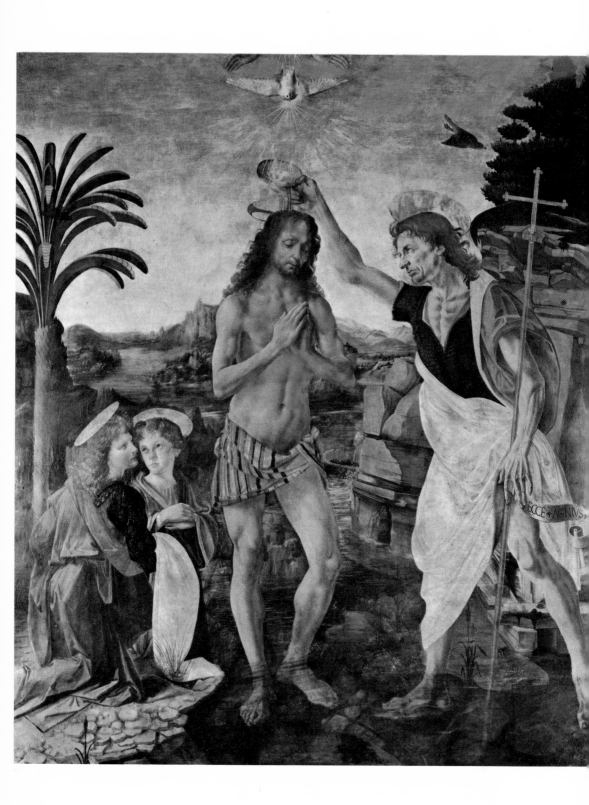

a technique only introduced to Italy later, chiefly by Antonello da Messina. All his works are painted in tempera, a process in which powder colour is "tempered" with a binder, at this period usually egg yolk. Sometimes a certain amount of drying oil was added and this possibly gave rise to the legend, though this was not in any sense of the word oil painting proper. In the early Renaissance, artists knew only two processes, tempera and fresco. Fresco was reserved for wall paintings and consisted basically of an application of a water-colour to damp plaster, care being taken that the plaster did not dry out during the process.

It is certain that Veneziano saw a number of Flemish paintings whilst in Venice, for he makes great use of the same kind of minute detail. His stay in Venice also influenced him in his use of delicate, luminous colours. This particular contribution combined with the strong influence of Masaccio and Uccello in matters of perspective and sturdiness of form produced a curiously gentle art which contrasts strongly with the restrained violence of Andrea del Castagno. Veneziano was the master of Piero della Francesca, who acted as his assistant. Unfortunately, only a few of his works have come down to us; amongst them is a fine *Sacra Conversazione** in which St Lucy, St Zenobius, St Francis and St John the Baptist, the four patron saints of the donors of the altar-piece, surround the Virgin, apparently engaged in conversation. There is already more than a hint of Raphael here in the sweetness and mild melancholy which appear on the women's faces. Also attributed to Veneziano is the remarkable *Adoration of the Magi* from the Berlin museum. This circular painting, probably a *tondo**, depicts one of the earliest landscapes in perspective from the Florentine school; the influence of Flemish painting is still discernible.

The picaresque tale of Filippo Lippi

Andrea del Castagno and Domenico Veneziano are important links between the early Renaissance artists and those of the following generation. The most significant painter of this transition period, however, is Fra Filippo Lippi*.

His whole life reads like a picaresque novel. He was born in Florence in 1406, the son of a butcher who died soon afterwards. Since he was an orphan, he was sent as a novice to the Carmelite monastery in Florence when he was eight years old; he was only fifteen when he took his vows. As a very young novice he would have seen Masolino and Masaccio painting the frescoes in the Brancacci chapel of the monastery church and in this way got his first lessons in painting from the masters themselves. In about 1432 he left the Carmelites—without, however, leaving off his monk's habit—and began a wandering life, painting more and more all the time. In 1450 he was imprisoned and whilst under torture confessed to fraud. Cosimo de' Medici, impressed by his talent, decided to become his protector and had him released. The following year saw an even more scandalous episode: appointed chaplain to the nuns of Santa Margherita at Prato, Filippo Lippi abducted the young and lovely nun Lucrezia Buti who was acting as his model for an altar-piece of the Virgin. She bore him a son, Filippino, who also became

a famous painter. Cosimo de' Medici intervened once again (especially as he "had had a good laugh at the brother's wild escapade") and got the pope to release them from their vows so that they could marry. Filippo Lippi does not seem to have been particularly grateful for he was soon off in pursuit of further adventures, his creditors ever at his heels. When he died in 1469, it was whispered that he had been poisoned by the family of one of his conquests.

In spite all these commotions, Filippo Lippi managed to produce a considerable volume of work and was the Church's favourite painter. His passionately sensual nature had no effect on his personal devotion to the Carmelite cult of the Virgin Mary. Almost all his easel-paintings are devoted to her: *The Annunciation, The Nativity, The Crowning of the Virgin*, themes which appear over and over again in his work are still present in his last commission—the frescoes in Spoleto Cathedral. He gave a new trend to religious iconography by relating it to humanism. "Gradually, under his influence, the human being in all its individuality took the place of uniform, standardised religious representations. The Madonnas became living virgins and real mothers to which the painter gave enthusiastically and sympathetically the virginal charm and the maternal tranquillity he admired and understood."[1]

It was in fact Filippo Lippi who made it standard practice to introduce proper portraits into the presentation of religious subjects. It is true that before him Fra Angelico, Giotto and others had dared to introduce contemporaries into their paintings, but always with discretion and never in the foreground. In Lippi's paintings, the faces of his saints are those of the men and women of his time. In *The Coronation of the Virgin*, painted for the church of Sant'Ambrogio in 1447, some of the town worthies can be seen among the blessed and on the left there is a young monk with his chin resting on his hand who is none other than Filippo himself. Many of his Virgins with child have the facial features of the beautiful Lucrezia Buti.

One of his most important works as a whole is represented by the frescoes in the choir of Prato Cathedral*. He worked on them—irregularly, it is true—for over twelve years. On the right, the *Life of St John the Baptist* and on the left *The Story of St Stephen*. The first series of pictures includes a much-admired *Herod's Feast* which is full of a curiously pagan sensuality; Salome's veils emphasise the curves of her body as she dances before the guests in their uncompromisingly 15th-century clothes—but she bows her head rather prudishly. There is a striking contrast between this scene and the *Funeral of St Stephen* on the opposite wall; here, the solemnity and emotional power of the work express a genuine religious feeling. Most of the figures in it, though, are taken straight from everyday life. The priest on the left who is reading a prayer-book is Donato de' Medici, bishop of Pistoia; a stout gentleman in the forefront of one group can be identified as Carlo de' Medici. The deep sorrow expressed by the bystanders in the picture stresses the supernatural serenity of Stephen's face.

It was at the request of the Medici family that Filippo Lippi started painting some

30 [1] G. Lafenestre, *La Peinture italienne*. Paris 1895.

frescoes in Spoleto Cathedral in about 1467; his son Filippino and his uncle Fra Diamante acted as his assistants. The basic theme of the frescoes is the life of the Virgin. In the *Coronation*, he attained the very height of his artistic power and strength of conception. This was his last masterpiece. The entire roof of the apse is covered by the apotheosis of the Queen of Heaven crowned by God the Father before a crowd of the blessed, of angels, saints and prophets. Filippo Lippi died on 8 October 1469 before he had had time to finish this great fresco which sums up and completes his work. It was finished after his death by Fra Diamante, whose less emotional style is easily recognisable. It was Fra Diamante who took over the education of Filippino as requested by Filippo Lippi in his will.

Fra Filippo Lippi was a major influence in the development of the Florentine school, for his innovations were enthusiastically adopted by his successors. Botticelli was one of his pupils.

Andrea del Verrocchio, the all-round craftsman

Many of the Quattrocento artists did not limit themselves to painting alone. Andrea del Verrocchio*, for instance, was an equally gifted sculptor, goldsmith, engraver and mosaic-worker. Out of this all-rounder's workshop came a multiplicity of things executed to order: clasps for the sacerdotal vestments of the priests of Santa Maria Novella, heavily chased cups and vases, exquisite candelabra for the Palazzo Vecchio*, ornamental fountains, busts, reliefs, statues, funerary monuments in marble, terracotta, bronze or silver. In addition, Verrocchio undertook the restoration of the antique statues belonging to his friend and protector, Lorenzo de' Medici, and organised his entertainments. Moreover, he was both a mathematician and a musician. Not surprisingly, he painted few pictures but none the less had a strong influence on the development of painting. Trained originally by Alesso Baldovinetti*, one of Filippo Lippi's most sensitive pupils, he reached a true originality through the effect of his sculptural technique on his pictorial art, more especially in the anatomical accuracy of his figure drawing and in the way he strove to express the subtlest thoughts on his characters' faces. Verrochio was also much preoccupied by unity of composition and this he achieved by restricting the number of figures integrated into the landscape; he was far ahead of his contemporaries here. These characteristics are found in the only two paintings which can be attributed to him with certainty: the *Baptism of Christ* and the *Madonna* from the Duomo at Orvieto. Verrocchio had a young assistant of fourteen helping him with the *Baptism*: his name was Leonardo da Vinci. Vasari says that Leonardo painted the angel on the left and that Verrocchio was so struck by his genius that he resolved to lay down his paint-brushes for ever!... One thing is sure: it was from Verrocchio's work that Leonardo took his female figures and the androgynous angels with their faint smiles and equivocal charm. The influence was an important one. Where else could Leonardo have found the fantastic rocks which form the background of the *Mona Lisa* if not in the *Baptism of Christ*? The most delicate parts of this latter work, which is for the most part painted in tempera,

are painted in oils. Verrocchio was therefore one of the first Florentine artists to experiment in the new techniques of colour and painting media; his studio was in some sense a laboratory where Leonardo, Perugino and Botticelli formed their techniques.

The workshop of the Pollaiuolo brothers

The Verrocchio workshop had a rival in Florence, a concern in the Via Vaccherecchia near the Ponte Vecchio. It was run by Antonio and Piero Benci who got their curious nickname from their father's trade of poultry-seller. Born in Florence, the elder in about 1432 and the younger about 1443, they were, like Verrocchio, sculptors and goldsmiths as well as painters. Contemporary documents show them delivering an altar-piece to the Pucci family (their well-known *St Sebastian*), a belt and a silver chain to a certain Filippo di Cino Rimiccini, designs for the embroidery of a chasuble and a cope for San Giovanni, the shield and accoutrements carried in a tournament by Benedetto Salutate, a silver helmet given to the Duke of Urbino by the Signoria of Florence, jewels, enamels, medals. Their last work was the tomb of Innocent VIII in the Vatican basilica. The brothers' collaboration was so close that it is difficult to know which brother did what. It seems probable that Antonio, the elder, had the stronger personality and that it was he who determined the main outlines of their joint undertakings. He laid out the plans for paintings which he did not himself paint. Most important, it is through Antonio that the influence of Andrea del Castagno can be most strongly felt—in the brothers' efforts to express the full physical strength of the body. Castagno's *Pippo Spano* is the inspiration for Antonio Pollaiuolo's *David* (painted without his brother's assistance). He was so passionately interested in anatomy, according to Vasari, that "he dissected many bodies to see how they were made underneath and was the first to show how to find the muscles according to how they appear in the human form". It was Antonio Pollaiuolo who, together with Mantegna, started the fashion for mythological subjects; it gave him the opportunity for drawing the nude in movement with the utmost skill and perfection. Two of the small paintings he did for the Medici—*Hercules fighting the Hydra* and *Hercules and Antaeus*—are very characteristic of his rather wild and impetuous manner. No one before had ever depicted such a violent display of muscular energy. The same obsession with human musculature is noted in the *St Sebastian* in which Antonio had the assistance of his brother.

Three paintings are known for certain to be the work of Antonio and Piero together: *Tobias and the Angel*, the *Annunciation* and *Three Saints*. Piero alone was responsible for the *Virtues*—Faith, Prudence, Charity etc.—commissioned by the Mercantazia and for a *Coronation of the Virgin* painted for the Collegiata of San Gimignano. His style is less vigorous than his brother's and has much less originality— it is possibly more elegant on that account.

Piero died in 1496 and Antonio two years later in 1498; both were in Rome where they had been working on the tombs of the Popes Sixtus IV and Innocent VIII. United in death as they had been in life, they lie side by side in the church of St Peter-in-Vincoli.

Domenico Ghirlandaio
Florence 1449-94
Adoration of the Magi
Oils on wood
Florence, Uffizi

Ghirlandaio the forerunner

There were, however, some studios which specialised in painting. There was, for instance, the workshop run by Domenico di Tomaso Bigordi, born in 1449 and better known as *Ghirlandaio*, the "garland-maker", a name which came from his father's supposed skill in making the gold and silver crowns popular at that time in Florence for hair ornaments. In fact, his father did not make these "garlands" at all—he was only a dealer in gold-smiths' work. Domenico started a family business in association with his two brothers, Davide and Benedetto, and his brother-in-law, Bastiano Mainardi. In addition, they employed quite a large number of pupils. The name Ghirlandaio came to mean some-thing "rather like the trade name of a company whose products are not all of the same quality: it is clear that the more Domenico was concerned with a painting, the closer the work came to perfection; for he was the head of the 'company', the master, the great artist of the family, the only one who really counted—and we have the proof of this in the fact that some contracts specify particularly that some figures in the paintings, figures of angels in particular, must be by his hand alone."[1] Domenico served his apprenticeship with Baldovinetti, where he learnt mosaic work as well as painting. His superb *Annunci-ation* in the lunette over the north door of the Duomo in Florence shows that his mosaics were every bit as good as his pictures. Fortunately, he did not emulate Baldovinetti in those experiments with new chemical formulae for colours which led to the rapid deterior-ation of the major part of the latter's work. Domenico Ghirlandaio remained true to the old techniques of tempera and in particular of fresco; with the help of his team of assistants he produced a tremendous volume of work in spite of a premature death at the age of forty-five. He did not live to realise his great dream of "painting every inch of the walls surrounding Florence".

As early as 1475, the *Story of Saint Fina* showed his great verve and the breadth of his ambition, in spite of a slight clumsiness of technique. Five years later, in Florence, he painted two frescoes in the church of Ognissanti: a *St Jerome* meditating in the middle of books and small objects, very humanist in presentation, and a *Last Supper* inspired by Andrea del Castagno's, but somewhat more delicate in execution—a foretaste of Leonardo's great work in Milan.

In 1481 he was invited along with Cosimo Rosselli, Botticelli and Perugino to decorate the pope's chapel in the Vatican—later known as the Sistine chapel. A strictly drawn-up contract stated that Domenico would have six months to complete two large frescoes: the *Resurrection* (now completely disappeared) and *The Calling of the Apostles*, still to be seen on the right-hand wall, looking towards the altar.

He had barely returned to Florence when the Signoria commissioned him to decorate one wall in the Sala dei Gigli in the Palazzo Vecchio. In this mural he set St Zenobius, patron saint of the city, alongside the republican heroes of antiquity: Brutus, Mucius Scaevola, Scipio, Cicero... The fame of his studio was now at its height

[1] H. Hauvette, *Ghirlandajo*, Paris 1907.

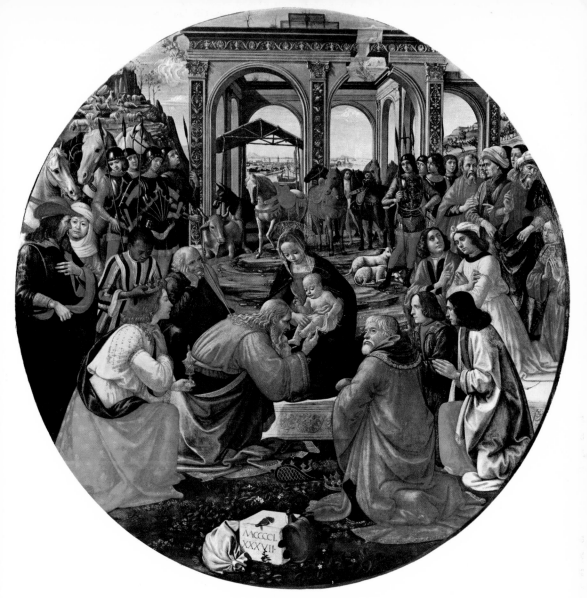

and it was therefore quite natural that the wealthy banker Francesco Sassetti should ask him rather than anyone else to undertake the special task of decorating a chapel dedicated to Sassetti's patron saint St Francis in Santa Trinita. Ghirlandaio planned a monumental cycle consisting of six frescoes in which he interwove scenes from the saint's life with portraits of the donor, his wife, children and friends, all in their finest clothes and set against the background of 15th-century Florence.

The work which really confirmed his reputation was commissioned in 1485 by another associate of the Medici family, Giovanni Tornabuoni, treasurer of Pope Sixtus IV. It consisted of fourteen scenes in the choir of Santa Maria Novella*. At this point, it is interesting to quote a clause from the contract between the donor and Ghirlandaio as an illustration of the restrictions the patron might impose on the artist's freedom of inspiration: "It is agreed that the artist should, before starting to paint any of the subjects listed above, make a sketch and submit to the aforesaid Giovanni Tornabuoni his design for the scene and for the painting he has in mind; only then can he begin to draw the picture and paint it where required, adding to it all the items desired, in the way suggested and in the form chosen by the aforesaid Giovanni; the execution of the entire scheme must in all things proceed according to the wishes of the aforesaid Giovanni...".

35

The subjects to be painted were as follows: on the left-hand wall, *Scenes from the life of the Virgin*, and on the right-hand wall, *Scenes from the life of St John the Baptist*. Once again, Ghirlandaio put into these religious scenes portraits of well-known Florentines, friends of the Tornabuonis or members of the family: Giovanni's lovely daughter Lodovica is one of the ladies visiting St Anne in childbed in the *Birth of the Virgin*.

In spite of his preference for large wall surfaces, Ghirlandaio painted a few easel pictures, outstanding among them *The Adoration of the Shepherds* and *The Adoration of the Magi*, as well as a *Portrait of an Old Man* of curiously touching ugliness—he bends his red drinker's nose affectionately over his adorable grandchild. By accepting all sorts of commissions, Ghirlandaio practised what he preached; he told his pupils to take anything that came into the studio, however ordinary it was; "And if you won't do it, then I will."

Some complain that Ghirlandaio's work lacks subtlety and poetry. The religious feelings expressed in his paintings are lacking in strength because they are not experienced with any depth of emotion or spirituality. But one must admit that his style had a remarkably fortunate influence on the Florentine school, for he transmitted to it both a superb sense of arrangement and a clarity of style; everything was subordinate to the general effect and to over-all unity. The road leading from Giotto to Michelangelo passes through Ghirlandaio—who was, after all, Michelangelo's master. Perhaps most important of all is the fact that we find in his paintings the full expression of the Florence of the Medicis at the moment when it was one of the great centres of Western civilisation, a marvellous eye-witness account of its citizens, its houses and its everyday life.

Gozzoli, witness to his time

Alongside these great innovators, Benozzo Gozzoli* seems curiously old-fashioned, in spite of being fourteen years younger than Ghirlandaio; his art is still closely linked to the old traditions of imagery and manuscript illumination. He painted for the common people rather than for the wealthy and gave them the sort of religious pictures they really liked. Born in Florence in 1420, he led a quiet, unobtrusive existence. When he was twenty-four he was taken on as an assistant in Ghiberti's studio when the artist was working on the second Baptistery door in Florence. Gozzoli's paintings never lost this early goldsmith's training, always discernible in his liking for abundant and minute detail. His real master, though, was Fra Angelico. He went with him to Rome in 1447 to work on the decoration of the pope's private chapel in the Vatican, then he accompanied him to Orvieto, where they were engaged on the frescoes of the San Brizio chapel in the cathedral. Fra Angelico absorbed the principles of perspective and other Quattrocentist discoveries late in life and it was through him that Gozzoli adapted them to his own theories of art. Indeed, he made a more thorough application of them than his master, though he never gave up the forms of the primitives. This compromise, this careful balance between two extremes gives the work of Benozzo Gozzoli its special character and charm.

36

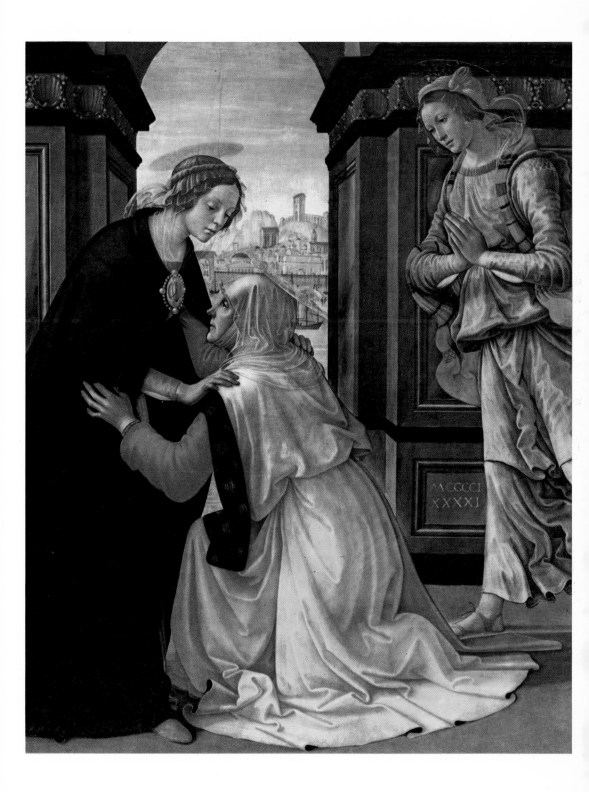

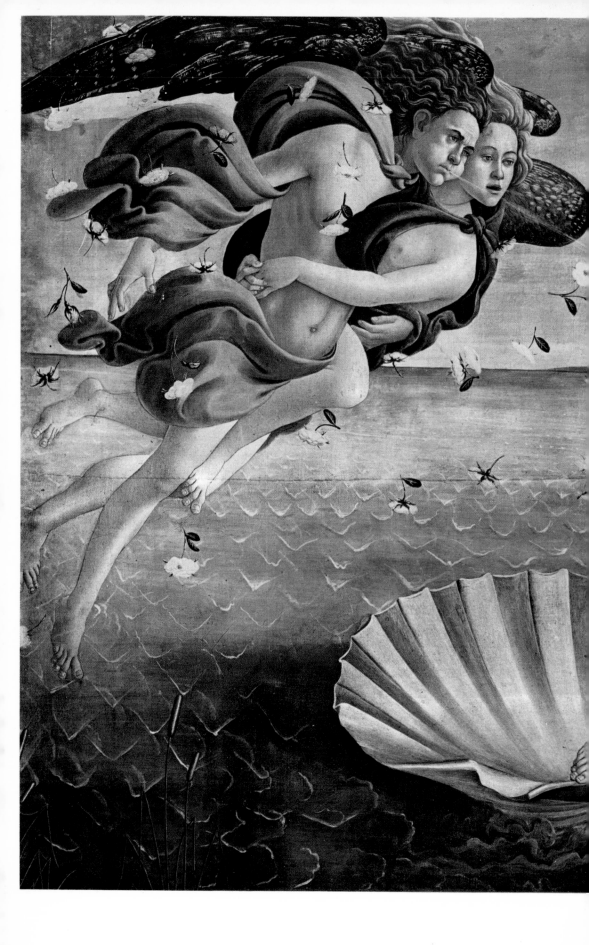

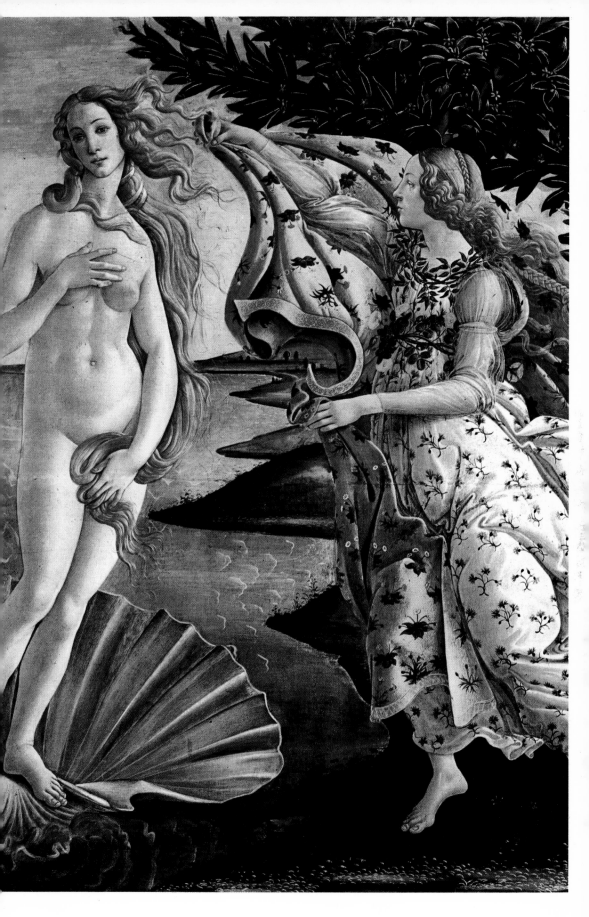

Sandro Botticelli
Florence 1444-1510
The Birth of Venus, about 1486
Oils on canvas 175 × 278 cm.
Florence, Uffizi

Once he had left Fra Angelico, he found commissions of his own. From 1450 to 1452 he painted frescoes on the walls of San Francesco* in Montefalco, a small town in Umbria. Twelve scenes show the *Life of St Francis*, a hundred and fifty years after Giotto had painted the famous Assisi frescoes on the same subject. Gozzoli paid tribute to him in his fresco by painting him between Dante and Petrarch with the inscription: *Pictorum eximius Iottus fundamentum et lux*.[1] In spite of this generous compliment, he drew little inspiration from Giotto's work and his frescoes have their own vigour and liveliness of narration. We see in them the first traces of his love for nature and small children: he took obvious pleasure in painting their pretty little faces and touching ways.

When he returned to Florence in 1459 he was famous enough to be offered a commission by Piero de' Medici which provided him with a splendid opportunity for displaying his skill: it was to be possibly his finest and certainly his best preserved work —the decoration of a private chapel in the palace which Michelozzo Michelozzi* had built for Cosimo de' Medici (now the Palazzo Riccardi). The room was dark and narrow— not in the least suitable. This did not matter to Gozzoli: he covered the walls in the brilliance of gold. By a stroke of genius hitherto unknown in the history of painting, he led the *Procession of the Magi* around three walls to converge on the altar which at that time was decorated by a painting by Filippo Lippi, *The Virgin kneeling before her Son*, a scene before which the Procession would naturally stop. The characters in the painting have the faces of the great men of the time: riding in the procession are the

[1] Giotto, the incomparable, source and inspiration of painters.

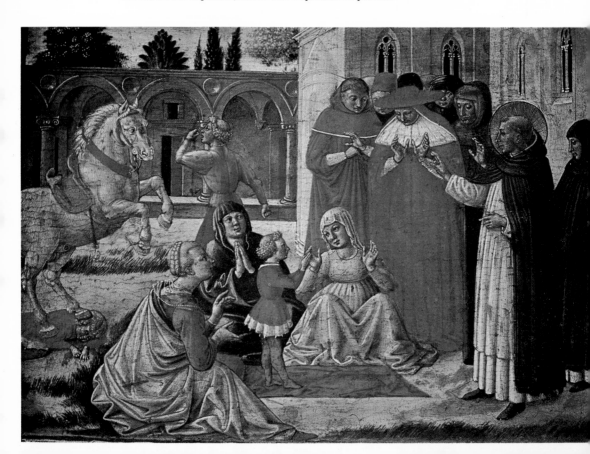

Emperor John Palaeologus and the Patriarch Joseph (both of whom came to Florence from Byzantium for the 1439 Council which tried to effect a reunion of the Eastern and Western Christian churches), Cosimo de' Medici, some of his sons and many of his courtiers.

Shortly afterwards, Gozzolo went to San Gimignano at the request of Domenico Strombi, otherwise called "the Parisian" since he held a doctorate from the Sorbonne. Strombi was wealthy and was the Prior of the local Augustinians; he invited Gozzoli to paint seventeen episodes from the life of St Augustine on the walls of Sant'Agostino. He was never more inventive and in the scenes of family life he excels himself; the pictures are full of marvellous detail—see, for instance, the one where the child Augustine is beaten by his teacher. Benozzo Gozzoli died of plague at Pistoia in 1497, but before this happened he had been settled in Pisa for more than sixteen years, happily engaged on a monster undertaking: *Scenes from the Old Testament*, a vast fresco of pictures covering the walls of the Campo Santo cloister over twenty-two feet high and over 400 feet long. "Opera terribilissima!" exclaimed Vasari. Of course, Gozzoli had to have help and the poor technique of some of his assistants spoils some parts of the frescoes. The end product is an enormous Biblical epic, unrolling all along the walls, often gaily, sometimes amusingly, covering the Bible from Babel to Sodom, from Abraham to the Queen of Sheba, all set very clearly and definitely in a totally anachronistic 15th-century Italy. Bennozo Gozzoli has recreated in this work all the public and private life of his period, with special emphasis on the life of the common people. One detail from the frescoes has amused people for over five hundred years: in the *Life of Noah* a servant girl—known ever since as *La Vergognosa*, "the prude of Pisa"—hides her face at the sight of the drunken patriarch's unwitting immodesty, but looks between her fingers to make sure that even so she sees what is happening...

Sandro Botticelli, pagan and mystic

Seek for the complement to Benozzo Gozzoli's easy-going, mischievous temperament and you will find it in the restlessness of Botticelli's romantic imagination.

He was the greatest painter of the late fifteenth century. His nickname was hopelessly ill-suited to his character and in fact it came from his father's affectionate name for another son—*Botticelli*, "little barrel". In Florence, it usually happened that, if one member of a family got a striking nickname, it was passed on to everyone else in the household. Botticelli's real name was Alessandro di Mariano Filipepi. Born in 1444, he went as an apprentice to Filippo Lippi's studio when he was working on the frescoes for Prato Cathedral. It is quite possible that Botticelli's first attempts at real painting appear on these walls. He never lost his affection for Filippo and it is certain that these early years had a permanent effect on his painting technique. It is from Filippo Lippi's art that Botticelli took the languid grace of his Madonnas, his frail transparent draperies and the clear, fluid outlines of his figures. The Prato *Salome* heralds the typical Botticelli woman.

41

Benozzo Gozzoli
St Dominic resurrecting a Small Boy
killed by a Horse
Milan, Brera Museum

The young Botticelli had a passion for knowledge that one teacher alone could not adequately satisfy. In 1470, he was working with Antonio and Piero Pollaiuolo and from the elder learnt the science of drawing the nude and the interpretation of mythology. Soon afterwards, he studied the extreme preciseness of relief drawing as found in Verrochio's work and took from him a tendency to give his faces an enigmatic cast.

The first painting of absolutely certain attribution is the allegory of *Fortitude* which goes with a set of six other Virtues by Piero Pollaiuolo for the Florence Mercatanzia. His own *Virtue* does not stand out especially from the six others as far as the sculptural quality of the work is concerned, but it does have an intimation of his originality in the dreamy expression and sensitivity of the face. This quest for delicacy of expression is even more noticeable in two tiny pictures from the same period, both inspired by the Biblical story of Judith: in *The Discovery of Holofernes' Corpse* and, more especially, in *Judith's Return to Bethany*, one of his earliest masterpieces: he presents a superb antithesis in the sword and the olive branch which Judith carries and which stress the dramatic opposition between the virginal sweetness of her face and the murderous blow she has struck at the head of the Assyrian general.

In 1473 Botticelli began working for the Medici family; this was the moment when he drew near the period of his fullest expression, gradually casting off all previous influences. Like Filippi Lippi, he painted madonnas on the inevitable "tondi" but he gave them a very individual expression: a deep underlying anxiety which contrasts movingly with the Child's serenity. See, for instance, *The Virgin and Child surrounded by Saints* and *The Madonna of the Magnificat*, as well as *The Adoration of the Magi*, where the artist placed himself on the extreme right of the picture in a voluminous yellow cloak. The Magi and their companions are none other than the Medici in full force; Cosimo kneels to kiss the Child's feet; behind him hover Piero, Giovanni, Giuliano, Lorenzo the Magnificent, a great cohort of familiars, poets, artists, all the hangers-on....

Botticelli was called to Rome in 1481, when he was thirty-seven, to take part in the decoration of the so-called Sistine chapel at the request of Pope Sixtus IV. This invitation set him on an equal footing with Ghirlandaio, Cosimo Rosselli, Perugino, etc. He painted three frescoes for the chapel: *The Cleansing of the Leper* and *The Temptation of Jesus*, scenes from *The Life of Moses*, *The Punishment of Korah, Dathan and Abiram*. Freedom of inspiration suffers considerably in circumstances where the artist is obliged to introduce into each fresco a series of episodes in which the principal character appears over and over again, but in spite of this handicap, the true Botticelli is present in this work—in the harmony of contour, the intensity of expression, the power of imagination and, above all, in the balance achieved between the descriptive detail and the breath of spiritual life which animates the whole concept.

When he returned to Florence in 1482 with a firmly established reputation, Botticelli soon became closely linked with the humanists, philosophers and poets surrounding Lorenzo de' Medici. He was immensely receptive to the ideas of Marsilio Ficino* and Pico della Mirandola*, who tried to reconcile Plato's teachings with those of Christ and to relate the wisdom of the ancients to the spirit of the New Testament.

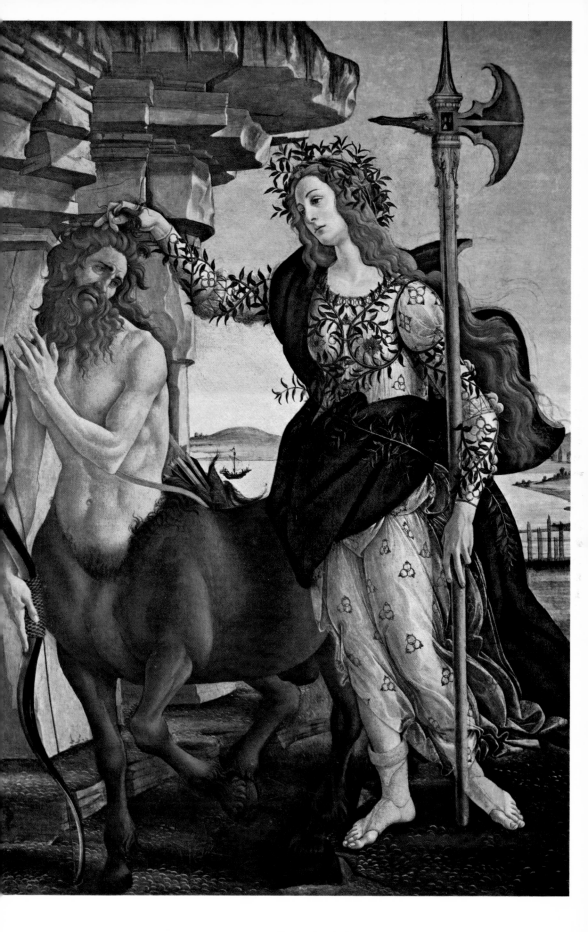

Sandro Botticelli
Pallas and the Centaur
Oils on canvas 239 × 147 cm.
Florence, Uffizi

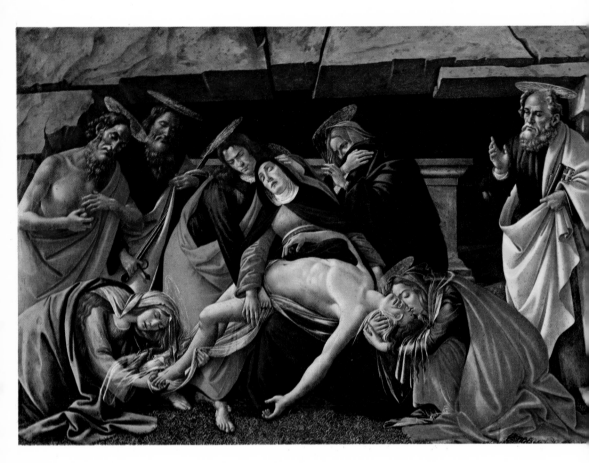

It is this influence which led to the full flowering of his personality and his famous master-piece *Primavera* offers ample evidence of this. Flora, the spirit of Spring, moves enigmatically through the dancers, mythological figures, allegorical symbols of neo-Platonic philosophy; the painting recalls the poems of Lorenzo the Magnificent as well as Poliziano's* verses. Indeed, it was a "stanza" of Poliziano's which provided the inspiration for *The Birth of Venus*. In this painting, Botticelli raised sensual imagery to truly spiritual heights; he painted Venus with that curious stylised elongation which became one of his characteristics and conveyed movement by the undulating lines of the body. There are other paintings in the same vein: *Pallas and the Centaur*, a political allegory relating to the Medici family, and *Calumny**, a work inspired by a description of a lost painting by Apelles in which Suspicion, Guile, Envy, etc. try to upset King Midas' sense of judgement.

In 1486 Botticelli went to the villa of Lorenzo Tornabuoni, Lorenzo de' Medici's cousin, to decorate it with frescoes in preparation for a wedding celebration. The frescoes were rediscovered under a thick layer of whitewash during the 19th century and were taken to the Louvre.

Sandro Botticelli
Calumny
about 1495
Oils on wood 62 × 91 cm.
Florence, Uffizi

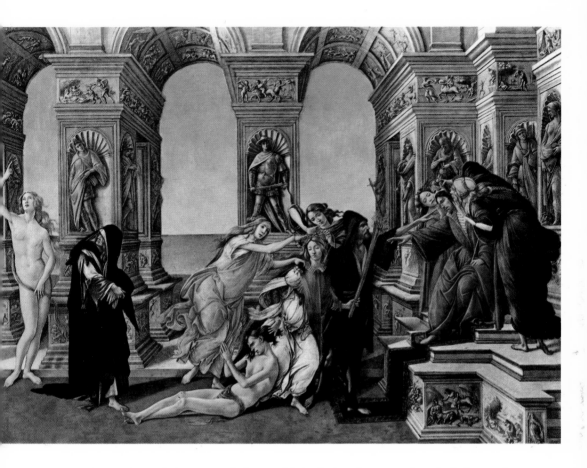

His thirst for knowledge concealed a troubled mind, only too ready to be influenced by the disturbing words of Savonarola *; this Dominican preacher dominated Florentine life from 1491 to 1498, at first only morally, but towards the end politically also, constantly preaching repentance and penitence and urging total rejection of the loose morals then prevalent. Botticelli was completely won over and became a *piagnone*, a "weeper", one of Savonarola's supporters; in 1497 the Dominican organised great bonfires to burn the vanities of Florence. Botticelli's drawings and paintings went into the flames together with other people's licentious literature and flimsy dresses.

But on 23 May 1498, Savonarola was arrested, tortured and burnt as a heretic in the Piazza della Signoria. Botticelli was shattered by this disaster and set his mind on continuing Savonarola's work by means of his art. A mystical exaltation illumines his *Adoration of the Magi*, a work he never finished. In the middle of the great crowd which has come to adore the Son of God, Savonarola himself presents to Lorenzo the Magnificent the Christ he had proclaimed sovereign ruler of Florence. The two *Entombments* he painted were deliberately conceived as illustrations of Savonarola's terrifying descriptions of the Passion. In his *Coronation of the Virgin*, an altar-piece commissioned

45

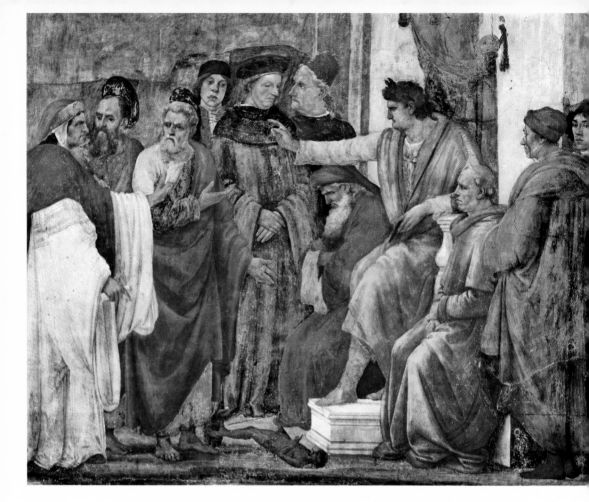

for San Marco, it is clear that at this point Botticelli abandoned recent progress in painting technique and returned to archaic formulae worthy of Fra Angelico. In his last picture, *Mystic Nativity*, he even abandoned all attempt at proportion and perspective and wrote in Greek at the top of the painting a clear indication that he still retained his faith in the eventual triumph of Savonarola's ideas: "I Sandro painted this picture at the end of the year 1500 in the troubles of Italy in the half-time after the time according to the 11th chapter of St John in the second woe of the Apocalypse in the loosing of the devil for three and a half years, then he will be chained in the 12th chapter and we shall see clearly as in this picture."

A vain prophecy which could not conceal Botticelli's despair. His life dragged hopelessly on for another ten years before he died on 17 May 1510, at the age of sixty-six. He had gone further than anyone else in the quest for rhythm and in the idealisation of reality. His restless, impressionable nature had led him from frank paganism to passionate mysticism. Throughout his painting career he taught younger artists in his studio in the Via Nuova, now the Via Porcellana.

A precursor of the baroque: Filippino Lippi

Botticelli's most famous pupil was Filippino* Lippi, fruit of the illicit relationship between Filippo Lippi and a nun. He was only twelve years old when his father died, leaving him in the care of Fra Diamante. What else could he do but paint? He was listed as an apprentice in Botticelli's studio from 1472 onwards, according to the register of the

46

Filippino Lippi
Florence about 1406-Spoleto 1469
St Peter and St Paul led before the Proconsul
between 1482 and 1487
Fresco
Florence, Santa Maria del Carmine

Corporation of St Luke. His art reveals in its early stages the double influence of his father and his teacher, but with the difference that unlike Botticelli he painted exclusively Christian subjects, though the religious feeling behind them was rather weak. It did however bring him a vast number of commissions from bishops and religious houses. He never approached Botticelli's genius, but was always a brilliant technician; beneath a cheerful demeanour he concealed a deeply troubled personality. Vasari called him: "Cortese, affabile e gentile". In one of his first works: *The Annunciation, between St James and St Andrew*, he wavers between imitating his father (especially in so far as the Virgin and the archangel are concerned) and reproducing Botticelli (in the painting of the apostles). However, the interpretation of the background landscape is his alone and this was always to be a particular feature of his style. In 1486 he painted a large *Seated Madonna* for a room in the Palazzo Vecchio. Mary and the saints surrounding her already give promise of his growing tendency to use a restless fluttering line and overcrowded, animated canvases.

A year later, he produced a masterpiece: *The Vision of St Bernard*. There is still the elongation of the figures to recall Botticelli but everything else is pure Filippino Lippi: the contrasts of light and shade, the ecstatic expression on the saint's face, the vigorous portrait of the donor kneeling in prayer in a corner of the picture.

No one knows exactly when the Carmelites and their financial advisers decided to appoint him to complete Masaccio's frescoes in the Brancacci chapel, left unfinished fifty years before. It must have been at some time between 1482 and 1487, approximately when he was painting his easel pictures. He made a very remarkable effort to adopt Masaccio's style and in particular to reproduce his monumental concept of pictorial art; Filippino restrained his natural technique in *St Peter and St Paul before Nero* and the *Crucifixion of St Peter*. He painted his own portrait in a group of other contemporary artists in this mural and set himself in the company of Botticelli and Antonio Pollaiuolo. His own technique can be seen rather more clearly in *St Paul visiting St Peter in Prison* and especially in *The Angel delivering St Peter from Prison* where the heavenly messenger is distinctly "Botticellian". He also completed the *Raising of Theophilus' Son* by filling in a blank space with a group of bystanders. The undertaking as a whole was a success, but Filippino's talent was too lightweight to stand up to Masaccio's sturdy magnificence.

His reputation, however, spread throughout Europe and Matthias Corvinus, King of Hungary, invited him to his court. Filippino refused, but made amends by introducing the king's portrait, copied from coins, into two altar-pieces which he sent to Hungary as a gift. In 1488 he left Florence for Rome, where he painted Cardinal Caraffa's chapel in Santa Maria sopra Minerva*. This was the Dominicans' mother church in Rome and the subject of the frescoes was naturally the life of the greatest Dominican of all, the angelic doctor, St Thomas Aquinas. Filippino tried in vain to restrain the natural exuberance of his imagination: until now, 15th-century pictorial art had observed a distinct sense of order, but at this moment a certain lack of balance started to creep in. In *The Assumption*, angel musicians drunk with ecstasy frolic wildly around the Virgin in glory.

47

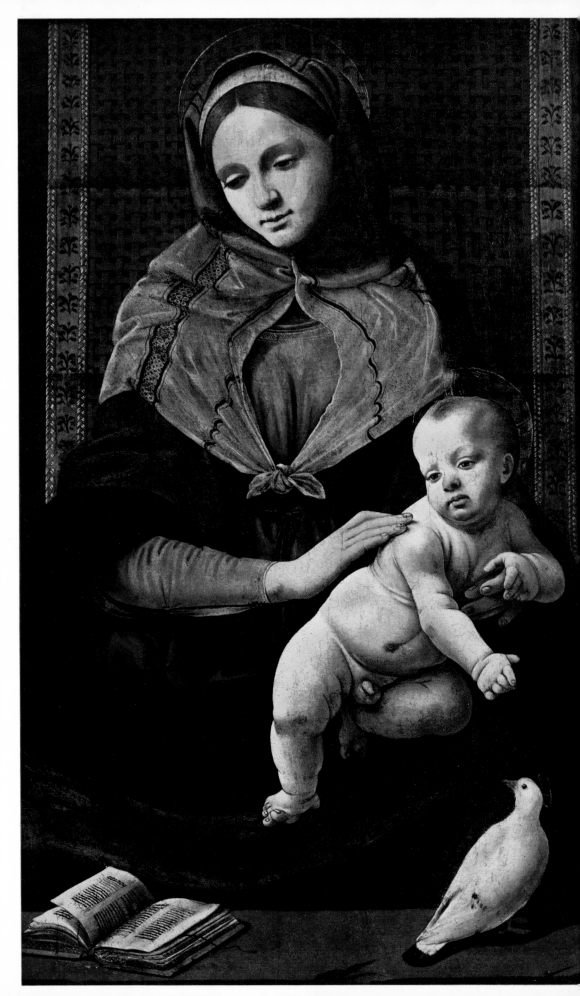

This taste for extravagance took over completely in his large altar-piece *The Adoration of the Magi* (1496). In his last cycle of frescoes painted for the Strozzi Chapel in Santa Maria Novella (1500-1502) he allowed himself to succumb to an absolute paroxysm of movement. When he painted the martyrdom of St John the Evangelist— and that of St Philip, too—he filled all available space with important characters gesturing extravagantly, all of generally haggard, emaciated appearance. Curious backgrounds heavily loaded with architectural motifs give a final touch of what was in due course to be typical of Baroque painting.

Filippino Lippi took his technique no further: in 1504, at the age of only forty-six, he died of a heart attack, mourned by the whole of Florence. The shops in the Via dei Servi were closed for his funeral as though he were a prince. He bequeathed some houses to his sister Alessandra and to his "beloved mother" Lucrezia Buti. He left the remainder of his estate to the Hospital of Santa Maria Novella on condition that it provided his mother with corn, wine, oil, salt pork, kindling charcoal and pocket money until the day she died.

Piero di Cosimo: between two centuries

The influence of Botticelli soon spread beyond his own pupils. It was particularly noticeable in the work of Piero di Cosimo*, a typical painter of the transition period between the 15th and 16th centuries. Son of a goldsmith, he was born in 1462 and was trained in the studio of Cosimo Rosselli*, a rather mediocre artist who was famous enough at the time to take part in the decoration of the Sistine chapel. Piero went with him to Rome in 1482 and acted as his assistant. Rosselli was extremely fond of him and soon realised that he was the better artist. It seems likely that the greater part of Rosselli's contribution to the Sistine chapel—the *Destruction of Pharaoh's Army at the Crossing of the Red Sea*— may well have been carried out by the twenty-year-old Piero di Cosimo. Young as he was, he showed astonishing virtuosity and vivid dramatic sense. When he went back to Florence, he was able to set up as an independent artist.

According to Vasari, he was a great eccentric, with a dreamy, fantastical temperament. He was always locked up in his studio, never allowing anyone to see him painting, living like a recluse. "He let no one sweep his rooms or tidy up his garden. His vines straggled all over the ground, his fig-trees were never pruned. He liked things only if he saw them in this neglected condition; he believed that taking care of natural objects only served to rob them of their strength and beauty. What pleased him most was finding some monstrosity in a plant or an animal. No object was too repulsive to provide him with material for contemplation. Filth and spittle stains on old cracked walls were pictures in the fire to him—he saw horses, battles, fantastic towns, vast landscapes. He saw the same kind of things in the clouds drifting overhead."

Stimulated by these strange tricks of the imagination, Piero tried to integrate them into his religious paintings, especially into the peculiar *Immaculate Conception* in which the Virgin Mary stands on a tomb gazing ecstatically at the dove of the Holy

49

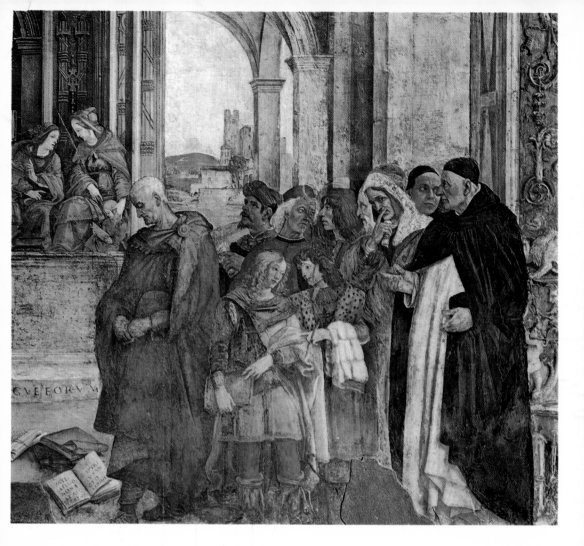

Ghost descending from heaven, whilst behind her unfolds a whole series of episodes from her life, set in a fantastic décor of palm-trees and strange buildings. He found a more propitious field in mythological pictures, no doubt influenced in this by Botticelli with whom he worked on the Sistine chapel. Following his example, he read Virgil, Lucretius and Ovid, as well as contemporary humanists. A true representative of a period in which rhetoric and art passed gradually from Christian symbolism to mythology, Piero di Cosimo brought the old tales to life again on the walls and *cassoni** of the houses of Florence. Everyone wanted him to paint panels for them. His own attitude towards death is made clear for us in the famous *Death of Procris*: a satyr amazed by the immobility of a nymph killed by accident, a dog's despair, complete indifference from surrounding birds and animals, all set in the glory of a summer's day; a poignant questioning and a peace passing all understanding. From the same period comes *Mars, Venus and Cupid*, a painting celebrating one of those ecstatic moments when a total fusion occurs between man and nature. But Piero's penchant for the irrational comes into full play in three panels showing the story of Perseus and Andromeda, painted in oils towards the end of his life under the influence of Leonardo da Vinci and when he was trying to achieve transparency of colour. The terrifying appearance of the sea monster, the fantastic architecture of the temple of Jupiter and a hundred other details produce an extraordinarily dreamlike atmosphere. In other works, Piero went further still: even his portraits betray this quest for the phantasmagoric. His picture of Simonetta Vespucci,

◄ Filippino Lippi
St Thomas Aquinas confounding the Heretics
(detail)
Rome, Santa Maria sopra Minerva

Piero di Cosimo (Piero di Lorenzo)
The Madeleine
Rome, Galleria Nazionale d'Arte Antica
▼

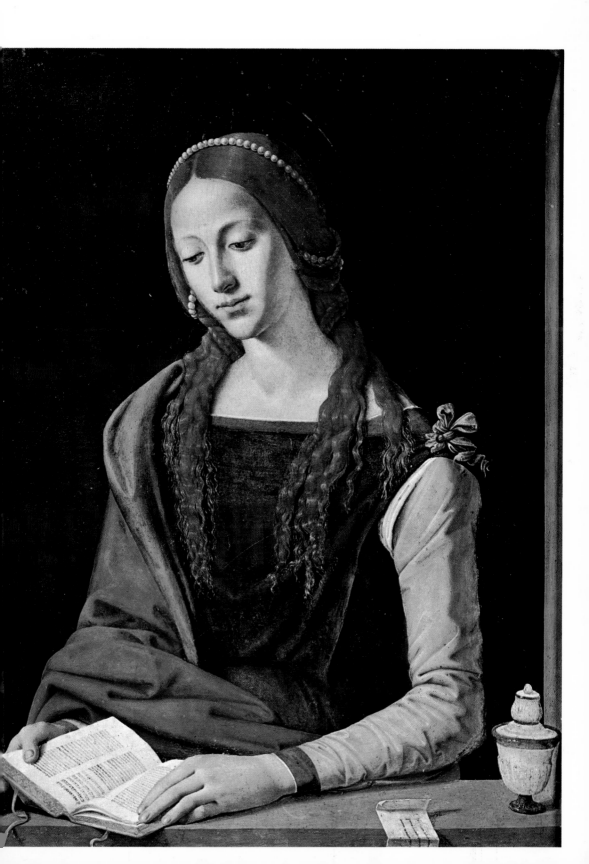

Filippino Lippi
St Thomas Aquinas confounding the Heretics
(detail)
Rome, Santa Maria sopra Minerva

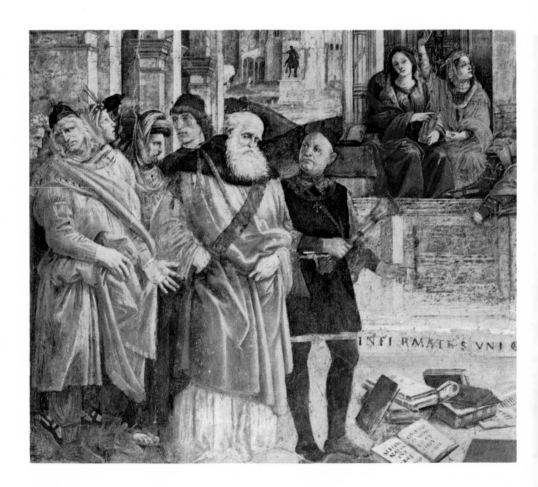

mistress of Lorenzo de' Medici, for example. He painted her as Cleopatra, naked to the waist, a snake around her throat, against a background of storm-clouds hanging heavily over a curiously diagrammatic landscape... It is only recently that art historians have appreciated Piero di Cosimo's close affinity with modern surrealism.

There was a tragic ending to his strange enchantment-obsessed life. During his old age he was paralysed and unable to paint, but continued to refuse any sort of medical help, spending his days in a state of morbid exaltation waiting for the end. One morning in 1521 he was found dead at the foot of his staircase. Among the young artists who walked with his coffin to the old church of San Pietro Maggiore there was one who had a great destiny: Andrea del Sarto.

A Florentine from Verona: Pisanello

The Florentine school of painting soon went beyond the city limits. At the beginning of the 15th century, its influence was clearly seen in the work of Vittore Pisanello*, though

Pisanello (Antonio di Puccio Pisano)
*Portrait of a Princess of the House
of Este*
Paris, Louvre

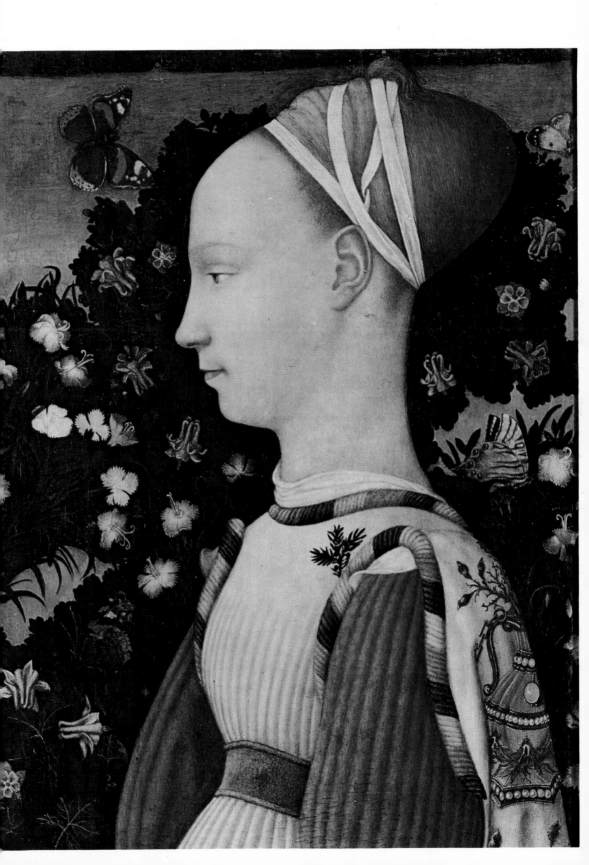

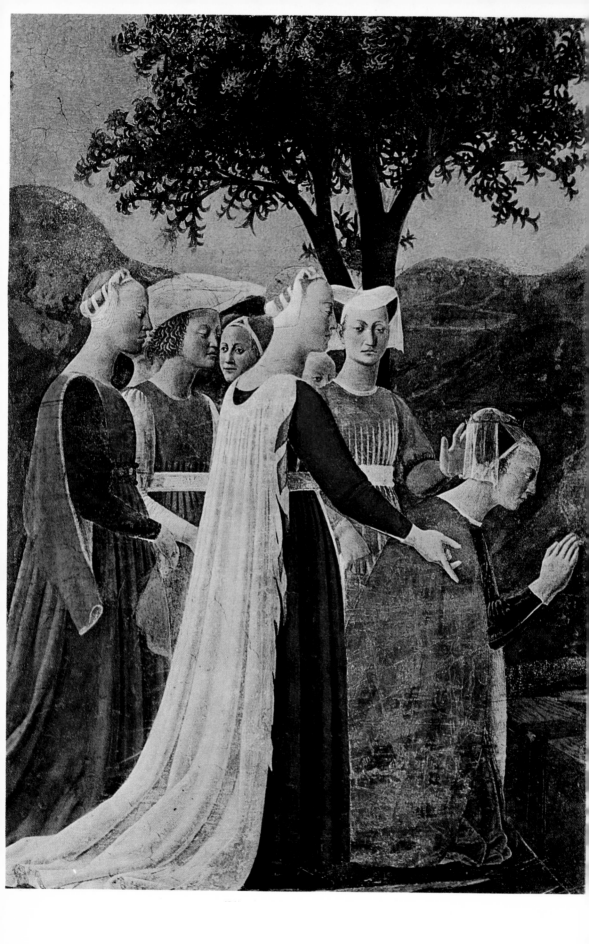

Piero della Francesca
Visit of the Queen of Sheba to Solomon
Arezzo, San Francesco

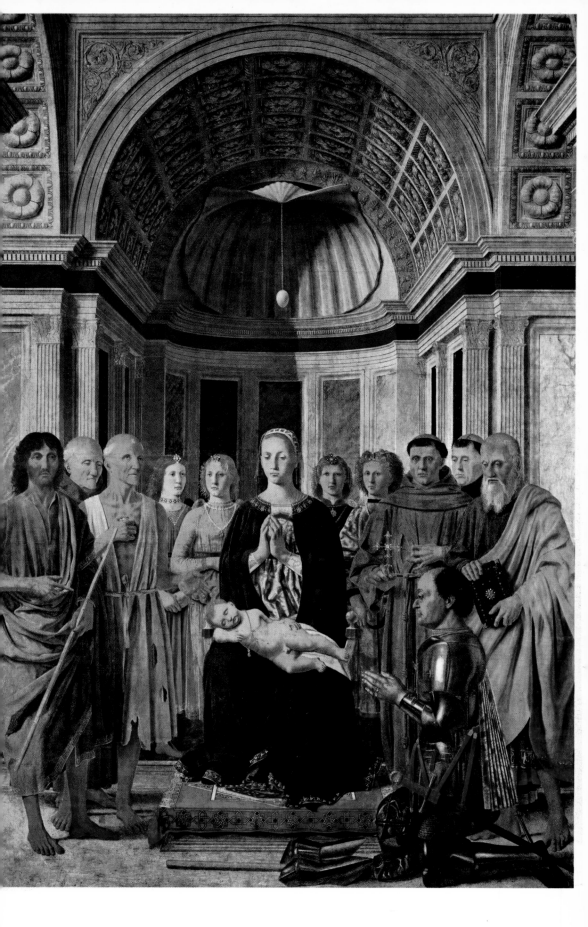

Piero della Francesca
The Montefeltro *Altar-piece*, 1472
Oils on wood 248 × 150 cm.
Milan, Brera Museum

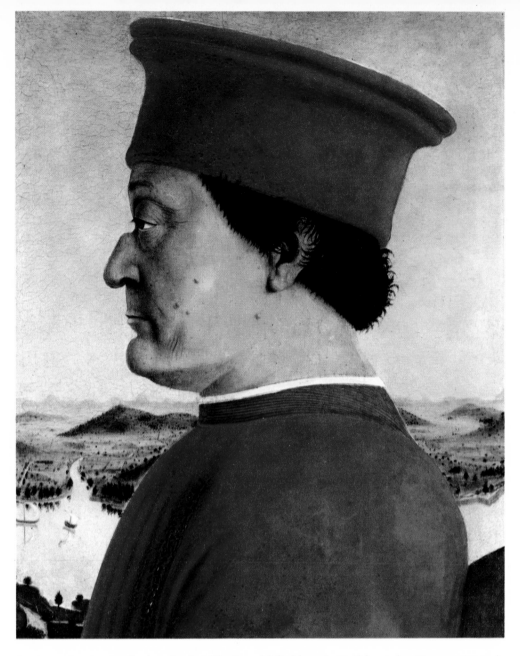

he was always deeply involved with the old-fashioned Gothic style. He was born in Verona in 1397 and it has been claimed that he came to Florence to be taught by Andrea del Castagno, but a comparison of dates shows this to have been impossible. At the very most, he might have studied with Domenico Veneziano or, more likely, Paolo Uccello, who belonged to the same generation. He and Uccello shared a passion for horses. It was probably Donatello who influenced him most: a drawing by Pisanello reproduces some of the motifs which appear on the pulpit the great sculptor made for Prato Cathedral.

It is not really important to know who his main teachers were, for Pisanello was above all a child of Florence by the naturalism of his style. In particular, he must be counted as one of the greatest animal artists of all time.

In addition, he was a medal-maker of genius, well in advance of his period. It is a tragedy that the greater part of his pictorial work has been destroyed. They have all gone—his first commission in the Doges' Palace with Gentile da Fabriano*, a series of Frescoes in St John Lateran in Rome, others in Pavia. His great masterpiece, the Pellegrini

Piero della Francesca
Portrait of Federigo da Montefeltro
After 1472
Oils on wood 47 × 33 cm.
Florence, Uffizi

chapel frescoes in Sant' Anastasia, Verona, is in a seriously damaged condition. It dates from the last part of his life and represents the culmination of his gradual development in the representation of the marvellous: in his hands, the Christian legend of *St George and the Princess of Trebizond* takes on the shimmering magic of a fairy tale steeped in romance: the saint renounces love, more dangerous for him than the dragon, but not without obvious reluctance. Several of his best-known easel pictures have the same unusual atmosphere and the same collection of fantastic details. The woodland setting of *St Eustache* is swarming with rabbits, herons, wild boars, swans and birds, witnesses to a drama which concerns them all. In the portrait of *Gineva d'Este*, the delicate profile of the princess is emphasised by an astonishing background of flowers and butterflies. This work, together with the portrait of *Leonello d'Este*, which is distinguished by the same characteristics, has a much deeper significance than appears at first sight and both induce the deepest contemplation.

In his *St Jerome*, Pisanello reveals his love for nature by painting a mountain landscape in a fashion quite new for the period; in *The Appearance of the Virgin to St Anthony and St George*, he comes close to symbolism. He opposes the holy hermit and the knight, that is the man of contemplation and the man of action and at the same time shows them linked by the same faith. A.-M. Martinie writes: "If one seeks to analyse what makes Pisanello so commandingly attractive, one reaches the conclusion that it is his freedom of mind, his youthful inspiration—both combined with an unusually precocious maturity of performance. He abandons himself to the enchantment of natural forms, but at the same time he is well able to depict the complex nature of his contemporaries; equally astonishing is the way he introduces the full power of reality into the supernatural ambiency of his legends ... He is always master of his own freedom and because of this he combines with the nobility of his art a wonderfully youthful charm in which the lifespring never fails"[1] According to Vasari, Pisanello died shortly after 1450 whilst he was working in the Campo Santo in Pisa.

Piero della Francesca, founder of the Umbrian school

The painters scattered in the little towns of Umbria, a province of central Italy, were very gradually influenced by the innovations of their Florentine neighbours. But there was always the difference that Umbria had the most marvellous light and an atmosphere even more subtle than that of Tuscany; for this reason, perhaps, Umbrian artists preferred delicacy of tone to strength of line. In addition, they sprang from a race of people whose religion was military in its ardour (Perugia provided the popes with their best mercenaries) and they were inclined to paint religious subjects rather than any other, though they interpreted them with great charm and spontaneity.

These were in general the characteristics of the Umbrian school which took on definite form with the work of Perugino in the 15th century but which were already

[1] A.-M. Martinie, *Pisanello*, Paris 1932.

57

Melozzo da Forlì
Angel Musician
Rome, Vatican Pinacoteca

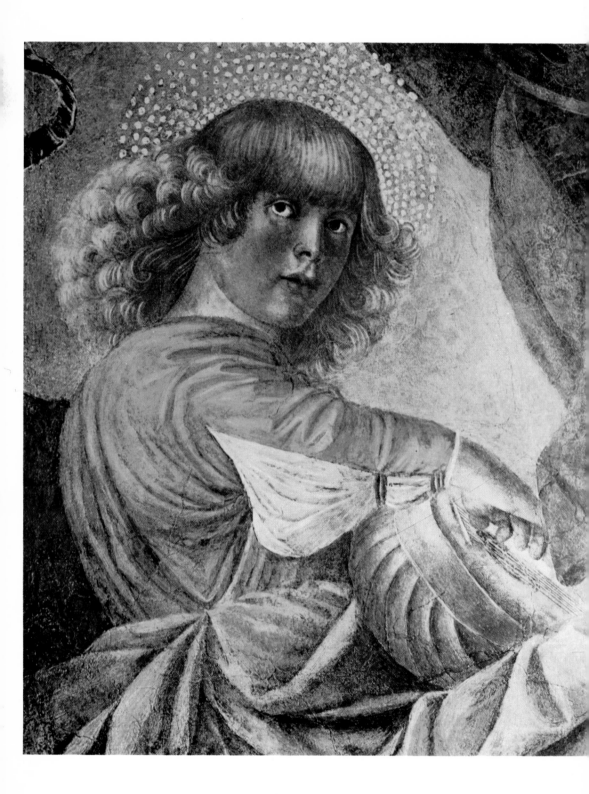

visible in the paintings of such transition artists as Piero della Francesca*, born in Umbria but trained in Florence and in whose work the two schools found a happy balance.

He was born in the tiny town of Borgo San Sepolcro at some unspecified date, probably between 1410 and 1420, the son of a cobbler-cordwainer called Benedetto dei Franceschi. We know nothing of his childhood and find our first trace of him in 1439 on the registers of the Hospital Santa Maria Novella in Florence, where he was working as assistant to Domenico Veneziano on the decoration of the choir of Sant'Egidio. He was back in his birthplace in 1442, serving as a town councillor. Three years later and still at Borgo San Sepolcro, he was held in sufficient esteem to be commissioned by the local Compagnia della Misericordia to paint an altar picture on the subject *The Madonna of Mercy* for the decoration of their confraternity altar. He was still struggling to find his own style through the influence of the Florentine painters, in particular Masaccio, whose arrangement and monolithic concept of figures appealed to him. Already, though, his work had a unique blend of sweetness and sharpness, a simplification of form and a subtlety of glowing colour tones which combined to give the first indication of an artist of genius.

In 1451, Piero was summoned by one of the most bloodthirsty *condottiere* of the century, Sigismondo Malatesta, tyrant of Rimini and murderer of his first two wives— and in spite of this a great humanist and real connoisseur of art, a combination not uncommon at the time. Malatesta was in the process of adapting the old church of San Francesco in Rimini to be a temple in memory of his mistress Isotta. Piero della Francesca painted Sigismondo kneeling before his patron saint surrounded by his greyhounds in a fresco in which his originality is revealed in the increasing luminosity of his colours and in a stylisation which recalls Egyptian reliefs. It was at this time, too, that Pope Nicholas V invited him to take part in the decoration of the Vatican; unfortunately his frescoes were destroyed and replaced by others painted by Raphael under Julius II.

His great masterpiece was begun in 1452: this was to be one of the outstanding works of the Quattrocento, the frescoes of San Francesco* at Arezzo. Piero della Francesca spent seven years on this colossal work; it is divided into ten sections which cover the side walls of the choir and the back wall, all based on the general theme of the *Story of the Cross*, as found in the Golden Legend of Jacopo da Voragine. One is instantly struck by his breadth and mastery of style and by his perfect synthesis of immobility and vitality, a trait which was to be a special characteristic of his genius. Throughout this long epic poem with its constant, violent contrasts, a marvellous look of eternity plays on the faces of the figures, their sculptural beauty fitting into the composition with geometric purity. The light suffuses colours which are sometimes translucent, sometimes intense and imparts life and unity to the whole.

Shortly afterwards, Piero della Francesca painted a deeply impressive *Resurrection of Christ* for the Palazzo Communale at Borgo San Sepolcro; the figure of the Messiah is painted with a straightness of line that goes very near to abstraction and expresses a detachment which transcends and transforms all suffering.

Many of Piero's panels and canvases are now in galleries all around Europe. *The Baptism of Christ* is in the National Gallery in London and *St Jerome with a Donor* in the Accademia in Venice; both these are early works still bearing traces of Masolino and Veneziano, but the presentation of the Umbrian landscape bathed in its special silvery light makes them very individual pictures. A much later painting in the National Gallery, the *Nativity*, shows how an almost idyllic pastoral scene can be transformed into a moment of deep religious feeling by a few simple, characteristic gestures. As for the *Madonna and Child*, the famous Brera altar-piece, it is a particularly curious work in which Piero took to extremes his desire to create perfect harmony between the figures and their background. He establishes a correspondence between the ten figures standing in a half-circle in a large niche behind the Virgin and the ten stone slabs which decorate the architecture. An unreal light which casts no shadows brings an air of mystery to the scene, enhanced by the huge scallop shell set in the vault from which hangs an egg, symbol of the Creation. This painting was probably commissioned in 1472 by Federigo da Montefeltro, Duke of Urbino, whom we see here on his knees before the Virgin. Piero della Francesco was to become the Duke's frequent guest and later his friend; he said that he owed all his fame to him. We certainly owe something to Piero for having painted so superbly a splendid diptych of the Duke and Duchess: Federigo's damaged face stands out strongly in profile—the missing right eye hidden, but the broken nose uncompromisingly presented, both the end results of a disastrous tournament. On the other panel, the strong calm face of the Duchess, set like her husband's against a marvellous landscape in perspective stretching out into the far distance, is drawn with the utmost delicacy.

It was during a visit to Urbino that Piero painted his *Flagellation of Christ*. No one knows who are the three figures standing like statues in the foreground, ignoring the tragic and painful scene being enacted at the other end of the portico. In this painting, the artist made clever use of perspective and applied its rules with a careful strictness borrowed from Uccello. In it, we find the very essence of his art, a serene beauty which contains geometric purity tempered with sensuality and diffused floods of light. This work marks a vital stage in the development of Quattrocento art.

Acknowledged "monarch of painting" by his fellow artists, Piero spent his last years in Borgo San Sepolcro. He was struck down by the greatest infirmity an artist can bear, blindness. Many years later, an old man told the writer Berto degli Alberti that when he was a child he led by the hand "Master Piero della Francesca, an excellent painter who had become blind". He died on 12 October 1492, the year the Old World discovered the New.

Melozzo de Forlì and the illusion of flight

Melozzo, who was closely connected with Piero della Francesca, was born at Forlì, a small town in the Romagna, in 1438. Very little is known about him other than the fact that he had lessons from Piero at Urbino during two visits to the town in about 1465 and

1471. It is probable that he too was working for the Duke. For a long time, it was thought that he was the artist responsible for a series of pictures at Urbino on the liberal arts, but it now seems more likely that they were due to either the Flemish painter Joos van Ghent or the Spaniard Pedro Berruguete*. It was probably due to the good words of Duke Federigo that he was summoned by Sixtus IV in 1477 to join the artists commissioned to decorate the Vatican library. Recently transferred to canvas in the Vatican Pinacoteca, Melozzo's fresco shows *Platina appointed Vatican Librarian*. It is the work of an accomplished artist, much influenced by Piero della Francesca, to whom it has many times been mistakenly attributed.

As one of the Pope's official painters, Melozzo became a founder member of the Academy of St Luke. In about 1480, he decorated the apse of SS. Apostoli at the request of Cardinal Giuliano della Rovere. When the church was demolished in 1711, Clement XI moved the fresco on *The Ascension of Christ* to the Quirinal and gave *Angel musicians* and *Heads of the Apostles* to the sacristy of St Peter. It is easy to see from these fragments why Melozzi da Forli's contemporaries were amazed by his power and ingenuity. In this fresco he made such consummate use of foreshortening technique that the great figure of Christ hovering arms out stretched amidst a mass of angels seemed, they claimed, "to fly straight through the vaulted roof". Melozzo together with Mantegna invented the technique of the *di sotto in sù*: the art of painting figures as it were at ceiling level, and by the use of vertical perspective giving the impression that they were flying in mid-air. The technique was enthusiastically taken up by Correggio and the later Venetians.

The last of Melozzo's major works dates from 1485 when he went to Loreto for another Cardinal della Rovere and decorated the cupola of the octagonal Treasure chapel there. He gave a curiously exotic air to his eight prophets meditating by setting turbans on their heads and enveloping them in great cloaks. High up in the roof vault, angels and cherubim hover in perfect proportion.

He retired to his home town and died there in 1494, in the same year as Ghirlandaio. All the works he painted in this last period of his life have been lost, apart from the *Pestapepe* (the pepper grinder), a very damaged fresco which was really a sign for a grocer's shop.

A great master: Luca Signorelli

Piero della Francesca's two best disciples took his teachings in two different ways: Melozzo da Forlí weakened his style by a sometimes excessive sweetness, but Luca Signorelli on the contrary brought to it an overwhelming vigour which on occasion was tinged with violence.

He was born at Cortona, near Lake Trasimene, in about 1441. He went to live in Arezzo with an uncle when he was quite young and was taken to Piero della Francesca's studio. It is possible that he worked on the famous frescoes in S. Francesco. The next artists to influence him were Verrocchio and more especially, Antonio Polluaiolo, who passed on to him his infectious enthusiasm for the anatomical study of the nude. Even

in his very earliest works, in particular a *Flagellation*, he showed obvious delight in the techniques of painting muscle formation and movement. His special talent in this direction showed at its best in *Pan and other Gods* (formerly in Berlin, but destroyed during the 1939-45 war). All possible problems connected with the presentation of the nude are gathered together in this one picture, but not to the detriment of the poetic charm which comes from the golden light of the setting sun and the dreamy languor of the figures. They seem, wrote Berenson, "begotten... upon the dew of the earth and they are whispering the secrets of the Great Mother".[1] Also from this period comes a *Madonna* in which two completely naked shepherds introduce an undeniable element of paganism.

We still have a good number of small panels by Signorelli, for example *The Circumcision* in which saints and prophets, filled with careful tenderness, watch over the priest as he carries out the ritual task with cautious concern. There is also *The Institution of the Eucharist* and *The Madonna surrounded by Saints* in which two figures are drawn as straight caricatures.

Above all, it was fresco painting which attracted him: the idea of covering huge plane surfaces with paint suited his imaginative powers. In about 1480, the same Cardinal della Rovere who had commissioned Melozzo da Forlí invited Signorelli to work on the decoration of the chapel of the Treasure at Loreto. He painted on the walls twelve apostles

[1] B. Berenson, *The Painters of Northern Italy during the Renaissance*, Paris 1938.

Luca Signorelli
Scene from the Life of St Benedict
Monte Oliveto, fresco from the cloister

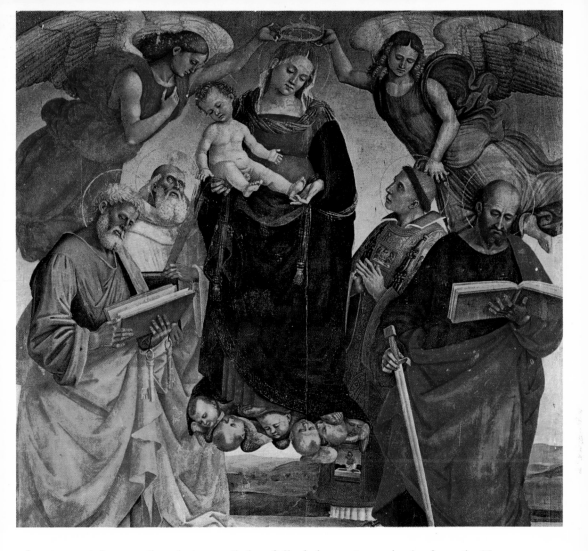

of monumental proportions but nevertheless full of vigour, two episodes from the New Testament—*The Calling of St Peter* and the *Incredulity of St Thomas* in which the figure of Christ glows with compassionate humanity and, best of all, *The Conversion of St Paul* in which the influence of Pollaiuolo is still perceptible but does not in any way prevent Signorelli from revealing the qualities which were entirely his own and which were fully developed in his Orvieto masterpiece. If one does not take into account the Sistine Chapel *Last Days of Moses*, of doubtful attribution anyway, the artist did no fresco work for the next twenty years. In 1497 the Prior of the Benedictines at Monte Oliveto Maggiore asked him to paint eight murals based on the *Life of St Benedict* on the cloister walls; they are unfortunately much damaged now. In them, Signorelli showed himself a superb painter of everyday life without any over-subtle use of symbolism. Gossip and malice are evident throughout the series. The soldiers of Totila, King of the Goths, are really Renaissance ruffians with evil faces, and their muscles swell beneath their jerkins almost as though they were naked.

Skill and technique thus firmly established, Signorelli was now ready for the frescoes of the S. Brizio chapel in Orvieto Cathedral, one of the most impressive undertakings of the Quattrocento.

Fifty years earlier, Fra Angelico had left the decoration of the ceiling unfinished. He had painted only two of the eight sections into which it was divided. The Duomo Council of Works signed a contract with Signorelli (described therein as "famosissimus

63

Luca Signorelli
Coronation of the Virgin
Rome, Castel Sant' Angelo

pictor in tota Italia ") for the completion of the ceiling decoration. For the work, he was to receive 180 ducats, two beds (one for him, the other for his assistant), the scaffolding, lime, and blue and gold paint. In the contract it was stipulated that the master himself should paint the figures, especially the upper torso and the faces. In January 1500 he asked for an increase which was given to him in the form of a bonus of corn and wine. In April of the same year, he finished the work and suggested a project for the decoration of the chapel walls. The Works Council, which was completely satisfied with the ceiling, accepted at once. For this new commission, Signorelli received 575 ducats, payable in instalments and finally settled in 1504. As before, he was expected to buy all his own paints apart from gold and blue. When he painted the ceiling, he sought to harmonise his work with that of Fra Angelico, especially in so far as composition and colour were concerned, but it is clear that the character types in *Choir of Patriarchs, Martyrs, Virgins* and *Doctors of the Church* are far less seraphic than Fra Angelico's and have that strength and vitality which are typical of Signorelli.

When he came to the walls, however, he gave his imagination full rein in *The Last Judgement*. In the horseshoe arch over the chapel door, he painted the *Signs of the End of the World*. The sun and the moon are veiled, the stars plummet to the earth. On one side, sybils and patriarchs utter prophecies. On the other sides men crash haphazardly to the ground, struck down by streams of fire hurled by demons hovering in the sky. In *The Preaching of Antichrist*, a being who has taken on the appearance of the Messiah stands on a pedestal and harangues the crowd—but it is the devil who whispers the words in his ear. In this part, Signorelli reveals a fierce and unprecedented vitality. He appears in the picture himself in the left-hand corner, wearing a velvet cap and a long black robe; behind him stands Fra Angelico. In *The Resurrection of the Flesh*, two giant angels with wings outspread sound the trumpet. At the call, the dead rise from their tombs, stretching like men newly awakened. There are scenes of recognition and reunion. A skeleton laughs wildly to see someone still only half-clad in flesh. These spectacular nudes dazzle the mind: Signorelli shows with the utmost power every muscular movement, every curve and sinew. In *Hell*, the artist's fierce genius rises to even greater heights. The throng of devils and damned, commanded by three archangels in helmets and armour, seethes with movement. Every possible twist and turn of the human body is there. Greenish devils attack their victims with stupendous ferocity. Michelangelo used the fresco as a source of inspiration for his own *Last Judgement*. In contrast to this descent into horror, *Paradise* shows an idyllic lyricism. The figures are still typical Signorelli nudes, but this time imbued with a supernatural gaiety.

The artist spent the last years of his life in Cortina, where he had his own studio and where he undertook various official commissions. In his old age, fate struck him very hard. He lost two of his three sons. When the body of one of them, a splendid boy he particularly adored, was brought to him, he had him stripped and drew the naked corpse without a moment of weakness. The artist's instinct was stronger in him than any other and helped him overcome his grief. In spite of these hardships, Signorelli lived till he was over eighty and died on 16 November 1523.

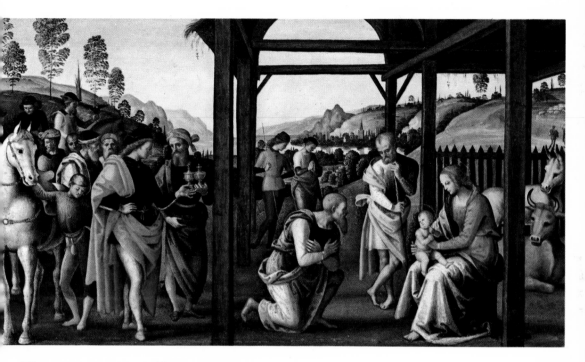

The greatness of Perugino

In the strictest sense of the term, the Umbrian school means Perugino and his pupils. The mysticism of the surrounding countryside constantly breaks through in their work, sometimes at the risk of creating a tedious proliferation of scenes of worship and of slipping into sheer affectation whenever a sincere religious feeling was lacking.

Pietro Vanucci was born of a fairly wealthy family in 1450, at Castel della Pieve near Lake Trasimene. He started his apprenticeship at nine years of age with an artist in Perugia and he returned there many times during his life: this is why he was always called Perugino, "the Perugian". It is very probable that he was greatly influenced by Piero della Francesca and that he learnt perspective from the mathematician Fra Lucia Pacioli*. He was almost certainly forced to leave Perugia by the war in 1475 and he "emigrated" to Florence, where he went to paint in Verrocchio's "bottega". We cannot follow his gradual development into a fine artist, for all his early works are lost. We know, though, that he was already famous in 1480, for he was summoned with other great painters of the time to take part in the decoration of the Sistine chapel. Much of the work he carried out there was destroyed during the reign of Paul III to make room for Michelangelo's *Last Judgement*. All that is left in the Sistine chapel now is *The Charge to St Peter*, in which the promise of his brilliance is already visible: the sense of space, the soft, warm light, the simple architectural lines harmonising perfectly with the calm gravity of the figures. The apostles wear the folded and draped garments of antiquity, but

65

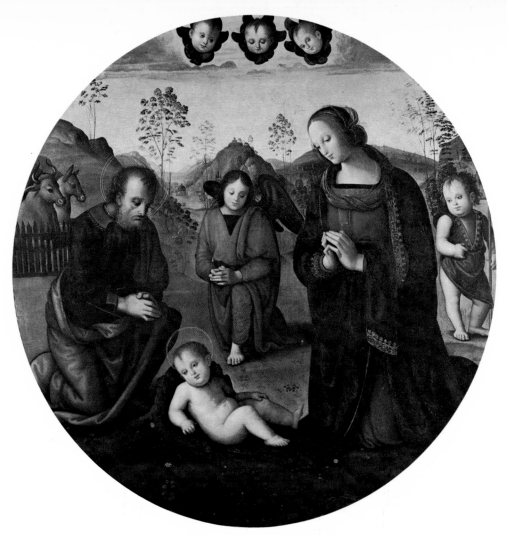

alongside them stand 15th-century figures in contemporary dress, amongst them Perugino himself, fifth from the right. He was back in Florence in 1486, where his apparently vindictive temperament revealed itself in various misadventures, especially in a street brawl where he attempted to murder one of the participants; he had to pay a fine of ten gold florins for this misdemeanour. He was now entering a period of great activity. Commissions poured into both his studios, the one in Florence as well as the one in Perugia—he travelled constantly between the two. The business enterprise he ran was extremely profitable, employing a whole crowd of assistants and pupils; he proved to be a shrewd and rather greedy businessman. He was soon a wealthy property-owner and married Chiara Fancelli, daughter of a famous architect; he seemed much taken with her beauty . . . but doubtless her dowry of 500 florins also spoke in her favour. He was as eager for honours as for money and joined the "Arte dei Pittori" in Florence; in Perugia, he filled various political offices. This activity did not affect his artistic output and some of his best works come from this period, notably the *Madonna between Two Saints and Two Angels*, where the gentle, dreamy figures are set in a cool atmosphere and a golden light which seem to be theirs alone. He began to give an increasingly important place to landscape in his paintings, especially to the Umbrian countryside which fills almost the whole of the fresco he painted in the three arches of Santa Maria Maddalena dei Pazzi in Florence. Here, Christ crucified, surrounded by a small number of saints, stands out against a paradoxically peaceful landscape. The same situation arises in the Palazzo

66

Perugino
Nativity
Madrid, Collection of the Duke of Alba

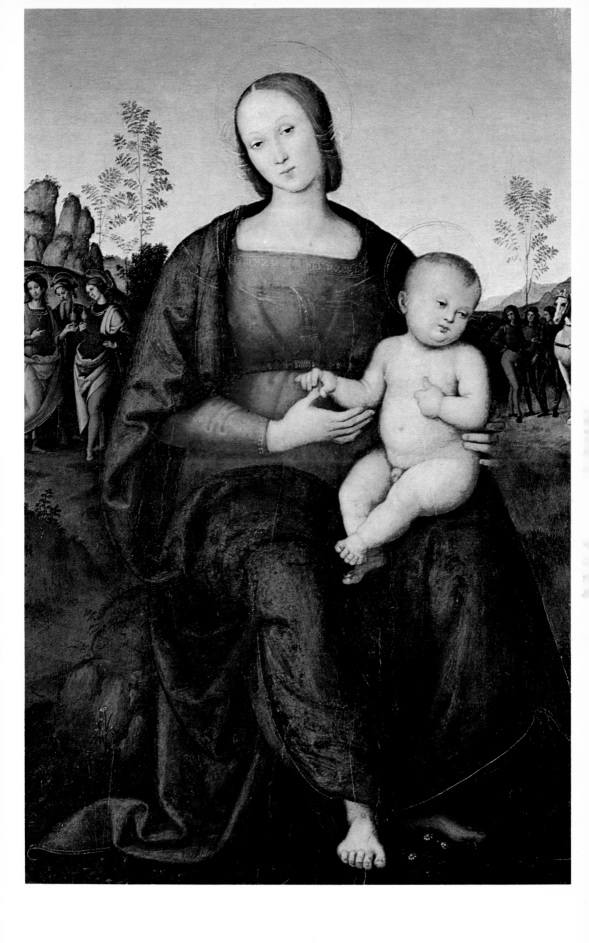

Perugino
Madonna and Child
Naples, Capodimonte

Pinturicchio (Bernardino di Betto)
Perugia 1454-1513
Funeral of St Bernardino
About 1485
Fresco, detail
Rome, Santa Maria in Aracoeli
▼

Pinturicchio
Portrait of a Young Boy, 1490
Oils on wood 35 × 28 cm.
Dresden, Town Museum

►

Pitti *Pietà*, where we see Perugino's reaction against Florentine grandiloquence. The drama and emotion of the moment are felt inwardly and are expressed only in the expression of the face. His *Vision of St Bernard* is nothing like the somewhat theatrical picture painted by Filippino Lippi. Even in the many *Martyrdoms of St Sebastian* he painted, he stuck to the same formula of a slender, rather effeminate body set against a clear, bright sky. During this period, he produced a considerable number of Madonnas, all wearing the same expression of remoteness and gentle charm; they were greatly admired at the time.

At the height of his fame, he decided to settle in Perugia to devote himself entirely to the decoration of the Cambio, the money exchange. The humanist Francesco Maturanzio wrote the Latin inscriptions for his frescoes.

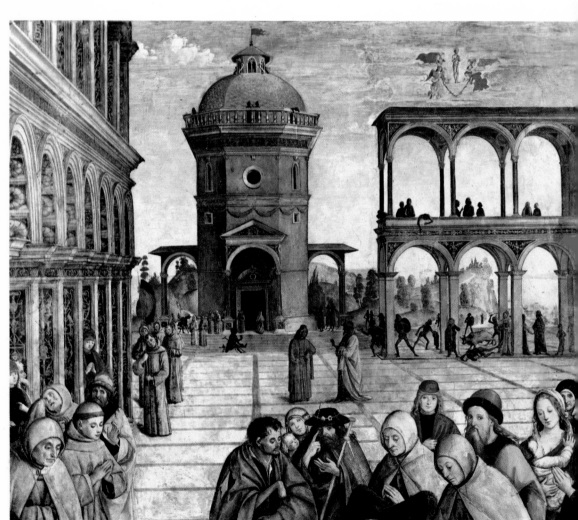

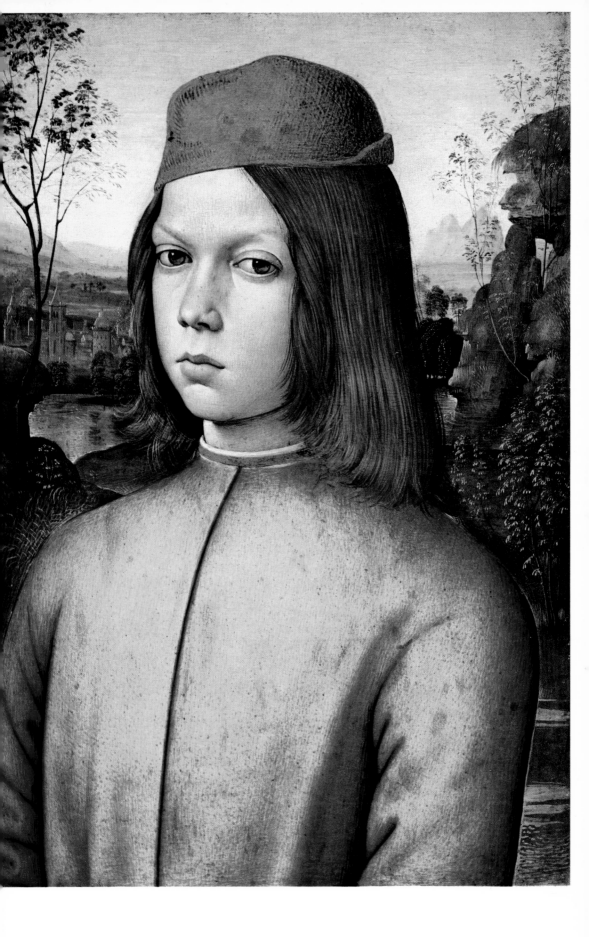

Perugino's last great work was the altar-piece for the Pavia Charterhouse. In it, we see his talent starting to decline: the sweetness has become too sugary, the remoteness too vacuous, all due no doubt to a lack of care and attention. Frequently, he did no more than supervise his ever-increasing band of assistants who, of course, were quite satisfied to keep on painting the same subjects over and over again until the ecstasy of the faces turned to sheer mawkish sentimentality. A great talent declines and fades away: originally an art which knew better than any other how to paint expressions which bore the imprint of a feeling far above anything ordinary and human—Raphael, who was his pupil, was deeply marked by his influence—Perugino's genius fell away into insipidity, vapidness, sheer stereotyped sentimentality, the earliest form of "Saint Sulpice" art that we have. His customers were not slow to see what was happening. Isabella d'Este, dissatisfied with the way he had painted *The Fight between Love and Chastity*, wrote to him bluntly: "If you had finished it more carefully, it would have brought me more satisfaction and you more honour."

Pinturicchio at the Vatican

A Perugian chronicler, Francesco Matarazzo, wrote after praising Perugino: "And there was another painter, whom some people called 'il Pinturicchio' and many other people called 'Sordicchio', because he was deaf and rather small, insignificant in appearance and demeanour; just as master Pietro (Perugino) was the best in painting, this artist was the next best; and, what was more, there was no one better that he was in so far as he was second best, even though there were many men in our town who were excellent painters and full of all kinds of qualities."

Bernardino di Betto, nicknamed "il Pinturicchio"—the dauber in many colours—was born in Perugia in 1454 and became the most famous member of the Umbrian school after Perugino. Like Perugino, he started out as a pupil of Fiorenzo di Lorenzo, but was much overshadowed by his fellow-student. He tried to bring more life and more vividness to his paintings, but without in any way detracting from the dreamy, contemplative expression of the characters' faces. Every time he gave way to his natural story-teller's enthusiasm, it became clear that he had more basic sincerity than Perugino, but in spite of this he went on imitating one of Perugino's annoying traits: his facility, his tendency to scamp a piece of work if pressure was great —usually to the detriment of its quality. This gave him his nickname and it seemed particularly apt when he too became a sort of "painting contractor", with a positive horde of assistants to help him with his big fresco cycles.

Fame came to him fairly late, when he was about thirty and when Perugino took him to work in Rome on the Sistine chapel; he seems to have painted almost all *The Journey of Moses in Egypt* and *The Baptism of Christ*, both of which are "signed" as it were by Pinturicchio's symbolic mark: a flight of ducks attacked by a falcon. In them, he shows his ingenious skill in illustration and his talent for portrait painting—several contemporary figures appear amongst the characters in these religious scenes. In fact, his portrait painting improved constantly—the *Portrait of a Young Man* from the Dresden Museum is ample testimony.

When he had finished his work in the Sistine chapel, Pinturicchio stayed in Rome to paint frescoes in the Buffalini chapel in Santa Maria Aracoeli*. The subject was one which particularly suited him and which gave him the opportunity for expressing genuine religious feeling: he was asked to illustrate the life of his patron saint Bernardino da Siena, whose loving-kindness ended the mortal hatred existing between the Buffalini and another Perugian family, the Baglioni. In these frescoes, Pinturicchio shows the full maturity of his technique: in the tenderness of the expressions, the gentle peace of the setting, the liveliness of the background detail.

Meanwhile he had won the favour of the ecclesiastical aristocracy and became the favourite painter of the della Rovere family, as well as of their enemies, the Borgias. For these two and for another papal family, the Piccolomini, and for the Colonna too, he planned and executed enormous decorative schemes which covered their palace walls with scenes from Roman history and mythology. Scenes and figures

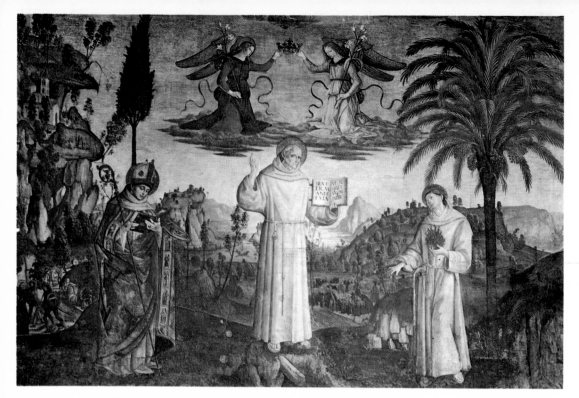

are painted in chiaroscuro or in paint on blue or mosaic-work backgrounds. A new
feature appeared: grotesques*. Pinturicchio may even have started the fashion for them.
The paintings were packed with harpies, gryphons, sphinxes, chimera and other
fantastic, imaginary monsters side by side with the spiral curves of stylised plants.

In 1492, Cardinal Borgia* was elected Pope Alexander VI and instantly asked
Pinturicchio to decorate several rooms in the Vatican as sumptuously as possible so that
they might serve as his private apartments*. The pontiff's impatience was so great that
he managed to get Pinturicchio to complete the scheme in less than two years: the
artist decorated six enormous rooms of different sizes with a series of frescoes whose
preservation is paradoxically due to the violent hatred roused by the memory of the
donor; when this Borgia pope died, his apartments were shut off as though they
were places of evil and they were left that way for centuries; as a result, Pintu-
ricchio's paintings escaped the fatal hands of the restorers. When Leo XIII re-opened
the rooms in the 19th century, they gave a perfect example of the luxurious décor to
be found in a prince's palace in the Quattrocento. Everyone is familiar with the
portrait of Alexander VI which Pinturicchio put into the first fresco, kneeling at the
foot of Christ's tomb. The artist painted him with frightening truth, mercilessly
presenting his sloping forehead, hard eyes and sensual lips. But Alexander was not in
the least offended by the truthfulness of the portrait and paid the artist handsomely for
it—his wages were a twenty-nine-year lease on two plots of land in Perugia.

In 1501, Pinturicchio painted some frescoes in the collegiate church of Santa
Maria Maggiore at Spello for a bishop of Perugia. It was one of his most delicate
works, but in it we see him sacrificing narrative power to histrionic displays of
decorative effects, especially to the new grotesque style.

Three years later, Cardinal Piccolomini (the future Pius III) had him appointed to
a new work of monumental proportions: the decoration of a room adjoining Siena
Cathedral* which he wanted to turn into a library for the books and papers of his
uncle, the humanist Aeneas Sylvius who, as Pius II, had been Pope from 1458 to 1464.
For the next ten years, Pinturicchio was occupied in painting the life of Pius II on

72

Pinturicchio
St Bernardino and Two Saints
Rome, Santa Maria in Aracoeli

the walls, creating a sort of "film biography" of the Pope and a visual history of the social life of the time, set in a series of *trompe-l'œil* arcades all decorated with grotesques.

Pinturicchio's peaceful life had a tragic end: he fell ill and became totally dependent on his flighty wife Grania. One day, she locked him up and ran away with a soldier from Perugia; he died, alone and helpless.

Squarcione and the Padua school

Under the influence of a curious character, a school of painting developed in Padua, a city of northern Italy, comparatively close to Venice, but well inland.

Francesco Squarcione* was born in 1394; the son of a notary, he started life as a tailor, then became an embroiderer before finally running away from home to travel in other countries, his aim being to collect bits and pieces of antique remains. He loved to draw these and to paint pictures of various kinds. He did not come back to Padua till he was about forty-five, after roaming all around Italy, Germany and even Greece. The fortune he inherited from his father allowed him to settle down in Padua and open a studio where his fanatical passion for teaching won him the nickname of "the father of painters"; at one time he had no less than one hundred and thirty-seven pupils. His principal teaching method was based on the practice of copying the antiquities in his possession. It was on this account, in fact, that he had considerable influence on his pupils: he gave tremendous importance to Graeco-Roman statuary. His fame was so great that the Emperor Frederick and St Bernardino wanted to meet him. We have only two pictures which can be attributed to him with certainty: *St Jerome in Glory*, still strongly in the Gothic tradition, and a *Madonna* which demonstrates all the essential traits of the school of painting founded by Squarcione: the importance of modelling, pronounced use of relief, sometimes taken to excess, incisive line and stiff contours, strong taste for complicated accessories: coloured marbles, sumptuous materials, garlands of flowers or fruit.

73

Andrea Mantegna
Isola di Cartura 1431-Mantua 1506
The Agony in the Garden, 1459
Oils on wood 66 × 88 cm.
Tours, Museum

Andrea Mantegna

In 1474, Squarcione died in Padua, laden with honours. His main claim to fame was to be that he had trained one of the outstanding artists of the Quattrocento: Andrea Mantegna*. Mantegna was born in 1431 in a small village near Padua. He was of humble parentage (his father was a carpenter) and was orphaned at an early age; Squarcione took him into his home and adopted him before 1441 since in this year he is already down on the registers of the *Fraglia*, or the Padua Corporation of Artists, as "Andrea, fiuolo de Francesco Squarcione, depentore". It was therefore through his adoptive father that Mantegna discovered even as a child the rare beauty of the masterpieces of antiquity; the influence of Squarcione was to be deepened at a later date by that of Donatello, who came to work in Padua in 1444 with a group of pupils. Much more than Squarcione, Donatello knew how to combine the new appreciation of pagan beauty with the modern techniques relating to the imitation of nature. Throughout the whole of his working life, Mantegna borrowed from Donatello his way of painting children, Christs and Virgins.

 In the earliest surviving paintings—his *St Luke* altar-piece and his St Euphemia, both dating from 1453—he is still a typical Gothic artist. It was between 1454 and 1459 that he produced a really crucial work: it was Squarcione's custom to let his best pupils carry out commissions in his place and he put Mantegna in charge of the studio for the execution of a fresco cycle on *The Lives of St James and St Christopher* in a chapel of the Eremetani church* in Padua. Six sections are by Mantegna himself;

74

▲

Lorenzo Costa
The Court of Isabella d'Este
Paris, Louvre

Andrea Mantegna
The Virgin of Victory
Paris, Louvre

►

in them we can see the full flower of his genius and his absorbing passion for archaeology. In the paintings of St James, he reproduced the monuments and the clothing of ancient Rome with fantastically detailed care.

It was not long before he began to feel the urge for independence and in 1445 he appeared before the Venice Court of Forty (a sort of appeal court) in an attempt to win the annulment of his contract with Squarcione on the grounds that he had entered into it when he was only fifteen years old and therefore a minor and not legally competent.

Shortly afterwards, he started a studio of his own and married the daughter of Jacopo Bellini, the famous Venetian painter whom Squarcione considered his most dangerous rival. The disagreement between the two Paduans got considerably worse.

His two brothers-in-law, Giovanni and Gentile, had a certain amount of influence on him in that they brought him the full knowledge of Venetian art at its best, which served to soften the severity of his style and to persuade him to use brighter colours.

Once his reputation was established by his paintings in the Eremitani, Mantegna was offered commissions by the score and started on his great creative period with the *Portrait of Cardinal Lodovico Mezzarota Scarampi*, a Paduan humanist. The painter accentuated the Roman element in the cardinal's physiognomy. The portrait has the sculptured severity of a bronze statue.

Next, in 1457, came the altar-piece for the church of San Zeno in Verona, a triptych showing *The Virgin surrounded by Angels*. Mary's throne is made up of fragments of ancient bas-reliefs. Garlands of fruit and flowers inspired by Squarcione are a constant decorative motif. A predella depicting *The Crucifixion*, *The Agony in the Garden* and *The Resurrection* is painted below. In the paintings, Mantegna reveals his sense of tragic realism and an overwhelming feeling of dramatic tension, especially in *The Crucifixion*, which must count as one of his most moving works.

Whilst he was working on the San Zeno reredos, he received a letter from Lodovico Gonzaga asking him to become his court painter in Mantua. It took three years of hard bargaining before Mantegna decided to settle at the Gonzaga court for a monthly salary of fifteen ducats with the additional bonus of lodging, heating and maintenance for the six people in his family. Luckily, the Gonzaga family were extremely indulgent towards the artist who was notorious for his irritable, difficult temperament. He was constantly asking them to settle quarrels which arose between him and his immediate neighbours. For instance, in a letter dated 27 July 1468, he complained to the marquis about various people who annoyed him and with whom he was quarrelling, in particular a woman gardener who, he said, had been rude to his wife.

In Mantua, Mantegna had a superb house built (which is still standing) and used it to display his extensive collections of antique statues. His reputation for being something of an expert in archaeological matters brought such collectors as Lorenzo de' Medici to consult him on the subject. Felice Feliciano, a Veronese scholar,

77

dedicated a collection of inscriptions from old monuments to him. We also have a letter from Cardinal Francesco Gonzaga in 1472 asking his father to send Mantegna to him at Poretta for a few days so that he could appraise some cameos, bronze busts and other finds.

In the Castello di Corte in Mantua, the principal home of the Gonzaga family, Mantegna was commissioned to paint the "Camera degli Sposi" (the bridal chamber) which in fact was not a bedroom but a special reception room for the celebration of princely marriages. Mantegna completely covered this enormous room with frescoes showing the fame and glory of the Gonzaga family. They hold a double interest for us: historical and artistic. The artist gives an eye-witness account of his times and recreates the still somewhat feudal customs of the Quattrocento. From the technical point of view, he handles *trompe-l'œil* and perspective effects of things seen from beneath with outstanding skill and genius. He is even more expert than Melozzo da Forlì and his work prepared the way for Corregio, Veronese and Tiepolo.

At the same time as he was painting the frescoes, he was working on various panels, notably on the famous triptych *The Adoration of Magi*, *The Circumcision* and *The Resurrection*. They have the delicacy and finish of miniatures, thanks to a special technique which involved a thin scumble of gold underneath the paint used for depicting materials. In *The Death of the Virgin*, Mantegna painted from nature the landscape setting of the lake of Mantua crossed by the Ponte dei Molini. In the Louvre *St Sebastian*, his passionate love for archaeology is shown by the splendid Corinthian column to which the martyred saint is tied. A subtle blend of agony and ecstasy shows on his face. His naked body is superbly lit by a shaft of light falling from the sky, but the illumination of curves and muscle is even throughout. There is more than a hint of Leonardo here. Most powerful of all is his *Lamentation over the dead Christ*, a painting of extraordinary realism aimed at arousing fear rather than pity and making the most astonishingly skilled use of the technique of foreshortening.

Meanwhile, duke followed duke in Mantua—Federigo succeeded Lodovico, Francesco, husband of the learned Isabella d'Este, succeeded Federigo. But Mantegna remained firmly in favour and the sons, like the fathers, treated him as an honoured friend and kept him as official court painter.

It was with great pride that Francesco Gonzaga wrote to Pope Innocent VIII, who had asked for Mantegna's help in decorating the Belvedere Chapel in Rome: "Well-beloved Holy Father . . . I send your Holiness Andrea Mantegna, an excellent painter, such as our age has never before seen; if his work is as splendid as I hope and as your Holiness's imagination has conceived, then his glory and triumph will be all the greater and I myself will be delighted beyond belief". Nothing is left of the frescoes Mantegna painted depicting *The Baptism of Christ*, *The Virgin Enthroned*, *The Adoration of the Magi*. We know them only through an enthusiastic description by Vasari.

In 1490, Mantegna returned to Mantua and took up again a work he had left unfinished when he went to Rome, a series of paintings showing *The Triumph of Caesar*.

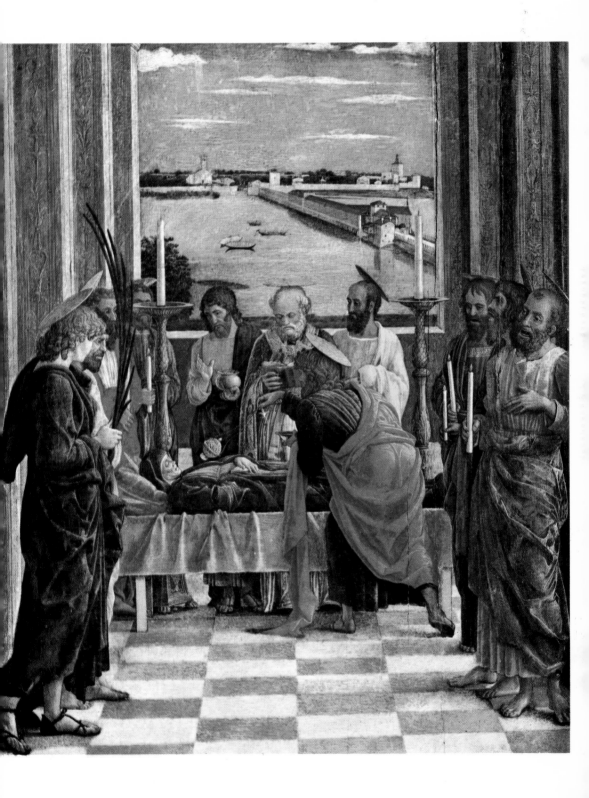

These nine huge pictures are painted in tempera and form a frieze 27 yards long and 3 yards high. They were intended as decoration for a small theatre. The long procession is led by soldiers playing trumpets. Next come the standard bearers and men carrying pictures showing incidents from the war, then soldiers laden with trophies, oxen decked for the sacrifice, elephants sumptuously caparisoned, captives, centurions holding the Roman eagle. Finally comes the triumphant Caesar's chariot, accompanied by a man carrying his famous sentence "Veni, vidi, vici". By doing this, Mantegna produced the most accurate reconstruction of the pomp of classical antiquity attempted to that date by a Renaissance artist.

Some of Mantegna's best-known pictures date from his old age, but the passing years never impaired his imagination, his enthusiasm or his love for classical antiquity. See for instance the two moral and political allegories on *Wisdom overcoming the Vices* and *Parnassus*, which Isabella d'Este chose for the decoration of a "grotta", or study set aside to the study of mythology. All the humanism of the Renaissance is to be found in these works by Mantegna where he reveals the quintessence of classical poetry.

Sickness and financial worries harassed his last days. He died in Mantua on 13 September 1506. Albrecht Dürer always said that one of the greatest disappointments of his life was not having been able to meet Mantegna, for he died just as Dürer was preparing to leave Venice to come and pay homage to the artist he admired so greatly.

80

▲
Lorenzo Costa
The Ship of the Argonauts
Tempera on wood
Padua, Museum

Cosimo Tura
Group of Horsemen

▶

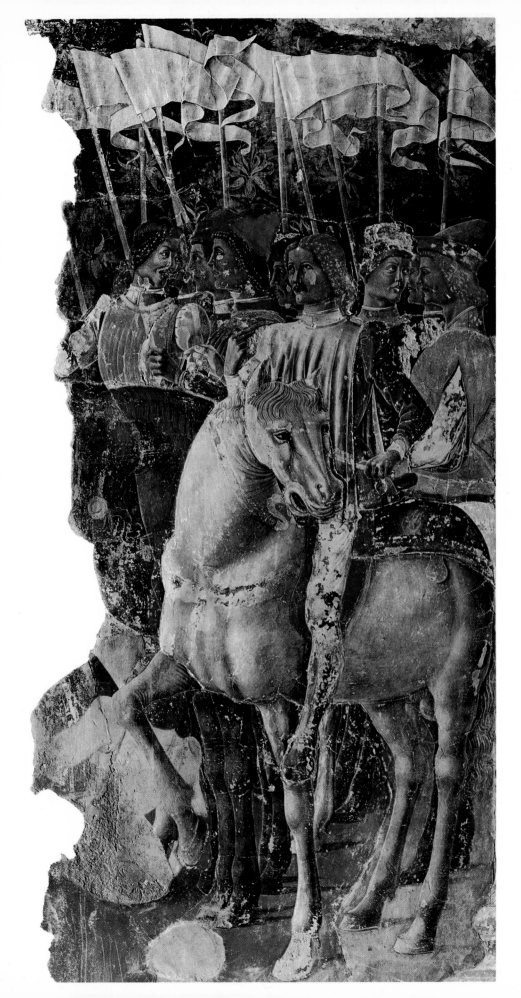

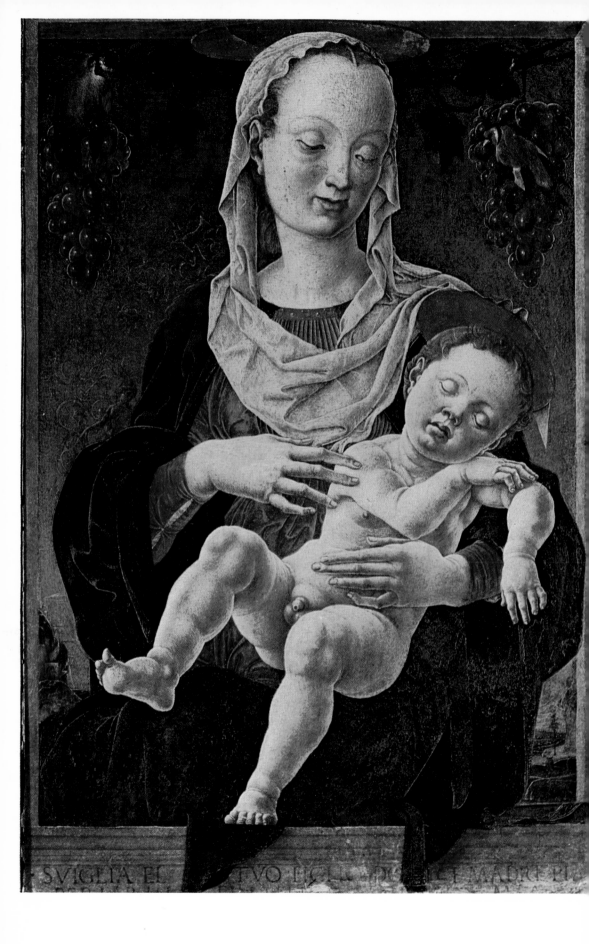

Cosimo Tura
Madonna and Sleeping Child
Venice, Accademia

Cosimo Tura

The Ferrara school mainly developed from its counterpart in Padua. The preponderant influences of Squarcione and Mantegna mingled with that of Piero della Francesca, but it was Cosimo Tura who was its main exponent.

He was born in Guarda in the province of Ferrara in about 1432 and was the son of a cobbler. He probably served his apprenticeship in Padua. The first definite information we have on him indicates that he started as a "cassone" painter like so many other artists of the period. Fortune smiled on him in 1458 when Borso d'Este appointed him court painter at Ferrara and granted him a wage of fifteen lira per month and free lodging as well. In about 1469, he painted a *St George* and an *Annunciation* for the organ panels in Ferrara Cathedral. These early works give a good indication of his rather harsh style; the realism of the figures is accentuated, with thin, gnarled bodies clad in garments with angular folds. The faces are anguished. Tura sought to impress rather than to please. The predominant colour is deep red and this was to be a characteristic of all the Ferrara school. A decided inclination for the bizarre gave his work a peculiar charm. He gave this full rein in a large altar-piece which the Roverella family commissioned from him for their chapel San Giorgio-fuori-le-mure in Ferrara, now broken up into several panels. The central panel, a *Virgin seated with sleeping Child*, has six large angel musicians one above the other and many other unusual details—for instance, a number of inscriptions in Hebrew set into the throne. The right-hand panel shows *Bishop Lorenzo Roverella protected by St Maurelio and St Paul*. The upper part, which is semi-circular, is a *Pietà*. The decorative motifs are restrained, but the violent anguish of the characters is expressed with pathetic intensity in the curiously grimacing manner which is very personal to Tura.

His *Virgin in Glory* surrounded by four saints is an absolute anthology of strange features and extraneous details: a glass ball, hovering angels mixed up with the ornamentation, turbaned heads springing out of capitals, crystal feet for the throne. Towards the end of his life, Cosimo Tura became rich, not through his painting, but through clever speculation in wool and wood, and was able to pay for the building of a church. He died in April 1495. A quarter of a century before, he had been briefly associated with another remarkable artist from Ferrara: Francesco Cossa *.

Cossa was born about 1438. There are many similarities between the two painters, but Cossa was more deeply influenced by Piero della Francesca and gave his figures a suppleness and grace which Tura never managed to achieve. The latter was nevertheless the greater artist. Cossa left Ferrara after his association with Tura and set up in Bologna, where he died some time after his forty-fifth birthday. He painted most of his panels here, notably the *St Vincent Ferrer* in the National Gallery where his taste for the bizarre is seen to be easily as well developed as Tura's and proves it a well-defined attribute of the Ferrara school. His allegorical picture of

Autumn, however, gives evidence of less fantasy, apart from the fact that the season is represented as a sturdy peasant lass leaning on a spade. His last work, a *Madonna*, shows a very developed sense of realism, especially in the way he has painted the character of St Petronio, Bishop and patron saint of Bologna, whose wrinkled face and sagging flesh are repellently fascinating.

But the outstanding work of Cosimo Tura and Francesco Cossa must certainly be the result of their association between 1465 and 1470. This was the decoration of a large room in the Palazzo Schifanoia (lit. free from care), the country home of the Este family. It was an enormous undertaking, but now only two of the four walls still have the frescoes on them and these were salvaged in 1840 from the appalling coat of whitewash which had been slapped over them years before. The encyclopaedic and subtle spirit of humanism is displayed in these frescoes—in a grandiose cosmological vision where the signs of the Zodiac, pagan gods, allegories of virtues and vices are mixed up with the important events of the life of Borso d'Este, the whole of this inextricably mingled with the everyday life of ordinary people.

The main followers of Tura and Cossa were Ercole de Roberti* and Lorenzo Costa*. We have few works left from the brush of Ercole de Roberti, successor to Tura as court painter to the d'Este family. His masterpiece, the frescoes of *The Passion* and the *Death of the Virgin* from San Pietro in Bologna, all much admired by Michelangelo, are now lost. Lorenzo Costa settled in Bologna when he was very young and became official painter to Giovanni II Bentivoglio, chief of the Signoria. He painted a number of fine murals, the best of which are those in San Giacomo Maggiore and the clever *Triumphs of Life and Death*. His talent as a painter deteriorated fairly quickly under the disastrous influence of his own follower Francesco Francia* with whom he shared a studio and a workshop.

The Venetian school

This is the most distinctive and most immediately recognizable of all schools of painting. The Venetians were primarily masters of colour, skilled in the creation of both gentle and dazzling harmonies, under the influence of the Venetian climate with its absorption in the interplay of sea and sky. There is another explanation for the special characteristics of this school in the fact that Byzantine traditions persisted much longer in Venice, where in the 12th century painters from the East and local artists trained by them produced the superb mosaics of the Basilica of St Mark. Humanism came late to this lively commercial centre where money always counted more than learning. Painting related more to the senses than to the mind and tended to glorify life for its own sake. And it must not be forgotten that Venice was open to influences from many places, not only the East, but also Germany and the Netherlands. From the Northern painters, Venice borrowed a minutely detailed technique. Indeed, among the very earliest members of the Venetian school, we find a German painter, Johannes Alamanus (Giovanni d'Alemagna), brother-in-law of the Venetian painter, Antonio Vivarini*.

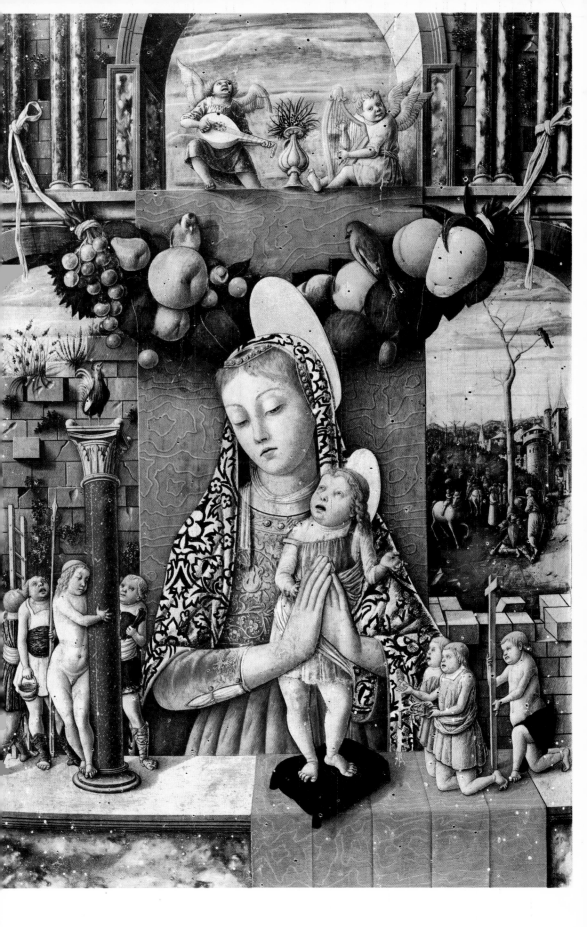

Carlo Crivelli
Venice, between 1435-40—after 1493
Virgin of the Passion
Verona, Museum

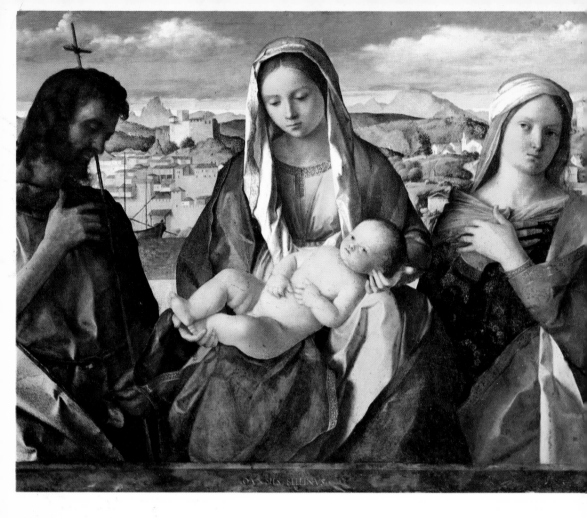

One of the Venetian painters first affected to any great extent by the spirit of the Quattrocento was Carlo Crivelli*. We know very little of his life other than the fact that he was actually born in Venice, for he never forgot to sign his name with the qualifying "Venetus" when he finished his pictures. The first mention made of him occurs when he was sentenced in 1457 to six months imprisonment and a fine of 200 lire for the kidnapping and restraint of a sailor's wife. Crivelli then settled in the Marches, first at Ascoli from 1476 to 1487, then in 1488 he moved to Camerino and possibly also lived at Fermo for a time. The year of his death is not known, but his last known picture was dated 1493. He was probably trained in Padua and was greatly influenced by Squarcione and Mantegna from whom he borrowed—to an excessive degree in some cases—architectural decoration and garlands of fruit. However, in spite of the adoption of these new elements, Crivelli remained cast in the old-fashioned mould. All his works show the Byzantine stamp and many Byzantine conventions: the icon-like immobility of the figures, backgrounds embossed or inlaid with gold, the polyptych in which each figure is separated from the rest by its own frame in relief. Possibly his isolated home in the Marches hindered his development, for his paintings never evolved in any way. His characteristics are already there in his earliest known painting *The Virgin with Child* (about 1463), a picture which reveals his tendency towards preciosity. Crivelli specialised in "anconae", large altar-pieces painted in several compartments. One of his first works of this genre dates from 1468. The reredos of Ascoli Cathedral (1473) shows a fully mature Crivelli painting with perfect mastery a work distinguished by the luxuriance of its ornamentation. Jewels, gold and

Giovanni Bellini
*Virgin and Child between St John the Baptist
and a Female Saint*
Venice, Accademia

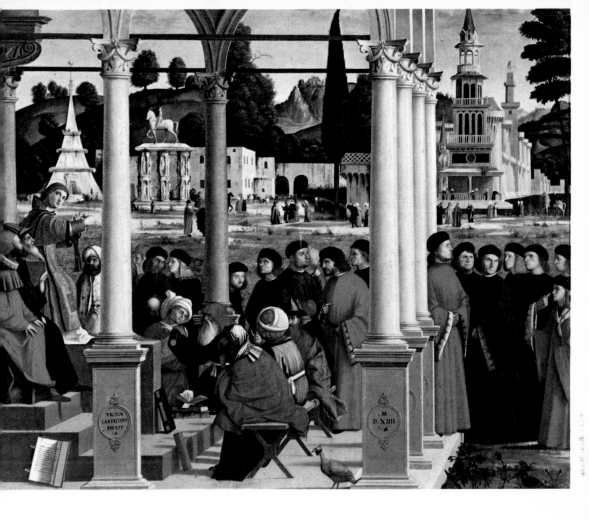

silver embroideries tumble in profusion on the ecclesiastical robes and turn the grave-faced bishops into characters from fairy tales. This tendency to over-decoration increased as he grew older until he painted his superb *Annunciation* (now in the National Gallery, London, but originally painted for the Church of the Annunciation at Ascoli); this painting is loaded with accessory details painted for sheer pleasure. Part of the picture contains "one of the most beautiful still-lifes in Venetian painting"[1], a loggia with a peacock, a cage, some flower-pots and a Persian carpet. Without giving up his production of "anconae" painted in the old-fashioned way, Crivelli also painted some works showing saints and other religious figures grouped together on one panel, but this was towards the end of his life. The first of these is an amusing *Handing the Keys to St Peter* where the Infant Jesus seated on the Virgin's lap hands an enormous key to St Peter kneeling in the middle of a vast assembly of grave-faced Franciscan saints. There is also a *Virgin between St Jerome and St Sebastian* in which St Jerome is dressed in the sumptuous clothes of a 15th-century dandy. And naturally, he painted numerous *Pietàs*. His religious feeling has all the emotional fervour of the Middle Ages as it twists the despairing faces of the women weeping for the dead Christ. Sometimes he achieves a wild vehemence and a genuine emotional impact.

In 1490, the antipapists seized power in Ascoli and asked the Neapolitans for help. Crivelli played an active part in the revolt and as a reward Ferdinand of Naples made

[1] E. Hüttinger, *La Peinture vénitienne*. Paris 1950.

Vittore Carpaccio
St Stephen arguing
Milan, Brera Museum

Giovanni Bellini
The Synthesis of Virtue
Venice, Accademia

him a knight. After this, he always signed himself with *Miles* or *Eques Laureatus* added to his name at the bottom of his pictures. Of all the last works we know, the finest is undoubtedly *The Madonna with the Candle (La Madonna della Candeletta)*. His type of Madonna is irresistibly attractive with the cool, remote expression of an Eastern idol; luxurious decoration combines with the utmost elegance of line and visionary fantasy. His closest follower was his brother Vittorio* who borrowed both his style and his decorative principles, but without the same degree of talent. His figures lack the character and the strength of Carlo's, though their gentle melancholy has its own charm where it does not deteriorate into mere sentimentality.

The Bellini family

The Bellini family had the most decisive influence on the development of Venetian art. The father of this group of painters was Jacopo*, son of a pewterer, who became a pupil of Gentile da Fabriano when the latter came to Venice with Pisanello to paint frescoes for the Sala del Maggior Consiglio in the Doges' Palace. In 1420, he followed his teacher to Florence to complete his training. In 1437 he returned to Venice and joined the Scuola* di San Giovanni Evangelista; in time he became its dean. By the time he was in his early forties, he was famous enough for Niccolo d'Este to summon him to the court at Ferrara. There he met the finest scholars of the day and became interested in their researches into classical antiquity. At some time before 1460 he went to Padua to paint a reredos in the Gattamelata Chapel of the Basilica of St Anthony. It was then that he met the young Mantegna whom he encouraged in his revolt against Squarcione. Two years later, he gave him the hand of his daughter Nicolosia in marriage. Very few paintings by Jacopo Bellini remain—most have been destroyed. Our best way of appraising his talent is to examine his superb albums of drawings in the Louvre and the British Museum; in them we see the strength of his talent and the extent of his contribution to Venetian art. The sketches, in silver-point and brush, show how he achieved the break with Byzantine hieratism and how he absorbed the new techniques of Florentine and Paduan artists to lead the way towards a style at once domestic and exotic, typically Venetian.

Jacopo Bellini had two sons, Gentile*, probably born in 1429, and Giovanni, his junior by several years, whose birth is shrouded in mystery. It seems likely that he was illegitimate, for not only is he not mentioned at the same time as Gentile as brother of Nicolosia in the marriage contract with Mantegna, he does not appear either in the last will and testament of Anna, Jacopo's rich widow. However, both brothers served their apprenticeship in their father's studio. Later, they worked as his assistants and collaborated with him in both his minor works such as the decoration of confraternity banners and in his major paintings. Some paintings from this period are clearly marked with an inscription saying that the work has been carried out by the father and the two sons: the altar-piece in Padua is one of them. They were very much their father's underlings at this time and out of the twenty-three ducats paid to Jacopo under

the terms of the contract, the sons got only two between them. Gentile and Giovanni stayed in their father's *bottega* until his death and then their paths went in different directions.

Gentile's first work on his own account was the painting of the organ panels for San Marco. He painted enormous figures of Saints Mark, Theodore, Jerome and Francis. The style of the work is very clearly derived from Mantegna's; in particular he uses the garlands of fruit and the swooping perspective of the Paduan artist. The same influence is also visible in *The Patriarch Lorenzo Giustiniani* (the Accademia, Venice), *Madonna with Donors* (Berlin Museum) and the two portraits of Doges in the Correr Museum in Venice. The painter became famous so quickly that in 1469 Frederick III conferred the title of Count Palatine on him. Five years later, he became official painter to the Venetian Republic with the special task of restoring the frescoes by Gentile da Fabriano and Pisanello in the Sala del Maggior Consiglio, already damaged by the humidity of the Venetian climate. In return, he was appointed a broker at the *Fondaco dei Tedeschi* which brought him an annual stipend of 120 ducats. He was also chosen by the Republic to be sent to Constantinople in 1479 to the court of Mahomet II, who had asked for the best painters in Venice. He painted portraits of the sultan and of the court dignitaries. For the sultan's palace, he painted a view of Venice and several erotic pictures. Ridolfi has a horrifying story in connexion with this visit. Apparently, the Grand Turk wanted to show the artist that he had made a mistake in the way he had painted the neck of the decapitated John the Baptist and instantly ordered the head of a slave to be cut off to prove his point. The terrified Gentile decided to leave Constantinople as fast as possible. He had in any case worked to the full satisfaction of the Sultan, who gave him the title of Bey and a gold chain worth 250 ducats. The *Portrait of Mahomet II* shows what a great portrait painter Gentile was. The very gentleness of the thin, sharp face inspires terror.

The surviving large paintings by Gentile Bellini are of much later date. The first picture for the decoration of the great hall of the Scuola San Giovanni Evangelista —*The Procession of the Relic of the True Cross in the Piazza di San Marco*—dates from 1496. It is a superb chronicle of Venetian life in an architectural setting. A second picture, finished in 1500, is an account of a *Miracle of the Holy Cross*. One day when it was being carried in procession, the reliquary fell into a canal after a short scrimmage. After several unsuccessful attempts to fish it out, Andrea Vendramin, the head of the Scuola, jumped in himself; and then the cross floated to meet him and came right into his hand. This painting gives a marvellous picture of the town he knew and loved. The great mercantile city is painted in perfect detail with all its pride, its passion for pleasure and its deep religious faith. Gentile is a true precursor of Guardi and Canaletto. In the crowd of people he painted can be seen—in the first line on the left— the former queen of Cyprus, Caterina Cornaro, dispossessed by the government of Venice, counting her beads in the middle of the crowd. Gentile also painted another fine portrait of her elsewhere.

In 1504, the Scuola di San Marco commissioned him to paint *St Mark preaching*

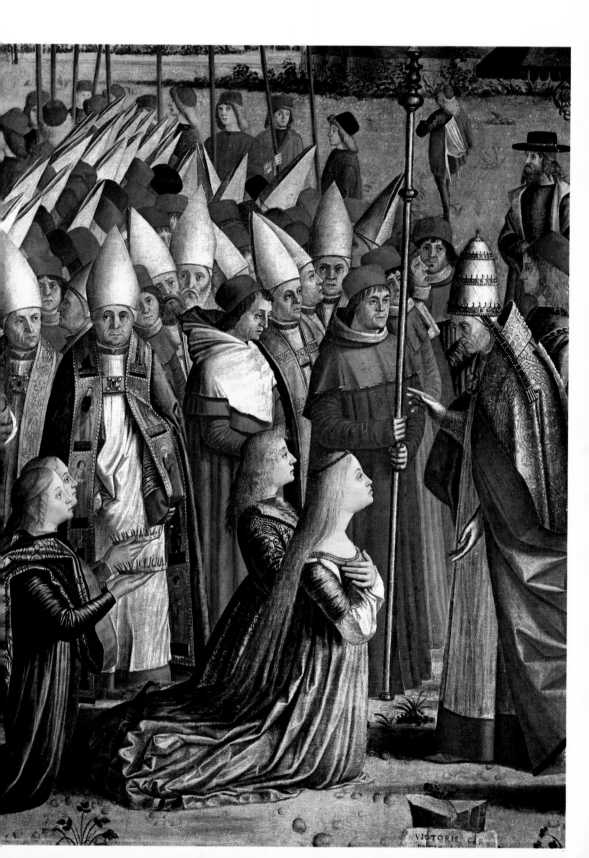

in Alexandria; he took a great deal of trouble to get the correct local colour as far as he could in matters of clothing, architecture and animals—there are even camels and giraffes in the picture. He used sketches made in Constantinople to help him, but he died in February 1507 before the work had been completed. Giovanni Bellini finished it in his place.

Giovanni, like Gentile, painted in his early years a series of works bearing the imprint of Mantegna's influence. However, his individual temperament soon showed itself in his painting. He softened the wiry lines of Mantegna's technique by means of swathed draperies and made his colours less strong, more delicate, more luminous. He showed a tenderness quite lacking in his brother-in-law's paintings. All these qualities are visible in *The Agony in the Garden, The Blood of the Redeemer* and *The Transfiguration*. He also showed considerable originality in his treatment of landscape which was much more naturalistic than Mantegna's; there is even a strong hint of the landscape of mood which was to become one of the important features of painting in Venice at a later date.

Giovanni was quite young when he started painting the Madonnas with child which were to be so typical of his work as a whole; his Pietàs also brought him considerable repute. Both types of picture express very deep religious feeling. In the Pietàs, the dead Christ is often placed between the Virgin, symbol of the Church, and St John, who represents Christian philosophy. One of them is especially moving in its intensity of feeling—the *Pietà* in the Brera Museum in Milan where in a gesture of immeasurable love the Virgin lays her old worn head, the features sharpened by pain, against that of her Son, still bearing its crown of thorns.

A short time after 1470, Giovanni and Gentile Bellini began an enormous undertaking in the Sala del Maggior Consiglio, every bit of which has now been lost. What we have from Giovanni's hands in this period is a *Transfiguration*, a *Resurrection* and a *St Jerome*, all showing his emancipation from the restraining influence of Mantegna. The harrowing, tragic style of the Padua school gave way in his work to a warm serenity often conveyed by the breadth and luminosity of the landscape. This change was made easier—indeed, some say actually brought about—by the popularisation of oil painting, borrowed from the Flemish school. Giovanni was one of the first to start using this new technique and it made it possible for him to impart even greater subtlety to his use of light by accentuating the transparency of his colour tones. His next undertaking was a series of large *pale* or altar pictures, all full of feelings of contemplation and poetry both mystical and homely (the San Giobbe *Pala*). At the same time, his fame as a portrait painter spread and he became a very popular artist; everyone in Venice wanted to have their picture painted by him. Unfortunately, few of these portraits have survived, but the painting which remains of *The Doge Leonardo Loredano* gives ample proof of his psychological insight.

In spite of the technical innovations he absorbed, Giovanni persisted for a very long time in choosing his subjects in the old-fashioned tradition of the primitive painters. It was only in his old age that he decided to adapt himself to the taste of

the time and began to paint scholarly compositions. From this period come that enigmatic picture in the Uffizi called *Christian Allegory* or *The Madonna of the Lake* whose subject is taken from a poem by Guillaume Deguilleville entitled *The Pilgrimage of the Soul* and five small *Allegories* intended to be set into a mirror frame: *Fortune, Prudence, Lies, Perseverance* and a fifth symbolic figure combining a number of attributes. He still preferred the old ways and he was not slow to complain loudly and bitterly when asked to paint something he did not particularly care for—even Isabella d'Este did not escape and many other would-be clients suffered equally. He always preferred religious subjects and his delight was clear when he was asked in 1505, an old man of almost eighty, to paint the famous *Sacra Conversazione* for San Zaccharia; in this, he seems to set down a superb résumé of all his favourite artistic concepts.

In the following year, Dürer visited Venice and hastened to visit the senior painter of the city. He wrote to his friend Willibald Pirkheimer: "Giovanni Bellini praised my talent as a painter very highly to a number of gentlemen. He would like to have one of my works. He came to see me and insisted that I paint something for him and said he would pay me well for it. Many very estimable people told me that he is an excellent person and that he likes me very much. He is old; but no painter in Venice is as lively as he." Giovanni went on working until the very last. In 1515, Alfonso II of Ferrara paid him 85 ducats as the last instalment for a large painting—*The Feast of Bacchus*—but he was never able to finish the picture which was eventually completed by his pupil Titian. A painting of *St Theodore of Urbino* has the date 1515. This is his last-known work. On 29 November 1516, Marino Sanudo wrote in his diary: "This morning, we heard of the death of Giovanni Bellini, that excellent painter whose fame is known throughout the world. Old as he was, he still painted like a dream. He has been buried in SS. Zanipolo where his brother Gentile is buried".

A variable and varied talent—Giovanni Bellini was able to preserve all the naïve charm of the primitives and at the same time capture the new features of Renaissance art. His influence on the Venetian school was immense. His greatest merit was to have revealed to the artists of that splendid city what their true vocation was by encouraging them to follow the way of their individual temperaments into sheer lyricism, a love of nature and a joyous feast of colour.

Carpaccio

Vittore Carpaccio* is the Venetian painter whose inspiration is closest to that of Gentile Bellini. We know practically nothing about his life, except that he was certainly of Venetian origin. His family had been settled in the city for over a hundred years when he was born in about 1455. The only document we have from his hand is a letter written to the Marquis of Mantua in which he speaks with the simple pride of a good craftsman of the excellence of one of his works, a panorama of Jerusalem: "As to my *Jerusalem*, I am confident that there is nothing quite like it in the world either for merit or perfection or sheer size."

Was he, as has been supposed, the pupil of an obscure artist called Lazzaro Bastiani? It was certainly Gentile Bellini who had the greatest influence on him. He was soon the equal of his master in his richness of colour, movement, spontaneity and sense of the picturesque. Did Carpaccio really visit the East as Titian said, or did he merely take his details for views of Turkey and Arabia from the engravings in Breydenbach's *Peregrinato in Terram Sanctam*, printed in Mainz in 1486? This is another unanswered question in his life.

From 1490 to 1496, Carpaccio worked on his greatest achievement: a series of paintings on the theme *The Legend of St Ursula*. The confraternity under the patronage of this saint was one of the many *scuole* in Venice. All the *scuole* were wealthy, thanks to the gifts of their members, and tried to make their meeting-places as sumptuous as possible. The Scuola di Sant' Orsola had more or less a monopoly of this saint's cult. No other organisation had the right to beg for alms in her name or to put up her statue. Carpaccio's chapel has been destroyed but the gigantic piece of work he carried out has been preserved and can be seen in the Accademia in Venice. The wall surface he had to cover was over 9 feet high and 100 feet long—there was also a picture 15 feet high by 10 feet wide. The story of the saint, taken from Jacopo da Voragine's *Golden Legend*, is divided into seven parts comprising twelve episodes. Carpaccio made no attempt to introduce topographical or chronological accuracy into the relating of this tale which originally took place in northern Europe in the 3rd century. Quite the contrary—by a splendid anachronism, he sets it firmly in the Renaissance and in the setting of his own beloved Venice: the background is a detailed and beautifully presented evocation of the 15th-century city with its domes, canals, gondolas and fashionable garments (slashed doublets, skin-tight hose and neat velvet caps), all the official processions, all the colour of Venice spread out to see. The work has the additional charm that he put into it several fascinating scenes of family life.

In 1502, Carpaccio painted a series of pictures on various subjects for the Scuola degli Schiavoni, an association of foreigners of Dalmatian origin. The most interesting ones concern the legends of St George, St Tryphon and St Jerome, patron saints of Dalmatia. In *St George fighting the Dragon*, painted in a sort of low relief, Carpaccio took great pleasure in setting the smooth symmetry of the saint's mount in contrast to the deformity of the monster. The fight takes place amongst a great litter of half-eaten corpses, bones and snakes, which add a dimension of evil omen to the picture. *St Jerome in his study* is a scene of reflective tranquillity without a trace of asceticism; the saint is painted as a prosperous Venetian ecclesiastic comfortably installed in his well-stocked and sumptuously decorated library.

Carpaccio painted several other large cycles with the aid of his pupils: *The Life of the Virgin* for the Scuola degli Albanesi between 1504 and 1508 and *The Story of St Stephen*, commissioned in 1511 for the confraternity of wool-workers. They show the same eagerness and unsophisticated expression, the same acute power of observation. Only the paintings from the very end of his life are of inferior quality. They show a monotony and stiffness which contribute to an over-all academic ponderousness: *The*

Martyrdom of the Ten Thousand on Mount Ararat is a good example of this. He died at some time before 26 June 1526, for in a document of that date his son Pietro mentions him as having died. Carpaccio's vision of Venice is the one which gives us the best and most entertaining picture of the city in the Quattrocento.

Antonello da Messina

Antonello da Messina*, a painter from southern Italy, must be counted as an important member of the Venetian school since he settled in the city and had a considerable influence on painting techniques.

His life story is full of unanswered questions. We know that he was born in Messina about 1430, son of a sculptor called Giovanni di Michele degli Antoni. Vasari claims that he went to Bruges to persuade Van Eyck to teach him the technique of oil painting after he had seen a picture by the Flemish artist in Naples. However, the dates do not tally. Van Eyck died in 1441—there was simply not time for Antonello to have been his pupil. Could he perhaps have travelled to Flanders? We have no proof of this. It is much more likely that Antonello was trained in Naples alongside the various Flemish painters who were working there at that time and who probably taught him to use oils. At the same time, he seems to have decided that it was in Venice, a city known for the excellence of its colourists, that he could best apply his newly learned technique and continue with his experiments. He settled there in 1474 and taught the Flemish methods with astonishing success, the proof of this being the decisive influence he exercised over Giovanni Bellini and his pupils.

His historical importance in the final evolution of the Quattrocento is therefore very considerable. The value of his works is no less great. The first painting of unquestioned attribution—*Christ giving a blessing*—shows him capable of producing a masterpiece imbued with a stirring mysticism. The type of Christ and the three-quarter lighting are completely Flemish in style. The same influence is visible in the two *Calvaries* now in Messina and Antwerp. Antonello was skilful enough to blend these features with the Italian manner and the light that was very special to Venice. His *St Jerome* shows another particular feature of Flemish painting—a minutely detailed background in which every item, however small, is painted with loving care.

Antonello da Messina's real greatness lies in his skill as a portrait painter. His many heads including his *Self-Portrait* (as we think) are some of the most penetrating studies ever made of the human face. Possibly the finest is the *Portrait of an Unknown Man* now in the Louvre, unforgettable in the way he shows the brutality beneath the aristocratic arrogance. The icy stare, the aggression, the sensuality, the scepticism: over the centuries the eyes of a Renaissance soldier of fortune stare coolly into ours. And this is why the painting bears the name *The Condottiere*.

Antonello died of fever in Messina in February 1479. He was one of the first in a long line of great Venetian portrait painters destined to come to full power in the Cinquecento, the century which saw the Venetian school reach its greatest heights.

Evidence and documents

The mediaeval aspect of the Italian Renaissance

It is an illusion to believe that the fifteenth century was connected with the fourteenth by a kind of hinge and that, after a few "transitional" masters—Gentile da Fabriano, Masolino da Panicale, Pisanello—painting in Umbria, Florence and Northern Italy then set off down the royal road of the new style, making fresh acquisitions as it proceeded. In fact, masters who were deeply involved in the spirit and forms of the Middle Ages persisted alongside these innovators, whose researches, moreover, were not unknown to them, and these latter were themselves, in a whole aspect of their genius, sunk deep in the past. Pisanello of Verona, painter and medallist, one of the most enigmatic and fascinating figures of a period which numbered many such, is without doubt the supreme poet of that vast reverie which ran through the whole of the later Middle Ages in the West; he may have learned to know its charm from the miniatures and tapestries which came from France, through Lombardy, to the towns of Northern Italy, but primarily he was predisposed towards it by the example of the great Altichiero and his own inherent affinity; he brought together all its enchantment in his paintings in Sant' Anastasia, devoted to the chivalrous legend of St George and the Princess of Trebizond, which unfolds itself against a landscape of crags and romantic castles. The drawings of the Recueil Vallardi are a superb testimony to his enquiries into the marvels of human and animal form, set down in the ornamental calligraphy of profile and silhouette, their inner structure and their outer skin accurately rendered, and situated in space with a diversity which produces, in identical objects, an astonishing variety of appearances. Courtly dress extends and disguises men and women, so that they look like enchanted birds. In his medals, Pisanello revived a technique of antiquity, but they are so full and vivid that, magnified, they could well adorn a façade. This is the summary of one of those lives which belonged both to the constructive experiments of the historical moment and to the last great reveries of the Middle Ages.

There were others, more single-minded, whose limpid reflection appears in works wherein the art of the illuminators survives undimmed. Craftsmen of seraphic dreams —Gentile da Fabriano, Fra Angelico, even Benozzo Gozzoli—followed one upon the other. In the convent of San Marco in Florence, beneath that unsullied light of the Tuscan sky which seems to prefigure eternity, Angelico seems outside time, blessed with the advantage of perpetual childhood. Yet nothing of the researches of his century passed him by, and he profited by them, although one could believe his pictures and even his frescoes to be the loveliest miniatures of the Middle Ages and, in their deep calm, their wealth of symbols, their airy shining quality, earlier than their actual date. The same conception of life, form and colour inspired the procession of the Three Kings which Gozzoli wound around the walls of the Riccardi chapel, with an oriental pomp, with which the Tuscan spirit had long been acquainted and which had no doubt been re-animated by the stay of the Emperor Michael Palaeologus in Florence, on the occasion of the council which was to have brought together the Churches of East and West. If one compares his interpretation of the life of St Francis at Montefalco with that of Giotto at

Assisi, one realises that it is the latter which is the more modern of the two, by virtue of its greater monumentality and its establishment of the future greatness of painting in Italy. Even in the Old Testament scenes in the Campo Santo at Pisa, where the canephori and the labourers on the Tower of Babel are amongst the proudest and loveliest figures of the Renaissance, there persists this anecdotal charm which shows that Gozzoli was as much a delightful illustrator as he was a painter of vast wall spaces.

They were all, it is true, attentive to the contemporary hubbub of ideas and to the experimental researches into the nature of space, and its rational structure, the enquiry in which mathematicians like Manetti collaborated with the painters and with that universal genius, the head of a whole dynasty of the mind, himself a painter, a sculptor, a great architect, a great humanist, an athlete and also a philosopher, Leon Battista Alberti. Here we are in the centre of the new discoveries, and that uneasiness concerning perspective, which we find in the previous century disturbing the Giottesque painters of Tuscany, at an end. The *Trattato della Pintura* formulates for the first time a group of practices based on the habits of natural vision, as interpreted by the geometric grid of the "piramide visiva", and whose extension constituted a direct menace to the monumental order of the Middle Ages by abolishing the homogeneity of the surfaces and volumes of the walls, and advancing beyond painting into all the arts, on which *trompe-l'œil* artifice tended to confer an illusory identity of purpose. And yet the sources of Alberti's thought must be looked for in the Middle Ages, in the Arabic perspectives and in the theory of Robert Grosseteste, Bacon's master, concerning the propagation of light. It is likewise curious to note that a painter such as Paolo Uccello, one of those who were most exercised by perspective, remained profoundly mediaeval in his pictures of battles, which are simply the old battle pieces enriched with fine studies of horses, seen from behind, in three-quarter view, in profile or from directly in front, as in some of the drawings of the *Recueil Vallardi*. Composition and treatment of colour, in the dominance of the local tones, the great expanses of white, the blacks and the reds, recall the art of the glass-painters. Nor was Uccello's perspective directed solely to verisimilitude; it served also for the creation of ornamental pattern.

In addition, it was an illusionistic technique, a device which was capable of giving the artfully treated plane surface a convincing appearence of relief and of conferring the full roundness of sculpture on the equestrian statue which Uccello painted in memory of the English *condottiere*, Giovanni Acuto, and on Andrea del Castagno's standing figures of Boccaccio, Farinata degli Uberti and Filippo Spano, painted in false niches, at the convent of Sant' Apollonia. This skilful deceit, attractive to the eye and delightful yet disconcerting to our sense of space, was not simply the early and capricious phase of an immature experiment: Italian art consistently retained its loyalty to, and its superior capacity for it, as, for instance, in architectural illusionism and theatrical decoration, and even in large-scale frescoes and the paintings of the masters. Early in the fifteenth century it produced its sculptural masterpiece in the doors executed by Lorenzo Ghiberti for the Florentine baptistery, which are admirable for the distribution and framework of the panels, for their wealth of invention, their fluid elegance and the noble sentiment of

the subjects. The gradation of the relief in accordance with the supposed distance of the various planes, the skilfully calculated transition from the fully round to high relief, from the latter to low relief and finally to the almost flat modelling of the medal, the strict foreshortening of the architecture, and the suggestion in the bronze of an atmospheric landscape struck the popular mind like a miraculous revelation: henceforward, the baptistery doors were the gates of Paradise. One is conscious of the factors—the science, the dignity, the quality, the great models of classical antiquity—which distinguish this memorable ensemble from the contemporary altar-pieces of Western Europe: the basic principle was, nevertheless, identical.

Henri Focillon
The art of the West
Translated by Donald King
London 1963.

Masaccio

He was a man of genius whose appearance marked an epoch in the history of art. He trained himself originally by looking at the works of the sculptors Ghiberti and Donatello. Brunelleschi showed him perspective. He saw Rome and doubtless gazed at the antiquities.

Masaccio opened a new direction in painting. The Carmine frescoes which fortunately escaped destruction in the fire of 1771 amply demonstrate this.

His foreshortenings are admirable. The different attitudes of the figures show a variety and a perfection unknown even to Paolo Uccello. The nudes are treated with a certain naïvety, but always with infinite skill. The greatest praise that one can give —and indeed, Masaccio well deserves every word— is that his heads have something of Raphael about them. He has the same talent as Raphael for giving each character a different expression. The famous figure of the "trembling nude" in *The Baptism of St Peter* (the man who has taken off his clothes and shivers with cold) had no rival till the century of Raphael, that is to say that nothing painted by Leonardo da Vinci or Andrea del Sarto came anywhere near it.

The human expression makes its entry into painting.

All men, witty or dull, phlegmatic or passionate, readily agree that man is nothing without thought or emotion. If the human machine is to start moving, it needs must have bones and blood. But man must have more than blood and bones if he is to reach his ultimate goal: to think and to feel.

It is the same with the history of drawing, colouring, chiaroscuro and every individual bit of painting technique compared to expression.

Expression is what makes art *art*.

A painting without expression is only a pretty picture to entertain the eyes for a moment. Painters must know how to draw, use colours, convey perspective etc.; without these techniques, a painter cannot work. But to stay within the confines of one of these lesser disciplines is to mistake the means for the end, to fail in one's chosen career. What did Santo di Tito achieve by being the Florentine artist who drew so superbly? Hogarth will last longer than he. Artists who were good colourists and who therefore

got nearer to the ideal of the picture are better prized. Equally inane in so far as expression is concerned, a Bonifazio *Last Supper* is worth ten times more than a Salviati *Deposition*.[1]

By its use of expression, painting joins with all that is fine in the hearts of great men: *Napoleon touching the Plague-stricken in Jaffa.*

By skill in draughtsmanship, it awakes the admiration of pedants.

By colouring technique it flies to the pockets of rich English merchants. Besides, one must not lightly accuse great painters of frigidity. In my time I have seen five or six great deeds and I have been struck by the simple naturalness of heroes.

Masaccio removes from his draperies every single bit of minute detailing. His garments are painted with natural folds, and few of these at that. His colour is true, varied, delicate and astonishingly harmonious; that is to say, he imparts admirable relief to his figures. This great artist was not able to finish his work in the Brancacci chapel; he died in 1433, probably from poison. He was only forty-eight.[2] It was one of the greatest losses art has ever known.

The Carmine church where he lies became the school for Tuscany's finest painters. Leonardo da Vinci, Michelangelo, Andrea del Sarto, Luca Signorelli, Perugino and Raphael himself came and studied the paintings with respect.[3]

Eyes which are used to gazing at the masterpieces of the following century may have some difficulty in appreciating Masaccio properly. I care too much for his paintings to be certain about this. But I sincerely believe that he is the first painter whose worth is real rather than historical.

Masaccio died young and as he was never satisfied with less than the best, his works are very few. In the Pitti Palace I saw a portrait of a young man which was sublime. He is supposed to have painted the evangelists on the vault in St Catherine's chapel in Rome; but this is a youthful work like the picture of St Anne in Sant' Ambrogio in Florence. Time has worn away his other frescoes.

Classical antiquity left us no chiaroscuro, no colour, no perspective and no expression—so Masaccio created rather than revived painting.

Stendhal
History of Painting in Italy
P. Didot l'Aîné, Paris 1817.

[1] Bonifazio, Venetian school, died in 1553 at the age of sixty-two; Salviati, a Florentine mannerist, 1510-1563; Hogarth, died in 1761.

[2] In fact Masaccio was only twenty-eight when he died. The loss is all the greater.

[3] This epitaph was set on his tomb:
Se alcun cercasse il marmo o il nome mio,
La Chiesa è il marmo, una capella è il nome;
Morri, chè natura ebbe individua, come
L'arte del mio pennel, uopo e desio.
From which Sir Christopher Wren's epitaph in St Paul's was taken:
Si monumentum quaeris, circumspice.
And possibly also:
Ille hic est Raphael, timuit quo sospite vinci
Rerum magna parens, et moriente mori.

Paolo Uccello

His real name was Paolo di Dono; but the Florentines called him Uccelli, or Paul-the-Birds on account of the drawings and paintings of birds and animals which filled his house: he was far too poor to feed any animals of his own or to buy any which were strangers to him. They say that when he was in Padua he painted a fresco of the four elements and that he decided to give air a chameleon for attribute. But he had never seen a chameleon so he drew instead a corpulent camel with its mouth wide open. (Of course, said Vasari, the chameleon is "a small shrivelled lizard" and the camel is "a lumbering great beast...").

Uccello paid no attention to the realism of objects, he saw only their multiplicity and the infinity of lines: this meant that he was happy to paint blue fields, and red cities, and horsemen clad in black armour mounted on ebony steeds with blazing mouths and lances soaring towards heaven like so many rays of light. And he spent hours drawing *mazzocchi* which were wooden circles covered in cloth which were worn on the head in such a way that the folds of material surrounded the face when they were turned back. Uccello drew them with all their points and surfaces shown from various angles in perspective all arranged in cones and pyramids, and drew them so well that he found a whole world of different combinations in the folds of the *mazzocchio*. And the sculptor Donatello would say: "Ah, Paolo, this perspective of yours makes you neglect what we know for what we don't know."

But the Bird continued this patient research and he drew circles and divided angles and he examined all creatures from every possible aspect, and he went to consult his friend the mathematician Giovanni Manetti about the interpretation of Euclid's problems; then he shut himself up and covered his parchments and his panels with points and curves. He spent days in the perpetual study of architecture and in this his friend Filippo Brunelleschi helped him; but it was not for the sake of actually building anything. He was interested only in the direction of the lines, from foundations to cornice, and in the convergence of intersecting lines towards a central point, and in the way to turn the arches of vaulted roofs, and in foreshortening floors by converging the beams so that they seemed to meet at the far end of a long, long hall. He also drew all kinds of animals and their movements, and men's usual gestures, with the idea of reducing them to a simple formula.

Next, for all the world like the alchemist who leans over his mixtures of metals and media and watches them in the hope that they will turn into gold, Uccello poured all forms into the crucible of forms. He joined them, blended them, melted them, trying to transmute them into one simple form, a form on which all others depended. This is why Paolo Uccello lived like an alchemist hidden in his little house. He thought he could change all lines into one ideal position. He wanted to conceive of the universe created as it was reflected in the eye of God who sees all forms and figures springing from one complex centre. Around him lived Ghiberti, della Robbia, Brunelleschi, Donatello, each of them a proud master of his craft, mocking poor Uccello and his mad

passion for perspective, pitying him for his poor empty house hung with spiders' webs; but Uccello's pride only grew. Every new combination of lines made him hope that he had found the answer to his questions. His absorption with *mazzocchi* did not reflect a desire to copy; on the contrary, he found his series of folded, swathed hats far more revealing in his search for the absolute than any of Donatello's magnificent marble statues.

This is how the Bird lived, his pensive head wrapped in his cape; he took no account of what he ate or of what he drank, for all the world like a true hermit. And one day he saw in a field, quite near to a circle of old stones half-buried in the grass, a young girl with laughing lips and a garland round her hair. She wore a long flimsy dress caught at the waist by a thin ribbon and her movements were as supple as the grass blades she bent. Her name was Selvaggia and she smiled at Uccello. He saw the curve of her smile. And when she looked at him, he saw the short lines of her lashes, and the circles of her pupils, and the curve of her eyelids, and the subtle twinings of her hair, and in his mind he drew and re-drew the twists and turns of the garland in her curls. But Selvaggia knew nothing of this, for she was only thirteen. She took Uccello by the hand and she loved him. She was the daughter of a dyer in Florence and her mother was dead. Another woman had come into the house and she had beaten Selvaggia. Uccello took her home with him.

All day, Selvaggia sat by the wall where Uccello drew and drew his universal forms. She never knew why he would rather look at these straight lines and curves than at the sweet and loving face she turned towards him. In the evening, when Brunelleschi or Manetti came to study with Uccello, she would fall asleep after midnight, curled up in the circle of shade under the lamp; in the middle of the intersecting lines. In the morning when she woke before Uccello she would laugh with pleasure to see the bright animals and the painted birds all around. Uccello drew her lips, and her eyes, and her hair, and her hands, and all the movements of her body; but he never did her portrait like other painters who were in love with pretty women. For the Bird took no joy in limiting himself to one particular individual: he never stayed still in one single place; he wanted to hover in an all-embracing flight over the whole world. And so Selvaggia's movements were tossed with other movements into the crucible of forms, mingling with the running of animals and the lines of plants and stones, and the rays of light, and the swirls of mist and the ripples of the sea. And Selvaggia meant nothing to him as herself, as he looked into his eternal crucible.

But there was nothing to eat in Uccello's house. Selvaggia never dared tell this to Donatello or the others. She kept silent and she died. Uccello drew the stiffened body, the tiny, thin hands joined in prayer, the line of the poor closed eyes. He had no idea that she was dead; he had had no idea that she had been alive. But he took the new forms he found and they went into the crucible with all the others.

The Bird grew old and no one understood his pictures any more. All they saw was a hectic confusion of curves. Nothing was recognisable, neither the earth, nor plants, nor animals. There was his last work; it would include everything he had discovered; it

would make his findings clear to all men at last. It was the essence of pictorial line and movement. It showed St Thomas the doubter before the open wounds of Christ. Uccello finished it when he was over eighty. Donatello came to see it and Uccello uncovered it for his comments. But Donatello said: "Well now. Now that it ought to be covered up, you're showing it to the whole world." And nothing more would he say. Uccello thought that he had accomplished his miracle. But Donatello had seen only a muddle of lines.

Several years later, they found Uccello dead of exhaustion on his pallet. His face was a mass of wrinkles. His eyes were fixed on the mystery revealed at last. In his tightly-closed hand he held a tiny circle of parchment covered in interwoven lines which went from the centre to the circumference and from the circumference to the centre.

Marcel Schwob
Les Vies imaginaires
G. Charpentier et E. Fasquelle, Paris 1896.

Botticelli: pagan visions, mystical visions, visions of the East

Primavera; Kingdom of Venus, say modern critics, one after the other. But when they try to explain what the scene represents, they muddle their exegesis most astonishingly. This very confusion leaves us with freedom of interpretation though it be of a very confused sort, and this may perhaps serve better than any other to convey Botticelli's involved philosophy, a poet's vision of the world, peopled with impalpable symbols, elusive memories, piercing sensuality, profound affection for Nature's gentlest smiles. On one point at least, every aesthetic in the world is in agreement: the ineffable beauty of the woman's face, the beauty of the queen of the painting, she whose gown is embroidered with flowers, she who remains inimitable: neither Leonardo, nor Raphael nor Corregio tried to capture her again.

On the edge of a sacred wood of lemon trees, a dark thicket loaded with golden fruit and streaked with the pale light of the sky, eight figures move across a meadow starred with flowers: they seem more like the fugitive visions of a dream than people engaged in some drama or idyll, the visible living form of a single idea. These eight figures are engaged in five different situations linked by a motive discerned only with difficulty. On the right of the spectator is a young girl naked beneath a diaphanous gauze, her hair dishevelled, her arms stretched forwards, wrenching herself from the grasp of an aerial spirit, a creature of ill-favoured mien, all greenish, its wings caught in the trees; the girl turns a pleading face towards the spirit, a flowering branch escapes from her lips. She flees across Primavera's path, but Primavera ignores her distress; she walks straight towards us, upright and steady, her great bright green eyes fixed upon us. In the centre of the picture, in the middle ground, a fair woman stands in front of a green bush, a white veil on her hair; she wears a bluish dress and looped over her arm she carries a

104

superb red cloak lined with gold-embroidered blue stuff. Her right hand sketches a benediction; her eyes gaze into space. Next to her three golden-haired Graces hold hands and dance in a ring. Two bare arms, two intertwined hands rise above the group and mark its unity and rhythm; pale blonde hair, loose for one, cunningly coiled for the others; gauzy garments made of air barely veiling the youth and beauty of their bodies. On the far left of the picture, a young man who is almost naked, a purple garment loosely draped across his body, wearing the hat and shoes of the god Mercury, raises his caduceus towards the trees as if to pull down a lemon; his back is towards the dancing maidens in the meadow. This Hermes is a Hippolytus; it is not at him, but at the Graces, that a small Cupid shoots his arrow, as he flutters above the white-clad woman.

All this is strange and mysterious. A mystery—the demon spirit and the flowering maiden who flees his grasp. A mystery—the austere figure of Venus chastely clad in the garments of a Roman matron whilst nymph and Graces wear indiscreet and tantalising veils. Mystery, too, the presence and the gesture of Mercury. It would be good to put a name to some of these figures. Did not Poliziano's *Giostra* serve as inspiration and theme for Botticelli? Therefore one should seek out Simonetta. The Hermes has the features of Giuliano; Simonetta should not be far away. But which lovely being, the nymph, Primavera or Venus, is the mistress of the handsome Medici? At one time or another they have all been taken for the representation of the beautiful Vespucci. Sandro certainly intended to show the entrance of the *Bella* into that delicious region of the Heavenly Fields where the Goddess of Love is supreme. And is not Mercury *Psychopompe*, the god who guides the souls through the other world? But in this painting, the god takes little notice of Simonetta's soul and leaves her to the spirit's clutches. Any critic who ignored the allusions to the *Giostra* would say that the nymph was only Flora fleeing from the Zephyr. But others have seen Simonetta in the picture, "alive, then born again and waking to a new life in the Elysian Fields". And so they see her here in a triple aspect: first, the nymph described by Poliziano (Primavera); next, in the centre, Simonetta Cattaneo "just as she was but with that expression of pain and suffering she wore at the last".

It is true that this central figure bears some resemblance to the Chantilly portrait, but the difference between Botticelli's Primavera and Piero di Cosmio's portrait is vast! Last, the terrified nymph who leaps from the lemon grove completes this strange trinity, one woman, one mistress in three persons.

I said previously that there are striking analogies between Primavera and Poliziano's nymph and indeed the poet described the painting for posterity. But there is an important contradiction between the two works. In the *Stanze*, the nymph is sitting on the grass and when she sees Giuliano she leaps to her feet, dropping the flowers she has been weaving into a garland:

> *Ghirlandetta avea contesta*
> *Di quanti fior creasse mai natura,*
> *De' quali era dipinta la sua vesta.*

105

Botticelli's Primavera walks slowly forwards and with her right hand takes the flowers gathered in her gown and scatters them on the grass.

Modern exegesis has relied very heavily on Poliziano and on the idea that the painting is Sandro's personal commemoration of those two sad figures Giuliano and Simonetta. It has been too often forgotten that in this picture Botticelli's inspiration must have been very free and very personal—that is, typically Florentine. I am quite willing to accept that lyric poetry, so much admired at the court of the Medici, must have bewitched his imagination and conspired to put those fresh bright colours on his palette. But let us remember that Sandro was a child of the people and that as a child in his father's shop, all around the streets and squares, on market days and feast days, he must have heard the sound of mandolines and the voices of country singers, beggars, blind wanderers, apprentice lads like himself, all singing those plain and simple country songs now collected by Giovanni Tigri, the *Canti popolari toscani*. This is the popular literature of the Mercato Vecchio. It is packed with memories of Nero, Constantine, the Carolingian epics, saints' legends; miracles and blood-curdling tales of terror. Above all, it is full of love stories, young girls, lovers won and lost. A whole collection is devoted to female beauty (*Bontà e belleza di donna*) and surely these symbols of beauty, happy memories of youth and gladness, must have come to Botticelli's mind:

"O fair white face—Where you pass by—The wind drops.—All the stars caress you,—You are the fairest rose in the garden—O orange blossom culled in Paradise,—Olive branch with lovely leaves,—Your beauty travels to France; It climbs the Emperor's staircase; It climbs the Empress's staircase; You are more limpid than spring water;—Sweeter than malmsey wine.—Fair one, who made your eyes?—Who gave them that loving glance?—White as mountain snow,—O rose from Naples,—You came through Rome,—You scattered Livorno with your roses,—The white roses on your heart,—The red roses in your cheeks. Why do they call you Neapolitan?—For you were born in Florence,—Baptised in the clear spring water."

The last eight lines offer a bridal bouquet of female beauty: "Lovely one, born in Paradise,—I was looking for a flower to pick,—The ones you wear on your face are so lovely;—They are red and white and many-coloured,—You have so many flowers in your lovely hair—That it looks like a garden of roses;—So many flowers twisted in your hair—That they make a garden of roses,—And so many flowers in your hands—That they look like a garden of pomegranates,"

> *N'avete tanti in quelle bianche mani,*
> *Che paion un giardin di melagrani.*

This simple *Song of Songs* which echoed on summer evenings in the dark streets of Florence, should it not be this rather than the sophisticated verses of Poliziano which gave Botticelli the naïve philosophy for his *Primavera*?

Emile Gebhardt
Sandro Botticelli
Hachette, Paris 1907.

The Umbrians: Piero della Francesca, Melozzo da Forlì, Perugino

Piero painted firm profiles which looked as though they were carved in copper, gowns embroidered with flowers as sharp as thorns, tall austere figures standing alone and erect. Horizontal clouds gathered in a sky where the Holy Dove stretched its rigid wings. The children of his mind stood high and terrible in their majesty. There was all the deep swell of violins in his harmonies. When he painted war, he was as hard as war; when he painted night, only a cuirass, a lance-tip and sleeping faces loomed in the blackness. His mind was formed by the methodical, assiduous study of all the exact sciences then known. He wrote treatises on perspective. He tried to make nature conform to the geometrical principles which had shaped his mind. The fusion of the living element which our sensitivity reveals to us and the mathematical element which comes to us from our intelligence operated in his work too and indeed his art offers us the strongest expression of that fierce desire felt by the Renaissance painters for the perfect blending of art and science, much more restricted in Piero than in Uccello and much less contrived than in Leonardo.

The comparison of Leonardo to Piero della Francesca suggests a retreat rather than an advance in the development of painting. Perspective and its related problems worry him and the effort to incorporate them into his paintings is easily perceptible and sometimes produces the rather uncomfortable feeling of two separate worlds existing side by side. In Piero's paintings, on the contrary, form becomes simultaneously the crystallisation and the heart of the spatial poem which the fresco develops in its full glory. Perspective is transformed from a mechanical exercise into a lyrical poem. It is true to say that it is Piero who really achieved the conquest of space in painting. I say "space" rather than atmosphere because the latter will in time be conquered by the Venetians. Geometrical space, not material space. Henceforward, the three dimensions will form a part of composition which will keep the dramatic character it had in the paintings of the purest primitives, possibly made all the stronger by virtue of its contact with the concept of space and with the formidable strictness of its lines, angles and perfect circles. There were new actors in those silent dramas acted in the dim darkness of tiny chapels: there was the moral import of gesture and facial expression, the significance of linear and chromatic combinations, and newest of all, this use of distance and space.

The most crucial example of Tuscan fresco painting to appear between the Arena Chapel in Padua and the Sistine Chapel in Rome is to be found in the humble church of San Francesco in Arezzo. Anyone who has not seen these huge figures walk in the depth of the wall, or sink deep into its thickness, who has not gazed on this vast murmuring immobile battle, these enormous kneeling women, these architectural complexes of cities, hills and trees, even if he has seen the Descent from the Cross here or the Creation of the World there has not known that marvellous solemn moment when every element of the great mural decoration reunited the scattered drama of human existence in a statement of geometrical volumes. In this work, feeling for the static in

Italian art is more strongly expressed than anywhere else and the figures involved stand like frozen blocks of breathing stone, articulated and girt with iron. Michelangelo's dynamism will bend them, but they will not break.

The figures in the fresco rise in tiers like houses, so strongly built that torsoes and shoulders, arms, heads and shoulders seem to have been planned in terms of mathematical calculation.

They look like statues walking, or kneeling, and the physical energy which sets them moving runs through their veins with the strength and solidity of bronze. They have the purity and grandeur of antiquity. None of the Italians ever managed to express the ultimate pride in the unique adventure of living with the same sense of the heroic as Piero, not Masaccio, not della Quercia, not Masaccio, not Michelangelo. He is possibly the greatest of these invincible men who stepped ever forwards through storms and tempests, tortured by passion, turning everything to their advantage, taking life as it came, an everyday drama, always searching for something loftier and more sublime and guided only by their determined, desperate spirits. Piero went through life like the heroes in his frescoes, pitiless, pure as strength itself, high above resignation's reach. The tree-trunks are bare, the leaves hang still, but something stirs and spreads throughout, the searing vital sap which keeps them tall and strong.

The dark earth itself seems a mass of curves which the fire below ground forces one into the other, as though in obedience to some rational power which directs its efforts. It is the most sublime work in Italy. And it was a decisive moment in the history of art. Rome and Tuscany met in Piero della Francesca, and his two main pupils, Luca Signorelli and Melozzo da Forlì announce the approach of Michelangelo and of Raphael.

The Umbrian influence, which will in time reach Raphael, grew stronger with Melozzo, like Raphael a native of that Transapennine Umbria which also gave birth to Gentile and which the Bolognese painter Francia was to link with Venice. Florentine intellectualism is often difficult for simple souls and the reaction of high mysticism it provoked is too strong for them to find the easy piety which suits them best and which cannot disturb the Vatican, that great distruster of mystics. With Melozzo da Forlì, we hear the gentle blowing of heavenly breezes, the fingers of great winged angels with blond curls draw from their harps a vague and distant music impossible to confuse with the thunder of the judgement trumpets. With Perugino, pious Umbria becomes over-zealous in its piety. The sturdiness of the capital was never appreciated by its painters, and the square palaces, the hillside streets, the up-piling of square houses and towers inspired only Bonfigli to paint great stony landscapes which make a pleasant change from enigmatic virgins and over-elegant angels. The man who best conveyed Umbria the land was a man who believed in nothing, drank and swore and worked for religion to get money quickly. When art is taken over by the zealots this is how it finds its revenge.

Perugino produced the first piety-pictures. This does not mean that he lacked charm; far from it, he had a rather mannered charm which could, though, prove

irritating when the pretty Umbrian faces, all blond and pink and fresh, smiled that Leonardo smile, inspired and slightly inane. He brought symmetry into painting, which is the opposite of equilibrium and immobilised space in the sugary stiffness of crude blues, greens and reds composed in chance harmony. His rounded strength, his off-beat but sturdy elegance, the sharp preciseness of his background landscapes (slender trees, smooth flowing lines of hills and dales), the energy of his upright figures who stand hips slanted and one foot forwards in a curious dancer's bearing explain to some extent the influence he had on Raphael, who spent the impressionable years after Urbino in Perugino's studio. He was strongly influenced by the very precise, very personal and very complete rhythms, choreographed into some static ballet, which Perugino imposed on to his figures in movement. He freed himself from his teacher only with the greatest difficulty and died before he had completely forgotten what he had learnt.

<div style="text-align:right">

Elie Faure
Histoire de l'Art
Jean-Jacques Pauvert, Paris 1964.

</div>

Piero di Cosimo

While Giorgione and Corregio were winning praise and glory for Lombardy, Tuscany was not devoid of distinguished men. Not the least of these was Piero, son of one Lorenzo, a goldsmith, and godson of Cosimo Rosselli, and owing to these circumstances he was always known as Piero di Cosimo. Indeed, he who instructs ability and promotes well-being is a truly a father as the one who begets. Piero's father, seeing the intelligence of his son and his fondness for design, entrusted him to Cosimo, who took the charge willingly, and always loved and regarded Piero as a son among all the pupils whom he saw about him, and watched him growing in years and ability. This youth naturally possessed a very lofty spirit and he was very abstracted and differed in tastes from the other pupils of Cosimo. He was sometimes so absorbed in what he was doing that those who conversed with him were frequently obliged to repeat all they had said, for his mind had wandered to other ideas. He was so fond of solitude that his one delight was to wander alone, free to build his castles in the air. His master Cosimo had reason to hope that they might be extensive for he frequently employed him on his own works, continually entrusting him with matters of importance, knowing that Piero possessed a finer style and a better judgement than himself. For this reason, he took him to Rome when summoned by Pope Sixtus to decorate the chapel. In one of the scenes there Piero did a beautiful landscape, as I have said in the life of Cosimo. As he drew most excellently from life, he did a quantity of portraits of distinguished persons at Rome, notably Verginio Orsino and Ruberto Sansovino, whom he introduced into the scenes. He also drew Duke Valentino, son of Pope Alexander VI. So far as I know, this picture cannot now be found, but the cartoon exists in the possession of M. Cosimo Bartoli, provost of S. Giovanni. He painted a quantity of pictures at Florence for the houses of various

persons; many good examples having come under my notice and he also did various things for many other people. In the Noviciate of S. Marco he did a Madonna standing with the Child, coloured in oils. In the church of S. Spirito in Florence, in the chapel of Gino Capponi, he did a picture of the Visitation with St Nicholas and a St Anthony reading, the latter wearing a pair of spectacles, a vigorous figure. There is an excellent representation of an old parchment book, and the balls of St Nicholas are made lustrous, reflecting each other, showing the curious fancies of Piero's brain, and how he sought out and performed difficult things.

After his death it appeared that he had lived the life of a brute rather than a man, as he had kept himself shut up and would not permit anyone to see him work. He would not allow his rooms to be swept, he ate when he felt hungry, and would never suffer the fruit-trees of his garden to be pruned or trained, leaving the vines to grow and trail along the ground; the fig-trees were never pruned nor any others, for he loved to see everything wild, saying that nature ought to be allowed to look after itself. He would often go to see animals, herbs or any freaks of nature, and his contentment and satisfaction he enjoyed by himself. He would repeat his remarks so many times that at length they became wearisome, however good they may have been. He stopped to examine a wall where sick persons had used to spit, imagining that he saw there combats of horses and the most fantastic cities and extraordinary landscapes ever beheld. He cherished the same fancies of clouds. He practised colouring in oils after seeing some things of Leonardo toned and finished with extreme diligence characteristic of that master when he wished to display his art. This method pleased Piero and he strove to imitate it, though he was a long way behind Leonardo, and any other eccentric things; indeed we may say that this spirit pervaded everything he did. If Piero had not been so eccentric, and had possessed more self-respect, he would have displayed his great genius and commanded admiration, whereas he was rather considered a fool for his uncouthness, though he really harmed no one but himself and greatly benefited art by his works. Thus every man of ability and every excellent artist ought to consider the end in the light of these examples.

In his youth Piero, possessing a capricious and extravagant invention, was in great request for the masquerades of carnival-time, and was a great favourite with the noble Florentine youths, because by his inventive mind he greatly improved those amusements in ornament, grandeur and pomp. He is said to have been one of the first to give them the character of triumphs, and at any rate he greatly improved them with his scenes, with music and appropriate speeches, and a grand procession of men on horses and foot, in costumes adapted to the subject. These proved very rich and fine, combining grandeur and ingenuity. It was certainly a fine sight at night to see twenty-five or thirty couples of horses, richly caparisoned, with their masters dressed in accordance with the subject of the invention; six- or eight-foot men in the same livery, in single file, carrying torches in their hands, sometimes more than four hundred, and then the car of triumph full of ornaments, spoils and curious fancies, which enchanted the people and instructed their minds.

Among these things, which were fairly numerous and ingenious, I shall briefly describe one of Piero's chief efforts when he was already mature. It was not, like many others, pleasant and pretty, but horrible and surprising, giving no small pleasure to the people. For as acid things give wonderful delight in food, so horrible things in these amusements tickle the fancy, as, for instance, in tragedy.

This particular device was the car of Death secretly prepared by Piero in the Pope's Hall, so that nothing transpired till it was made public to all at the same time. It was a large car drawn by black buffaloes and painted with white death's-heads and crossbones. At the top of the car a gigantic Death held his scythe, while round the car were many tombs with their stones. When the car stopped, these opened, and figures clothed in black issued out, with the complete skeleton painted on their draperies, the white set off by the black. From a distance there appeared some of the torches with masks painted behind and before like skulls including the throat, most realistic but a horrid and terrible sight. At the raucous, dead sound of the trumpets, they came half out of the tombs and, sitting on them, sang the following noble canzone to a music full of sadness:

Dolor, pianto, e penitenzia etc.

In front and following the car there were a great number of dead mounted on the leanest and boniest horses that could be found, with black trappings marked with white crosses. Each one had four footmen dressed as the dead, carrying black crosses and a great black standard with crosses, skulls and crossbones. After the triumph they dragged in ten black standards, and as they marched they sang the Miserere, a psalm of David, in unison, with trembling voices. This lugubrious spectacle, by its novelty and tremendous character, as I have said, at once terrified and amazed the whole city, and although it did not seem at first sight suited to the carnival, yet it pleased everyone because of its novelty and because everything was admirably arranged. Piero, the inventor, received hearty praise for his work and this encouraged him to produce witty and ingenious devices, for the city has no rival in the conduct of such festivals. Old people who saw this spectacle preserve a lively recollection of it and are never tired of talking about this curious invention. I have heard it said by Andrea di Cosimo, who helped him with this work, and by Andrea del Sarto, his pupil, who also had a share in it, that this invention was intended to signify the return to Florence of the houses of the Medici, exiles at the time and practically dead. Thus they interpret the words:

Morti siam, come vedete,
Cosi morti vedrem voi:
Fummo gia come voi sete,
Voi sarete come noi etc.

to indicate their return, like a resurrection of a dead man to life, and the banishment of their opponents. However this may be, it was natural that a special significance

should be attributed to these words when this illustrious house returned to Florence, as men are apt to apply words and acts that happened before to events that follow after. This opinion was certainly entertained by many and it was much discussed.

I do not think that anyone painted frightening objects better than Piero, as for example a marine monster which he did and presented to Giuliano de' Medici, of remarkable and curious deformity so that it appears impossible that Nature should have produced anything so fantastic.

In the house of Francesco Pugliese, Piero did some scenes of fables in small figures about a room, the diversity of the fantastic creations in which he delighted . . . After the death of Francesco and his children, they were removed and I do not know what has become of them.

For Filippo Strozzi the elder, Piero painted a picture of Perseus delivering Andromeda from the monster, in small figures containing some beautiful things. It is now in the house of Signor Sforza Almeni, having been given to him by M. Giovanni Battista di Lorenzo Strozzi, who knew how fond he was of painting and sculpture. He values it highly, for Piero never did a more lovely or better-finished picture; no more curious sea-monster can be seen than the one which he drew there, while the attitude of Perseus is fine as he raises his sword to strike. Andromeda's beautiful face is torn between fear and hope, as she stands bound, and before her are many people in various curious costumes, playing and singing, some laughing and rejoicing at seeing her release. The landscape is very lovely and the colouring soft, graceful, harmonious and well blended.

Piero also painted a picture of a nude Venus with a nude Mars lying asleep in a meadow full of flowers, surrounded by Cupids who are carrying his helmet, gauntlets and other armour. It also contains a myrtle bush and a cupid frightened by a rabbit, with the doves of Venus and other accessories of Love. This picture is in Florence in the house of Giorgio Vasari, treasured in memory of the author whose fancies always delighted him.

The master of the Ospedale degli Innocenti was a great friend of Piero and when he wanted a picture for the Chapel of the Pugliese on the left hand on entering the church he allotted it to Piero, who completed it to his satisfaction. But he drove the master to distraction as he was not allowed to see it before it was finished. It seemed strange to him that a friend should be always thinking of the money and not allow him to see the work, and he refused to make the last payment unless he was allowed to see the work. But when Piero threatened to destroy what was done, he was forced to give him the rest, with anger exceeding his former patience. The work certainly contains many good things.

He did some Bacchanalian scenes about a chamber for Giovanni Vespucci, who lived opposite S. Michele in the Via de' Servi, now Via di Pier Salviati, introducing curious fauns, satyrs, wood-nymphs, children and bacchantes, the diversity of creatures and garments being marvellous, with various goatish faces, all done with grace and remarkable realism. In one scene Silenus is riding an ass, with a throng of children, some carrying him and some giving him drink, the general joy being ingeniously depicted.

Piero's works betray a spirit of great diversity distinct from those of others, for he was endowed with a subtlety for investigating curious matters in nature and executed them without a thought for time or labour, but solely for his delight and pleasure in art. It could not be otherwise, for so devoted was he to art that he neglected his material comforts and his habitual food consisted of hard-boiled eggs which he cooked while he was boiling his glue, to save the firing. He cooked them a good fifty at a time and would eat them one by one from a basket in which he kept them. He adhered so strictly to this manner of life that others seemed to him to be in slavery by comparison. The crying of babies irritated him, and so did the coughing of men, the sound of bells, the singing of the friars. When it rained hard, he loved to see the water rushing off the roofs and splashing on to the ground. He was much afraid of lightning and was terrified of the thunder. He would wrap himself up in his mantle, shut up the windows and doors of the room and crouch in a corner until the fury of the storm had passed. His conversation was so various and diversified that some of his sayings made his hearers burst with laughter.

But in his old age, when eighty years old, he became so strange and eccentric that he was unbearable. He would not allow his apprentices to be about him, so that he obtained less and less assistance by his uncouthness. He wanted to work, and not being able on account of his paralysis, he became so enraged that he would try to force his helpless hands, while he doddered about and the brush and stick fell from his grasp, a pitiful sight to behold. The flies annoyed him and he hated the dark.

Thus fallen sick of old age, he was visited by a friend who begged him to make his peace with God. But he did not think he was going to die and kept putting it off. It was not that he was bad or without faith, for though his life had been uncouth he was full of zeal. He spoke sometimes of long wasting sicknesses and gradual dying and its wretchedness. He abused physicians and apothecaries, saying that they made their patients die of hunger, in addition to tormenting them with syrups, medicines and other tortures such as not allowing them to sleep when drowsy. He also spoke of the distress of making a will, seeing relations weep, and being in a room in the dark. He praised capital punishment, saying it was a fine thing to go to death in the open air amid a throng of people, being comforted with sweetmeats and kind words, the priest and people praying for you and then going with the angels to Paradise. And thus he went on with the most extraordinary notions, twisting things to the strangest imaginable meanings.

After such a curious life he was found dead one morning at the foot of the stairs, in 1521, and was buried in S. Pier Maggiore.

He had several pupils, among them Andrea del Sarto.

Giorgo Vasari
The Lives of the Painters, Sculptors and Architects
Translated and published 1927, Everyman's
Library edition.

Ghirlandaio

Although this imitation in which the Florentine painters delight is too literal, it has, on the whole, a special grace. It is necessary to visit the church of Santa Maria Novella in order to appreciate its charm. There, Ghirlandaio, the master of Michael Angelo, has covered the choir with his frescoes. They are poorly lighted and awkwardly piled up one on top of the other; but toward midday they can be seen. They represent the story of St John the Baptist and the Virgin, the figures being half the size of life. Through education as well as instinct, this painter, like his contemporaries, is a copyist. He sketched people while passing his goldsmith's shop and the resemblance of his figures excited admiration. He regarded painting as 'wholly consisting of drawing'. Man, to the artists of this epoch, is still only a form; but he had so just a sentiment of this form, and of all forms, that on copying the Roman amphitheatres and triumphal arches, he drew them as accurately with the eyes as with a compass. Thus prepared one can readily see what speaking portraits he put into his frescoes; there are twenty-one of these, representing persons whose names are known, Christoforo Landini, Ficin, Politian, the bishop of Arezzo, others of women—that of the beautiful Ginevra de' Benci, all belonging to families controlling the patronage of the chapel. The figures are a little commonplace; several of them are hard and have sharp noses, and are too literal; they lack grandeur, the painter keeping near the ground, or only cautiously flying above the surface; it is not the bold flight of Masaccio. Nevertheless he composes groups and architecture, he arranges figures in circular sanctuaries, he drapes them in a half-Florentine half-Grecian costume which unites or opposes in happy contrasts and graceful harmonies the antique and the modern; above all this, he is simple and sincere. An attractive moment this, a delicate aurora consisting of that youthfulness of spirit in which man first recognises the poesy of reality. At such a time he traces no line that does not express a personal sentiment; whatever he relates he has experienced; as yet there is no accepted type which bodies forth in conventional beauty the budding aspirations of his breast; the greater his timidity the more vivacious he is, and the forms somewhat dry on which he leads are the discreet confessions of a new spirit which dares neither to escape from nor reserve itself. One might pass hours here in contemplating the figures of the women; they are the flower of the city in the fifteenth century; we see them as they lived, each with her original expression and the charming irregularity of real life; all with those half-modern half-Florentine features so animated and so intelligent. In the *Nativity of the Virgin*, the young girl in a silk skirt who comes on a visit is the plain demure young lady of good condition; in the *Nativity of St John*, another, standing, is a mediaeval duchess; near her the servant bringing in fruits, in statuesque drapery, has the impulse, vivacity and force of an antique nymph, the two ages and the two orders of beauty thus meeting and uniting in the simplicity of the same true sentiment. A fresh smile rests on their lips; underneath their semi-immobility, under these remains of rigidity which imperfect painting still leaves, one can divine the healthy passion of an intact spirit and a healthy body. The

curiosity and refinement of ulterior ages have not reached them. Thought, with them, slumbers; they walk or look straight before them with the coolness and placidity of virginal purity; in vain will education with all its animated elegancies rival the divine uncouthness of their gravity.

This is why I so highly prize the paintings of this age; none in Florence have I studied more. They are often deficient in skill and are always dull; they lack both action and colour. It is the Renaissance in its dawn, a dawn gray and somewhat cool, as in the spring when the rosy hue of the clouds begins to tinge a pale crystal sky and when, like a flaming dart, the first ray of sunshine glides over the crests of the furrows.

<div style="text-align:center">

H. Taine
Italy: Florence and Venice
Trans. J. Durand, New York 1869.

</div>

The Venetian school: the Primitives, Giovanni Bellini, Carpaccio

The Academy of the Fine Arts contains a collection of the works of the earliest painters. A large picture in compartments of 1380 quite barbarous, shows the first steps taken: here, as elsewhere, the new art issued from Byzantine traditions. It appears late, much later than in precocious and intelligent Tuscany. We encounter, indeed, in the fourteenth century, a Semiticolo, a Guariento, weak disciples of the school which Giotto founded at Padua; but, in order to find the first national painters, we must come down to the middle of the following century. At this time there lived at Murano a family of artists called the Vivarini. With the oldest of these, Antonio, we already detect the rudiments of Venetian taste, some venerable beards and bald heads, fine draperies with rosy and green tones, little angels almost plump and Madonnas with full cheeks. After him his brother Bartolomeo, educated undoubtedly in the Paduan school, inclines painting for a time to dry and bony forms*. With him, however, as with all the rest, a feeling for rich colours is already perceptible. On leaving this antechamber of art the eyes keep a full and strong sensation which other vestibules of art, at Siena and at Florence, do not give, and, on continuing, we find the same sensation, still richer, before the masters of this half-legible era, John Bellini and Carpaccio.

I have just examined at the Frari a picture by John Bellini which, like those of Perugino, seems to me a masterpiece of genuine religious art. At the rear of a chapel, over the altar, within a small piece of golden architecture, sits the Virgin on a throne in a grand blue mantle. She is good and simple like a simple innocent peasant girl. At her feet two little angels in short vests seem to be choirboys and their plump infantile thighs are of the finest and healthiest flesh colour. On the two sides, in the compartments, are two couples of saints, impassible figures in the garbs of monk and bishop, erect for

*A Virgin of 1473 at Santa Maria Formosa.

eternity in hieratic attitude, actual forms reminding one of the sunburnt fishermen of the Adriatic. These personages have all lived; the believer kneeling before them recognised features encountered by him in his boat and on the canals, the ruddy brown tones of visages tanned by the sea-breezes, the broad and pure carnation of the young girls reared in a moist atmosphere, the damask cope of the prelate heading the processions, and the little naked legs of the children fishing for crabs at sunset. He could not avoid having faith in them; truth so local and perfect paved the way to illusion. But the apparition was one of a superior and august world. These personages do not move; their faces are in repose and their eyes fixed like those of figures seen in a dream. A painted niche, decked with red and gold, recedes back of the Virgin like the extension of an imaginary realm; painted architecture in this way imitates and completes actual architecture, while the golden Host on the marble, crowned with rays and a glory, displays the entrance into the supernatural world disclosing itself behind her.

On regarding other pictures by John Bellini and those of his contemporaries in the Academy, it is evident that painting in Venice, whilst following a path of its own, ran the same course as in the rest of Italy. It issues here, as elsewhere, from missals and mosaics, and corresponds at first wholly to Christian emotions; then, by degrees, the sentiment of a beautiful corporeal life introduces into the altar-frames vigorous and healthy bodies borrowed from surrounding nature, and we wonder at seeing placid expressions and religious physiognomies on flourishing forms circulating with youthful blood and sustained by an intact temperament. It is the confluence of two ages and two spirits, one Christian and subsiding and the other pagan and about to become ascendant. At Venice, however, over these general resemblances special traits are delineated. The personages more closely copied from life, less transformed by the classic or mystic temperament, less pure than at Perugia, less noble than at Florence; they appeal less to the intellect or to the heart and more to the senses. They are more quickly recognised as men and give greater pleasure to the eye. Powerful, lively tones colour their muscles and faces; living flesh is already soft on the shoulders and on children's thighs; open landscapes recede in order to enforce the dark tints of the figures; the saints gather around the Virgin in various attitudes unknown to the monotonous perceptions of other primitive schools. At the height of its fervour and faith the national spirit, fond of diversity and the agreeable allows a smile to glimmer. Nothing is more striking in this respect than the eight figures by Carpaccio relating to St Ursula*. Everything is here; and first the awkwardness of the feudal image-fabricator. He ignores one-half of the landscape, and likewise the nude; his rocks bristling with trees seem to issue from a psalter; frequently his trees are as if cut out of polished sheet iron; his ten thousand crucified martyrs on a mountain are grotesque like the figures of an ancient mystery; he did not, evidently, live in Florence, nor study natural objects with Paolo Uccello, nor human members and muscles with Pollaiuolo. On the other hand, we find in him the chastest of mediaeval figures, and that extreme finish, that perfect truthfulness, that bloom of the Christian

116 *Pictures from 1490 to 1515.

conscience which the following age, more rude and sensual, is to trample on in its vehemences. The saint and her affianced, under their great drooping blond tresses, are grave and tender, like the characters of a legend. We see her, at one time asleep and receiving from the angel the announcement of her martyrdom, now kneeling with her spouse under the benediction of the pope, now translated in glory above a field of crowned heads. In another picture she appears with St Anne and two aged saints embracing each other; one cannot imagine figures more pious and more serene; she, pale and gentle, her head slightly bent, holds a banner in her beautiful hands and a green palm-branch; her silky hair flows down over the virginal blue of her long robe and a royal mantle envelops her form with its golden confusion; she is indeed a saint, the candour, humility and delicacy of the Middle Ages entirely permeating her attitude and expression. Such is the age, and such the country! These paintings provide scenes of social significance and rich decorations. The artist, as at a later period his great successors, displays architecture, fabrics, arcades, tapestried halls, vessels, processions of characters, grand bedizened and lustrous robes, all in petty proportions but in brilliancy and diversity anticipating future productions as an illuminated manuscript anticipates a picture. And in order fully to show the transformation under way he himself once attains to perfect art; we see him emerging from his primitive dryness in order to enter on the new and definitive style. In the middle of the grand hall is a *Presentation of the Boy Jesus* which one would not believe to be by him were it not signed by his hand (1510). Under a marble portico incrusted with mosaics of gold appear personages almost of the size of life, in admirable relief, exquisitely finished, and perfect in composition and amidst the most beautiful gradations of light and shadow; the Virgin, followed by two young females, leads her child to the aged Simeon; beneath, three angels play on the viol and the lute. Save a little rigidity in the heads of the men and in some of the folds of the drapery, the archaic manner has disappeared; nothing remains of it but the infinite charm of moral refinement and benignity, while, for the first time, the semi-nude bodies of little children show the beauty of flesh traversed and impregnated with light. With this picture we cross the threshold of high art and, around Carpaccio, his young contemporaries, Giorgione and Titian, have already surpassed him.

H. Taine
Italy: Florence and Venice
Trans. J. Durand, New York 1869.

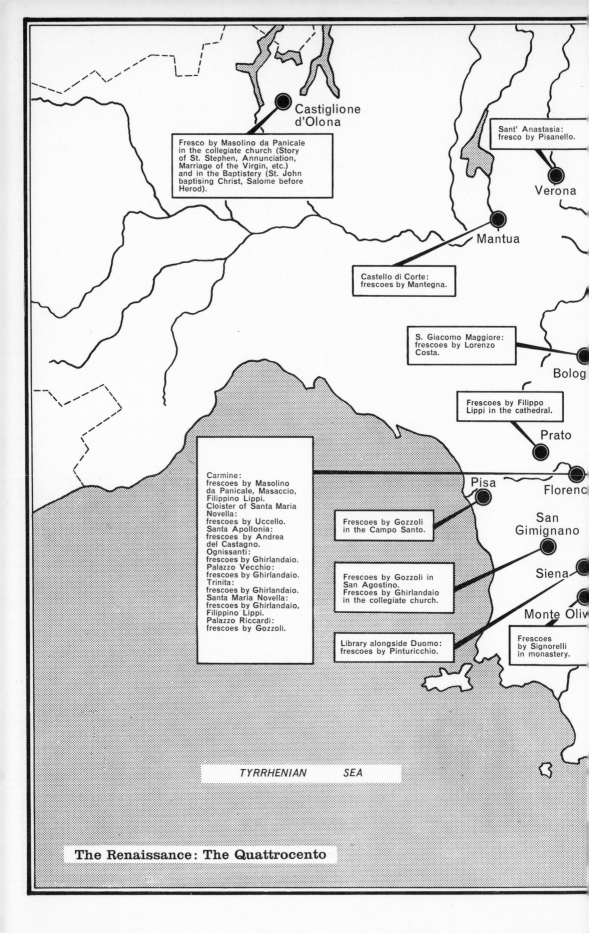

Castiglione
d'Olona

Fresco by Masolino da Panicale
in the collegiate church (Story
of St. Stephen, Annunciation,
Marriage of the Virgin, etc.)
and in the Baptistery (St. John
baptising Christ, Salome before
Herod).

Sant' Anastasia:
fresco by Pisanello.

Verona

Mantua

Castello di Corte:
frescoes by Mantegna.

S. Giacomo Maggiore:
frescoes by Lorenzo
Costa.

Bolog

Frescoes by Filippo
Lippi in the cathedral.

Prato

Carmine:
frescoes by Masolino
da Panicale, Masaccio,
Filippino Lippi.
Cloister of Santa Maria
Novella:
frescoes by Uccello.
Santa Apollonia:
frescoes by Andrea
del Castagno.
Ognissanti:
frescoes by Ghirlandaio.
Palazzo Vecchio:
frescoes by Ghirlandaio.
Trinita:
frescoes by Ghirlandaio.
Santa Maria Novella:
frescoes by Ghirlandaio,
Filippino Lippi.
Palazzo Riccardi:
frescoes by Gozzoli.

Pisa

Florenc

Frescoes by Gozzoli
in the Campo Santo.

San
Gimignano

Siena

Frescoes by Gozzoli in
San Agostino.
Frescoes by Ghirlandaio
in the collegiate church.

Monte Oliv

Frescoes
by Signorelli
in monastery.

Library alongside Duomo:
frescoes by Pinturicchio.

TYRRHENIAN SEA

The Renaissance: The Quattrocento

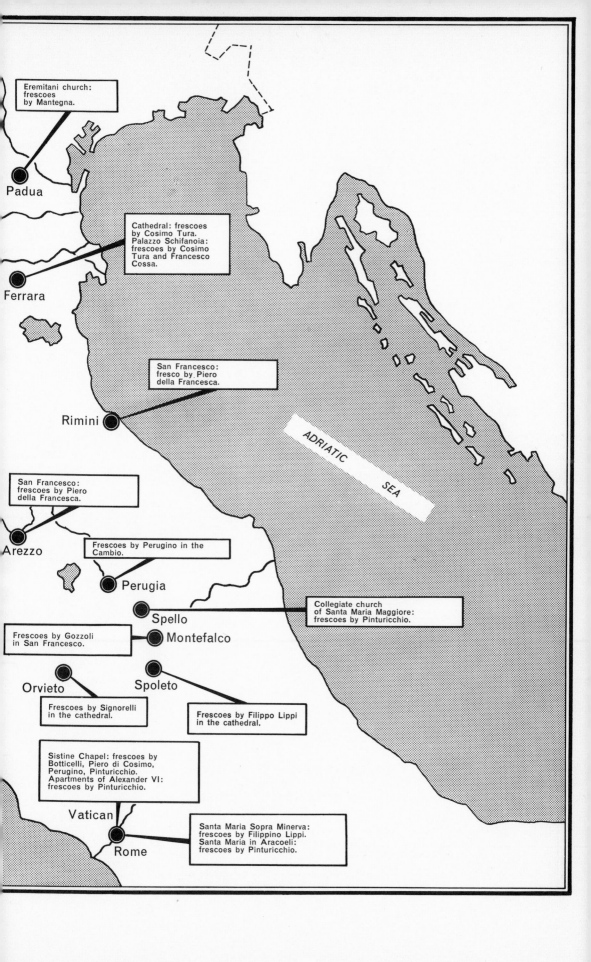

Eremitani church:
frescoes
by Mantegna.

Padua

Cathedral: frescoes
by Cosimo Tura.
Palazzo Schifanoia:
frescoes by Cosimo
Tura and Francesco
Cossa.

Ferrara

San Francesco:
fresco by Piero
della Francesca.

Rimini

ADRIATIC
SEA

San Francesco:
frescoes by Piero
della Francesca.

Arezzo

Frescoes by Perugino in the
Cambio.

Perugia

Spello

Collegiate church
of Santa Maria Maggiore:
frescoes by Pinturicchio.

Frescoes by Gozzoli
in San Francesco.

Montefalco

Orvieto

Spoleto

Frescoes by Signorelli
in the cathedral.

Frescoes by Filippo Lippi
in the cathedral.

Sistine Chapel: frescoes by
Botticelli, Piero di Cosimo,
Perugino, Pinturicchio.
Apartments of Alexander VI:
frescoes by Pinturicchio.

Vatican

Santa Maria Sopra Minerva:
frescoes by Filippino Lippi.
Santa Maria in Aracoeli:
frescoes by Pinturicchio.

Rome

Dates	Political events	The Arts	Intellectual life The Sciences	Religion
1335		Work starts on the Palais des Papes, Avignon.		
1336		Death of Giotto.		Benedictine reform.
1337	Hundred Years' War begins.		Petrarch in Vaucluse. Birth of Froissart.	Birth of St Catherine of Siena.
1338	Ottoman Turks reach the Bosphorus	Simone Martini finishes his *Annunciation* in Siena.	Small size cannon made as individual fire-arms.	
1342		Matthew of Arras starts building Prague Cathedral		Death of Benedict XII. Clement VI.
1345	Failure of the main banks in Florence causes financial crisis in Europe.			
1348		Death of Ambrogio Lorenzetti.	Boccaccio starts the *Decameron*.	Jeanne of Naples sells Avignon to Clement VI.
1350		In spite of sinking foundations, work on the cathedral tower at Pisa is continued (the Leaning Tower). Orcagna: *Life of the Virgin* at S. Maria Novella.		
1352				Death of Clement VI. Cardinals' plot to win power in the Church foiled by new pope, Innocent VI.
1360	Turks capture Philippopoli and Andrinopolis.			Innocent VI reforms the Dominicans.
1365		Andrea da Firenze: frescoes in the Spanish Chapel, S. Maria Novella.		
1367			Froissart: *L'Epinette amoureuse*.	Urban V leaves Avignon for Rome.
1370		Birth of Ghiberti. Birth of Gentile da Fabriano.	Playing-cards reach Europe from the East.	John V's plans fail. He leaves Rome. Urban V returns to Avignon. His death. Gregory XI.

Dates	Political events	The Arts	Intellectual life The Sciences	Religion
1374			Death of Petrarch.	
1375		*Triumph of Death* in the Campo Santo, Pisa.	Death of Boccaccio.	
1378				Beginning of the Great Schism.
1380				Death of St Catherine of Siena.
1383		Birth of Masolino da Panicale.		
1386		Birth of Donatello.		
1387		Birth of Fra Angelico.		
		Birth of Brunelleschi.	Froissart starts his *Chronicles*.	
1390	Giovanni de' Medici takes over the opposition to the Albizzi in Florence.		Birth of Alain Chartier. 1390-1400: Cennino Cennini writes *Libro dell' Arte*.	
1394		Birth of Squarcione.		
1396	The French capture Genoa.	Birth of Michelozzo Michelozzi.		
1397		Birth of Paolo Uccello. Birth of Pisanello.		St Vincent Ferrer starts preaching.
1400		Birth of Jacopo Bellini. Birth of Domenico Veneziano.		
1401		Birth of Masaccio.		Birth of Nicholas of Cusa.
1403		1403-1452: Ghiberti carries out the reliefs for the Baptistery in Florence.		Benedict XIII flees from Avignon.
1406	The Florentines capture Pisa.	Birth of Filippo Lippi. Birth of Alberti.	The clearing-bank of San Giorgio founded in Genoa.	Gregory XII succeeds Innocent VII.
1410		Between 1410-1420: birth of Piero della Francesca.	Death of Eustache Deschamps.	Death of Alexander V, elected the previous year. John XXIII.

121

Dates	Political events	The Arts	Intellectual life The Sciences	Religion
1415	Battle of Agincourt.	Birth of Vivarini. Birth of Jean Fouquet.		John XXIII tries to transfer the Council of Constance to Italy. He is deposed. Gregory XII abdicates. Benedict XIII is rejected. Execution of John Huss.
1416	The Venetians defeat the Turkish fleet before Gallipoli.			
1420		Birth of Benozzo Gozzoli.	Thomas à Kempis: *Imitation of Christ*.	Martin V calls for a Crusade against the Hussites.
1423	Birth of Louis XI.	Birth of Andrea del Castagno. Masaccio: *St Anne, Virgin and Child*. 1423-1426: Masolino: the Brancacci Chapel.	Henry the Navigator sets up a permanent headquarters for sailors, cartographers and cosmographers to help scientific exploration.	Opening of the Council of Padua, later transferred to Siena.
1425	The League of Venice: Florence and the Pope against Milan.	Birth of Baldovinetti. Masaccio: *The Virgin of Humility*. Piero della Francesca: *The Virgin of Mercy*. Brunelleschi starts San Lorenzo in Florence.		The Congregation of Mantua formed amongst the Carmelites.
1426		Birth of Giovanni Bellini. Masaccio: *Virgin with Child*. 1426-1427: Masaccio: the Brancacci Chapel.		
1428		Death of Masaccio.		Wycliff's bones burnt by order of the Church.
1429	Joan of Arc raises the siege of Orleans. Death of Giovanni de' Medici. His son Cosimo succeeds him.	Birth of Gentile Bellini.	Death of Gerson. The Portuguese sail round Cape Bojador.	

Dates	Political events	The Arts	Intellectual life The Sciences	Religion
1430		Birth of Antonello da Messina. Birth of Fra Diamante. Fra Angelico: *The Annunciation*.	Birth of François Villon.	Convocation of the Council of Basle.
1431	Trial and condemnation of Joan of Arc.	Birth of Mantegna. Uccello: *The Creation* in the cloister of Sta Maria Novella.	Henry the Navigator occupies the Azores.	
1432		Birth of Pollaiuolo. Birth of Cosimo Tura.	Nicholas of Cusa: *De Concordantia catholica*.	
1433	Exile of Cosimo de' Medici.		Birth of Marsilio Ficino.	The Czechs in Basle. Reconciliation of Eugene IV and the Council. Prague conference with Hussites.
1435	Alfonso V in Italy. Defeated and made prisoner.	Birth of Verroccio. Masolino: decoration of Baptistery at Castiglione d'Olona. Between 1435 and 1440: Birth of Carlo Crivelli.		
1436	Alfonso V released, renews fighting in Italy.	Uccello: Portrait of Sir John Hawkwood.	Henry the Navigator occupies Rio de Oro.	Schism in the Council on reform of the Holy See. Pope appeals to heads of state for support. First seminary founded in Florence.
1438		Birth of Francesco Cossa. Birth of Melozzo da Forlí.		Eugene IV suspended at Basle. Council transferred from Ferrara to Florence.
1439		Birth of Cosimo Rosselli.	1439 (?): first typographical printing in Strasbourg.	Eugene IV promises John Palaeologus help against the Turks. Church Union. Eugene IV deposed in Basle. Felix V elected.
1440	Trial of Gilles de Rais.	Death of Masolino da Panicale.		

123

Dates	Political events	The Arts	Intellectual life The Sciences	Religion
		Uccello: *St George and the Dragon*.		
		1440-1445: Fra Angelico: frescoes at San Marco.		
1441	Siege of Constantinople by Turks.	Birth of Signorelli.	Public library opened in Florence.	
1443			Luca della Robbia uses a lead-based enamel on his sculptures.	Last session of Council of Basle. Transferred to the Lateran.
1444		Birth of Botticelli.		Death of St. Bernardino.
1445		Andrea del Castagno: frescoes in convent of Sant' Apollonia.		
		Uccello: *The Flood*, fresco, cloister of Santa Maria Novella.		
1446		Death of Brunelleschi.	Birth of Christopher Columbus.	
1447	Death of Filippo Maria Visconti: republic proclaimed in Milan.	Filippo Lippi: *The Coronation of the Virgin*.	Genoese map of the world drawn up in the Pitti Palace, Florence.	Death of Eugene IV. Nicholas V.
1449	Charles VII wins back Normandy.	Birth of Ghirlandaio.	Nicholas of Cusa: *De quaerendo Deum*.	Abdication of Felix V, the last antipope.
1450	Sforza proclaimed Duke of Milan.	Birth of Francia. Birth of Berruguete. Birth of Perugino. Birth of Ercole Roberti. Death of Gentile da Fabriano. Death of Pisanello.	Gutenberg opens a printing works in Mainz.	Torquemada: the Spanish Inquisition.
1451	Arrest of Jacques Cœur.	Andrea del Castagno: *Famous Men and Women*.		
1452		Filippo Lippi: frescoes in Prato Cathedral.	Arnould Gréban: *True Mystery of the Passion*.	Birth of Savonarola.

Dates	Political events	The Arts	Intellectual life The Sciences	Religion
		1452-60: Piero della Francesca: frescoes in S. Francesco, Arezzo.	Alberti finishes his 10-volume work on architecture.	
		Birth of Leonardo da Vinci.		
		Michelozzo finishes San Marco in Florence.		
1453	Mahomet II takes Constantinople. End of the Byzantine empire.			
1454	1454-55: failure of the Congress of Rome called to organise a Crusade against the Turks.	Birth of Pinturicchio. 1454-59: Mantegna: frescoes in the Eremitani Chapel, Padua.	Birth of Poliziano.	St Francis of Paola founds the order of Minims.
1455		Death of Ghiberti. Death of Fra Angelico. Birth of Carpaccio.	Gutenberg prints a Bible with 42 lines per page.	Death of Nicholas V. Calixtus III.
1456		1456-57: Uccello: *Battle of San Romano*.	The Portuguese reach the Gulf of Guinea. Marsilio Ficino: *Institutiones platonicae.* 1456-71: Argyropoulos teaching in Florence. François Villon: *Petit Testament.*	
1457		Birth of Filippino Lippi. Death of Andrea del Castagno.	Marsilio Ficino: *De Voluptate.* Psalter printed by Pierre Schaeffer.	Argument between Nicholas de Cusa and Sigismond of Austria about the reform of the laity.
1459	Failure of the Congress of Mantua called to organise a Crusade against the Turks.	Gozzoli: frescoes in the Riccardi Palace. Mantegna: San Zeno altar-piece. Mantegna: *Portrait of Cardinal Lodovico Mezzarata.*	Academy for the study of Plato founded in Florence.	

Dates	Political events	The Arts	Intellectual life The Sciences	Religion
1460	The Turks destroy the state of the Morea.	Birth of Lorenzo Costa. Death of Veneziano.	Fust of Mainz sells his printed books in Paris. First illustrated books printed in Germany.	
1462	Pius II recaptures the Marches and the Romagna from Sigismondo Malatesta.	Birth of Piero di Cosimo.		Franciscan monks start a pawnshop in Perugia.
1463			Birth of Pico de la Mirandola.	
1465		Gentile Bellini: *The Patriarch Lorenzo Giustiani*. Giovanni Bellini: *Agony in the Garden*.	Marsilio Ficino translates Plato. 1465?: death of François Villon.	Catharism dis-appears from Bosnia.
1466	Death of Francesco Sforza: his son Galeazzo Maria succeeds him. The Pitti plot against the Medici.	Death of Donatello. 1466-69: Filippo Lippi: frescoes in Spoleto Cathedral.		
1468		Cosimo Tura: decoration of organ doors in Ferrara Cathedral. 1468-85: Benozzo Gozzolo: Campo Santo of Pisa.		Paul II has the members of the Roman Academy arrested and tortured.
1469	Death of Piero de' Medici.	Death of Filippo Lippi. Piero Pollaiuolo: decoration of the Mercatanzia. Tura and Cossa: Palazzo Schifanoia. Uccello: *Miracle of the Sacrement*. Birth of Fra Bartolomeo.	1469-74: Marsilio Ficino: *Theologia platonica*.	
1470	The Turks capture Negropont from the Venetians.	Death of Jacopo Bellini. Botticelli: *La Forza*.	*Farce de Maître Pathelin*. Commines: *Mémoires sur le Règne de Louis XI*.	

Dates	Political events	The Arts	Intellectual life The Sciences	Religion
1472		Piero della Francesca: portraits of Federigo of Urbino and his wife. Piero della Francesca: *Madonna with Federigo da Montefeltro kneeling.* Death of Michelozzo Michelozzi.	Use of Arabic figures for numbering book pages.	
1473	The Venetians try to establish a protectorate over Cyprus.	Crivelli: reredos for Ascoli Cathedral.	Birth of Copernicus.	
1474	Sixtus IV wins back Umbria.	Death of Squarcione. Between 1474 and 1484: death of Vivarini.	Marsilio Ficino: *De Christiana Religione.* Birth of Ariosto.	The Pazzi become the bankers of the Church instead of the Medici. Reform of the Abbey of Fontevrault.
1475		Antonio Pollaiuolo: *St Sebastian.* Death of Uccello. Antonello da Messina: *Il Condottiere.* Ghirlandaio: frescoes at San Gimignano. Birth of Michelangelo.	Sixtus IV opens the Vatican Library to the public.	
1477	The Pazzi's Plot. Lodovico il Moro revolts in Genoa.	Death of Francesco Cossa. Melozzo da Forlì: *Sixtus IV appointing Platina Librarian.* Botticelli: *Primavera.* Birth of Sodoma. Birth of Titian.		Sixtus IV puts Florence under an interdict.
1479	Revolt in Milan; Lodovico il Moro seizes power. Venice negotiates with the Turks. They grant them part of Albania.	Death of Antonello da Messina.	Mobile cannon lead way to development of small guns.	

Dates	Political events	The Arts	Intellectual life The Sciences	Religion
1480	Turks at Otranto.	Ghirlandaio: frescoes at Ognisanti. Signorelli: decoration of chapel at Loreto. Melozzo da Forlì: first frescoes in Sistine Chapel.		Reconciliation of Sixtus IV and the Medici.
1482	1482-84: Venice at war with the rest of Italy.	1482-87: Filippino Lippi: decoration of Brancacci chapel.	Diogo Cam discovers the mouth of the Congo.	
1483	Venice asks Charles VIII of France to invade Italy.	Birth of Raphael.		Birth of Luther.
1485	Innocent VIII supports revolt against Ferrante of Naples.	Melozzo da Forlì: frescoes in chapel at Loreto. Ghirlandaio: starts frescoes at Sta Trinita and Sta Maria Novella.	110 printing works in Europe (50 in Italy, 30 in Germany, 9 in France, 8 in Holland, 5 in Switzerland, 4 in England, 2 in Bohemia, 1 in Poland).	
1486		Botticelli: *Birth of Venus.* Birth of Andrea del Sarto.	Pico della Mirandola draws up his questionnaire.	Peace between the Pope and Naples. 1486-98: Savonarola preaching in Florence.
1487		Crivelli: *Handing the Keys to St Peter.* Filippino Lippi: *The Vision of St Bernard.*	Pico della Mirandola condemned by the Pope.	*Malleus Maleficarum,* handbook of how to deal with witchcraft first published.
1488		Death of Verrocchio. Filippino Lippi: frescoes in Sta Maria sopra Minerva.		
1489	Venice occupies Cyprus.		Pico della Mirandola: *Heptaplus.*	Savonarola prior of San Marco, Florence.
1490		1490-96: Carpaccio: cycle of *St Ursula.* Crivelli: *Madonna della Candeletta.* Mantegna: *Triumph of Julius Caesar.*	Lefevre d'Etaples: *Introduction à la Métaphysique d'Aristote.*	

Dates	Political events	The Arts	Intellectual life The Sciences	Religion
1492	Death of Lorenzo the Magnificent.	Death of Piero della Francesca. Pinturicchio: decorates the private apartments of Alexander VI.	Birth of Aretino. Christopher Columbus crosses the Atlantic and lands in Cuba, discovering America.	Death of Innocent VIII. Alexander VI Borgia.
1493		Perugino: Uffizi *Madonna*. Perugino: *Virgin enthroned*. Vienna Museum.	Treaty of Torde-sillas: New World divided between Spain and Portugal. Columbus returns.	
1494	Death of Ferrante of Naples. Alfonso succeeds him. Charles VIII of France in Italy. Lodovico il Moro, Duke of Milan. Fall of the Medici in Florence. Charles VIII in Rome.	Death of Ghirlandaio. Death of Melozzo da Forlì. Birth of Corregio.	Birth of Rabelais. Luca Pacioli's book of arithmetic.	
1495	Charles VIII takes Naples.	Death of Cosimo Tura. Botticelli: *Calumny*.	Aristotle's works appear in Greek in Venice.	
1496		Death of Ercole Roberti. Gentile Bellini: *Procession of the Relic of the True Cross*. Filippino Lippi: *Adoration of the Magi*.	Birth of Clément Marot.	
1497		Death of Benozzo Gozzoli. Signorelli: decoration of monastery of Monte Oliveto Maggiore.	Start of Vasco da Gama's expedition. John Cabot discovers Newfoundland.	Birth of Melanchthon. Savonarola excommunicated.
1498	Death of Charles VIII. Louis XII.	Death of Fra Diamante. Death of Antonio Pollaiuolo.	Vasco da Gama discovers the sea route to the Indies.	Savonarola burnt in Florence.
1499	Louis XII forms alliance with Venice and Florence. Louis XII in Italy. Milan and Genoa taken.	Death of Baldovinetti. Perugino: frescoes in the Cambio in Perugia. Signorelli: decoration of Orvieto Cathedral.	Amerigo Vespucci and Hojeda discover the coast of South America.	

Dates	Political events	The Arts	Intellectual life The Sciences	Religion
1500	Lodovico captured at Novara. Cesare Borgia Duke of Romagna.	Botticelli: *Nativity*. Filippino Lippi: frescoes Sta Maria Novella.	Vasco da Gama returns to Portugal. Cortereal in Labrador and Cabral in Brazil. Slave trade starts.	
1501		Pinturicchio: frescoes Sta Maria Maggiore, Spello. Mantegna: *Wisdom conquering the Vices: Parnassus*.		
1502		Carpaccio: *St George and the Dragon*. Giovanni Bellini: *Portrait of the Doge Loredano*.		
1503		Leonardo da Vinci: *Mona Lisa*.	Albuquerque in the Indies.	Death of Alexander VI. Pius III, then Julius II, succeed him.
1504	The French lose Naples.	Death of Berruguete. 1504-08: Carpaccio: *Life of the Virgin*. Pinturicchio: frescoes in Siena Cathedral. Death of Filippino Lippi.	Erasmus: *Enchiridion*	
1505		Giovanni Bellini: *Sacra Conversazione*. Raphael: *Madonna del Granduca*.		Martin Luther takes monastic vows.
1506		Death of Mantegna.		
1507	Genoese revolt against the French.	Death of Gentile Bellini. Death of Cosimo Rosselli.	Leonardo da Vinci: notes on painting.	Luther ordained priest.
1510		Death of Botticelli. Carpaccio: *The Courtesans*.	Peter Henlein invents the pocket watch.	Julius II lifts the excommunication on Venice and pronounces against Louis XII. Louis XII and the Emperor Maximilian decide to call a council at Pisa. Luther in Rome.

Dates	Political events	The Arts	Intellectual life The Sciences	Religion
1513	The French recapture Milan. Battle of Novara.	Death of Pinturicchio.	Reuchlin condemned by the Inquisition.	Louis XII disowns the Council of Milan. Leo X succeeds Julius II.
1515	François I becomes King of France. François I in Italy: battle of Marignano.	Giovanni Bellini: *St Theodore of Urbino*. Leonardo da Vinci in France.	Erasmus: *St Jerome*.	
1516		Death of Giovanni Bellini.	Pomponazzi: *Tractatus de Immortalitate Animae*. Machiavelli: *The Prince*. Thomas More: *Utopia*. Ariosto: *Orlando Furioso*.	
1521	Sforza retakes Milan.	Death of Piero di Cosimo.	Machiavelli: *Dialogues on the Art of War*.	Luther excommunicated. Death of Leo X. Melanchthon establishes Protestant dogma.
1523		Death of Signorelli.		Death of Adrian VI, Clement VII succeeds him. Luther: *On temporal authority*.
1524	La Trémoille recaptures Milan.	Death of Perugino. Birth of Palestrina.	Birth of Ronsard. Birth of Palestrina.	Luther: *Letters to the Princes of Saxony*.
1526	League of Cognac against the Italian States.	Death of Carpaccio. Sodoma: *Descent into Limbo*. Titian: *The Pesaro Altar*. Andrea del Sarto: *The Last Supper*.	New Guinea discovered by the Portuguese sailor Menezès.	Foundation of the Capuchin order. Organisation of the Lutheran church. Ignatius de Loyola: *Spiritual exercises*.

131

Museography

Name	Town	Museum	Title	Year	Type	Size (cm)
Antonello da Messina (ca. 1430–ca. 1479)	Antwerp	Musée royal	*Calvary*	1475	Wood	52.5 × 42.5
	Berlin	Kaiser-Friedrich-Museum	Portrait of a young man		Wood	36 × 27
	Cefalù	Museo	Head of a man		Wood	37 × 28
	London	National Gallery	*St Jerome*		Wood	45 × 36
	London	National Gallery	Supposed self-portrait		Wood	35.5 × 25.5
	Messina	Museo	*Calvary*		Wood	59 × 42.5
	Paris	Louvre	Portrait of a man: *Il Condottiere*	1475	Canvas	35 × 38
	Pavia	Museo	Head of a man		Wood	36 × 28
	Rome	Borghese Gallery	Head of a man		Wood	36 × 28
	Turin	Museo	Head of a man	1476	Wood	36.5 × 28
Bellini, Gentile (1429-1507)	Berlin	Kaiser-Friedrich-Museum	*Madonna with Donors*		Wood	85 × 75
	Milan	Brera Museum	*St Mark preaching in Alexandria*	1504	Canvas	361 × 742
	Venice	Accademia	*Lorenzo Giustiniani*	1465	Canvas	221 × 155
	Venice	Accademia	*Procession of the Relic of the True Cross*	1496	Canvas	362 × 743
	Venice	Accademia	*Miracle of the Holy Cross*	1500	Canvas	362 × 740
	Venice	Correr Museum	Portrait of a Doge		Wood	35 × 25
	Venice	Layard Collection	Portrait of Mahomet II	1479		
	Venice	San Marco	Decoration of organ doors (St Mark, St Theodore, St Jerome, St Francis)	*About* 1464		
Bellini, Giovanni (1426-1516)	Berlin	Kaiser-Friedrich-Museum	*Resurrection*	*About* 1470	Wood	148 × 128
	Florence	Uffizi	Christian Allegory	1480-1490	Wood	73 × 118
	London	National Gallery	*Agony in the Garden*	1465-1470	Wood	81 × 127 81 × 127
	London	National Gallery	*The Blood of the Redeemer*	*About* 1470	Wood	45 × 37

Name	Town	Museum	Title	Year	Type	Size (cm)
	London	National Gallery	St Jerome	*About* 1470	Wood	46 × 33
	London	National Gallery	*The Doge Loredano*	*About* 1502	Wood	61 × 44
	London	National Gallery	*St Theodore of Urbino*	1515 1502	Wood	61 × 48
	London	National Gallery	*St Theodore of Urbino*	1515	Wood	61 × 48
	Murano	St Peter Martyr	*St Peter Martyr*		Wood	200 × 320
	Naples	Museo	*Transfiguration*	*About* 1470	Wood	115 × 151.5
	Venice	Correr Museum	*Transfiguration*		Wood	134 × 88
	Venice	Accademia	*Virgin with Child*		Wood	77 × 60
	Venice	Accademia	*Pietà*		Wood	65 × 87
	Venice	Accademia	Allegories		Wood	34 × 32 43 × 22 34 × 22 32 × 22
	Venice	San Zacharia	*Sacra Conversazione*	1505	Wood	471 × 258
	Washington	National Gallery of Art	*Feast of Bacchus*	1514	Canvas	170 × 188
Bellini, Jacopo (1400-70)	London	British Museum	Album		Drawings	
	Paris	Louvre	Album		Drawings	
Botticelli, Sandro (1444-1510)	Florence	Uffizi	*Allegory of strength*	1470	Wood	163 × 85
	Florence	Uffizi	*Holofernes*		Wood	27 × 20
	Florence	Uffizi	*Virgin of the Magnificat*		Wood	111 diameter
	Florence	Uffizi	*Judith*	Betw. 1470- 1474	Wood	28 × 21
	Florence	Uffizi	*Adoration of the Magi*		Wood	111 × 134
	Florence	Uffizi	*Birth of Venus*	*About* 1486	Canvas	175 × 278
	Florence	Uffizi	*Pallas and the Centaur*		Canvas	239 × 147
	Florence	Uffizi	*Calumny*	*About* 1495	Wood	62 × 91

Name	Town	Museum	Title	Year	Type	Size (cm)
	Florence	Accademia	*Primavera*	1477-1478	Wood	203 × 314
	Florence	Accademia	*Coronation of the Virgin*	1491-1498	Wood	372 × 243
	London	National Gallery	*Nativity*	1500	Canvas	93 × 75
	Milan	Poldi-Pezzoli Museum	*Entombment*			
	Munich	Pinakothek	*Entombment*		Wood	132 × 211
	Paris	Louvre	*Lorenzo Tornabuoni before the Seven Liberal Arts*	1486	Fresco	
	Paris	Louvre	*His fiancée receiving the homage of Venus and the Three Graces*	1468	Fresco	
	Rome	Sistine Chapel	*Cleaning of the Leper and the Temptation*		Fresco	
	Rome	Sistine Chapel	Scenes from the life of Moses		Fresco	
	Rome	Sistine Chapel	*Punishment of Korah, Dathon and Abiram*		Fresco	
Carpaccio, Vittore (*about* 1455-1526)	Venice	Accademia	*Legend of St Ursula*	1490-1496	Canvases	
	Venice	Accademia	*Life of the Virgin*	1504-1508	Canvas	
	Venice	Accademia	*Story of St Stephen*	After 1511		
	Venice	Accademia	*St George and the Dragon*	1502		
	Venice	Scuola di San Giorgio	*St Tryphon saving the Emperor's daughter*			
	Venice	Scuola di San Giorgio	*St Jerome in his study*	1502	Canvas	
	Venice	Accademia	*The Martyrdom of Ten Thousand on Mount Ararat*			
	Venice	Correr	*The Courtesans*	*About* 1500	Wood	164 × 194
Castagno, Andrea del (1423-57)	Florence	Sant'Apollonia	*The Last Supper* *The Passion*		Frescoes	
	Florence	Sant'Apollonia	*Famous Men and Women*	*About* 1451	Frescoes	

Name	Town	Museum	Title	Year	Type	Size (cm)
Cossa, Francesco (1438-1477)	Berlin	Kaiser-Friedrich-Museum	*Autumn*		Wood	43 × 105
	Bologna	Pinacoteca	*Madonna*		Wood	190 × 109
	London	National Gallery	*St Vincent Ferrer*			
	Milan	Brera Museum	*St Peter*		Wood	112 × 55
Costa, Lorenzo (1460-1535)	Bologna	San Giacomo Maggiore	*Triumphs of Love and Death*		Frescoes	
Crivelli, Carlo (betw. 1435-40 and after 1493)	Ascoli	Cathedral	*Virgin and Saints*	1473	Wood	300 × 275
	Berlin	Kaiser-Friedrich-Museum	*Handing the Keys to St Peter*	1487	Wood	191 × 196
	Detroit	Museum	*Pietà*			
	London	National Gallery	*Virgin* (Ancona)		Wood	482 × 315
	London	National Gallery	*Annunciation*	1486	Wood	207 × 146
	London	National Gallery	*Virgin between St Jerome and St Sebastian*		Wood	149 × 107
	Massa Fermana	Museo	*Virgin and Saints*	1468	Wood	105 × 44 (central panel)
	Milan	Brera Museum	*Madonna*	1482	Wood	218 × 220
	Milan	Brera Museum	*Pietà*		Wood	250 × 150
	Milan	Brera Museum	*Madonna della Candeletta*	About 1490	Wood	218 × 75
	Milan	Brera Museum	*Crucifixion*		Wood	218 × 74
	Milan	Brera Museum	*Virgin and Child*		Wood	219 × 75
	Milan	Brera Museum	*St Anthony*		Wood	24 × 59
	Milan	Brera Museum	*St Jerome*		Wood	24 × 59
	Milan	Brera Museum	*St Andrew*		Wood	24 × 59
	Vatican	Museo	*Madonna*		Wood	135 × 32
	Vatican	Museo	*Madonna*		Wood	135 × 32

Name	Town	Museum	Title	Year	Type	Size (cm)
	Vatican	Museo	*Pietà*		Wood	106 × 203
	Verona	Civic Museum	*Virgin with Child*	*About* 1463	Wood	135 × 32
Ghirlandaio, Domenico (1449-1494)	Florence	Ognisanti	*St Jerome, meditating*	1480	Fresco	
	Florence	Ognisanti	*Last Supper*	1480	Fresco	
	Florence	Palazzo Vecchio	*St Zenobius with heroes of antiquity*	1482-1484	Fresco	
	Florence	Sta Trinita	*Life of St Francis of Assisi*	From 1485	Fresco	
	Florence	Sta Maria Novella	*Life of the Virgin*	From 1485	Fresco	
	Florence	Sta Maria Novella	*Life of St John the Baptist*	From 1485	Fresco	
	Florence	Accademia	*Adoration of the Shepherds*	1485	Wood	167 × 169
	Florence	Innocenti	*Adoration of the Magi*	1488	Wood	
	Paris	Louvre	Portrait of an old man and his grandson	*About* 1480	Canvas	62 × 46
	Rome	Sistine Chapel	*Calling of the Apostles*	1481	Fresco	
	San Gim-ignano	Collegiate Church	*Story of Santa Fina*	1475	Fresco	
Gozzoli, Benozzo (1420-1497)	Florence	Palazzo Riccardi	*Procession of the Magi*	From 1459	Fresco	
	Monte-falco	S. Francesco	*Life of St Francis*	1450-1452	Fresco	
	Pisa	Campo Santo	*Stories from the Old Testament*	1468-1485	Fresco	
	San Gim-ignano	San Agostino	*Life of St Augustine*		Fresco	
	Paris	Louvre	*Triumph of St Thomas Aquinas*		Wood	227 × 102
	Vatican	Pinacoteca	*Madonna with the Girdle*		Wood	100 × 150
		Private collection	*Miracle of St Zenobius*		Wood	24 × 34
Lippi, Filippo (1406-1469)	Berlin	Kaiser-Friedrich-Museum	*Adoration of Jesus by Mary*		Wood	83 × 77
	Chantilly	Musée Condé	*Virgin between St Peter and St Anthony*		Wood	20 × 16

Name	Town	Museum	Title	Year	Type	Size (cm)
	Florence	Uffizi	*Coronation of the Virgin*	1447	Wood	200 × 287
	Florence	Uffizi	*Virgin with Child*		Wood	83 × 77
	Florence	Uffizi	*The Camaldoli Virgin*		Wood	108 × 78
	Lugano	Thyssen Collection	*Madonna enthroned*		Wood	105 × 62
	Munich	Pinakothek	*Virgin with Child*	*About* 1460	Wood	76 × 54
	Prato	Cathedral	*Life of St John the Baptist*	From 1452	Fresco	
	Prato	Cathedral	*Life of St Stephen*	From 1452	Fresco	
	Rome	Museo d'arte antica	*Annunciation*		Wood	153.5 × 143
	Spoleto	Cathedral	*Life of the Virgin*	From 1467-1469	Fresco	
Lippi, Filippino (1457-1504)	Florence	Uffizi	*Madonna with Saints*	1486		
	Florence	Uffizi	*Adoration of the Magi*	1496		
	Florence	Badia	*Vision of St Bernard*	1487	Wood	152 × 137
	Florence	Brancacci Chapel	*St Peter and St Paul before Nero; Crucifixion of St Peter; St Paul visiting St Peter in Prison; The Angel delivering St Peter*	1482-1487	Fresco	
	Florence	Sta Maria Novella	Episodes from the life of St John the Evangelist and St Philip	1500-1502	Fresco	
	Rome	Sta Maria sopra Minerva	*Life of St Thomas Aquinas*	From 1488	Fresco	
Mantegna, Andrea (1431-1506)	Berlin	Kaiser-Friedrich-Museum	Portrait of Cardinal Lodovico Mezzarota	*About* 1460	Wood	44 × 33
	Florence	Uffizi	*Adoration of the Magi*		Wood	76 × 76.5
			Resurrection		Wood	86 × 42.5
			Circumcision		Wood	86 × 42.5
	Hampton Court		*Triumph of Julius Caesar*		Canvas	270 × 300

Name	Town	Museum	Title	Year	Type	Size (cm)
	Madrid	Prado	*Death of the Virgin*		Wood	54 × 42
	Mantua	Castello Vecchio	Camera degli Sposi: decoration	Finished 1474	Fresco	
	Milan	Brera Museum	*Lamentation over the Dead Christ*		Canvas	66 × 81
	Milan	Brera Museum	*St Luke with Saints*	1453	Wood	178 × 227
	Naples	Museum	*St Euphemia*	1453	Canvas	171 × 78
	Padua	Ovetari Chapel	*Baptism of Herm- ogenes; St James before the Emperor; St James going to execution; The death of St James; The death of St Christopher; The carrying off of St Christopher's body*	1454- 1459	Fresco	
	Paris	Louvre	*Crucifixion*	1459	Wood	66 × 90
	Paris	Louvre	*St Sebastian*	*About* 1475- 1480	Canvas	257 × 142
	Paris	Louvre	*Wisdom overcoming the Vices*	1501	Canvas	160 × 192
	Paris	Louvre	*Parnassus*	1501	Canvas	160 × 192
	Tours	Musée	*Agony in the Garden*	1459	Wood	66 × 88
	Tours	Musée	*Resurrection*	1459	Wood	66 × 88
Masaccio (1401-1428)	Florence	Uffizi	*St Anne, Virgin and Child*	1423	Wood	175 × 103
	Florence	Carmine	*Expulsion; The Tribute Money; St Peter and St Paul curing the Sick with Their Shadows; St Peter distributing Alms; Resurrection of Theophilus' Son*	1426- 1427	Fresco	
	London	National Gallery	*Virgin with Child*	1426	Wood	104 × 53
	Naples	Museo	*Crucifixion*		Wood	77 × 64
	New York	Duveen Collection	*Virgin of Humility*	1425	Wood	102 × 52
Masolino da Panicale (1383-1440)	Castiglione d'Olona	Baptistery	Stories of St Stephen, St Lawrence, St John the Baptist	*About* 1435	Fresco	

Name	Town	Museum	Title	Year	Type	Size (cm)
	Florence	Carmine	*The Curing of the Cripple; Raising of Tabitha; Original Sin*	1423-1426	Fresco	
Melozzo da Forlì (1438-1494)	Forlì	Museo	The *Pestapepe*		Fresco	
	Loreto	Chapel of Church of Santa Casa	Decoration of ceiling: prophets, angels, cherubim	1485	Fresco	
	Rome	Vatican Museum	*Platina appointed Librarian*	1477	Fresco transferred to canvas	370 × 315
	Rome	Quirinal	*The Ascension*	About 1480	Fresco	
	Rome	Sacristy, St Peter's	*Angel Musicians*	About 1480	Fresco	
	Rome	Sacristy, St Peter's	Heads of apostles	About 1480	Fresco	
Perugino (1450-1524)	Florence	Sta Maria Maddalena dei Pazzi	*Christ crucified surrounded by Saints*		Wood	166 × 272
	Florence	Pitti	*Pietà*	1493-1494	Wood	168 × 172
	Florence	Uffizi	*Madonna*	1493	Wood	485 × 239
	London	National Gallery	Altar-piece from Charterhouse, Pavia	1499	Wood	130 × 65
	London	National Gallery	*Madonna with St John*	1490	Wood	67 × 45
	London	National Gallery	*Madonna with Two Saints*	1507	Wood	180 × 124
	London	National Gallery	*Adoration of the Shepherds*	1523	Fresco	245 × 790
	Munich	Pinakothek	*Vision of St Bernard*	1495-1496	Wood	175 × 165
	Paris	Louvre	*Martyrdom of St Sebastian*	1494-1495	Wood	160 × 185
	Paris	Louvre	*Struggle between Love and Chastity*	1505	Wood	156 × 192
	Paris	Louvre	*Madonna between Two Saints and Two Angels*	1494	Wood	80 × 66
	Perugia	Cambio	*Transfiguration; Adoration of the Shepherds:* allegorical figures of virtues and heroes of antiquity	1499	Fresco	
	Rome	Sistine Chapel	*Handing the Keys to St Peter*	1480	Fresco	

Name	Town	Museum	Title	Year	Type	Size (cm)
	Vienna	Museum	Madonna enthroned	1493	Wood	186 × 144
	Vienna	Museum	Madonna, half-length		Wood	85 × 67
Piero della Francesca (1410-20) to 1492)	Arezzo	S. Francesco	*Story of the Cross*	1452-1460	Fresco	
	Borgo San Sepolcro	Museo	*Madonna della Misericordia*	1445	Wood	134 × 90
	Borgo San Sepolcro	Museo	Resurrection		Fresco	225 × 200
	Florence	Uffizi	Portrait of Federigo da Montefeltro	After 1472	Wood	47 × 33
	Florence	Uffizi	Portrait of Baptista Sforza	After 1472	Wood	47 × 33
	London	National Gallery	*Nativity*		Wood	126 × 123
	London	National Gallery	*Baptism of Christ*			
	Milan	Brera	Altar-piece of Madonna and Federigo da Montefeltro praying	1472	Wood	248 × 150
	Rimini	S. Francesco	*Sigismond Malatesta*		Fresco	
	Urbino	Museo	*Flagellation*		Wood	81 × 58
	Venice	Accademia	*St Jerome*	Wood	Wood	49 × 42
Piero di Cosimo (1462-1521)	Berlin	Kaiser-Friedrich-Museum	*Mars, Venus and Cupid*			
	Chantilly	Musée Condé	Portrait of Simonetta Vespucci			
	Florence	Uffizi	*Conception of the Virgin*			
	Florence	Uffizi	*Sacrifice to Jupiter for Andromeda's Safe Deliverance*			
	Florence	Uffizi	*Perseus delivering Andromeda*			
	Florence	Uffizi	*Marriage of Perseus and Andromeda*			
	London	National Gallery	*Death of Procris*			
	Rome	Sistine Chapel	*Destruction of Pharaoh's armies crossing the Red Sea*	1482		

Name	Town	Museum	Title	Year	Type	Size (cm)
Pinturicchio (1454-1513)	Dresden	Museum	Portrait of a young man	1490	Wood	35 × 28
	London	National Gallery	*Return of Ulysses*	1507-1508	Fresco	
	Perugia	Museo	*Virgin and St John, St Augustine, St Jerome, etc.*	1496	Wood	249 × 150
	Rome	Vatican	Decoration of the apartments of Alexander VI	1492 on-wards	Fresco	
	Rome	Sistine Chapel	*Moses' Journey in Egypt; The Baptism of Christ* (with Perugino)	1484	Fresco	
	Rome	Sta Maria Aracoeli	*Life of St Bernardino*		Fresco	
	San Gim-ignano	Palazzo communale	*Virgin in Glory*		Wood	280 × 187
	Siena	Cathedral	Life of Pius II	From 1504	Fresco	
	Spello	Collegiate church of Sta Maria Maggiore	*The Annunciation; The Adoration of the Shepherds and the Magi; Jesus amongst the Doctors; Sybils*	From 1501	Fresco	
	Spello	St Andrea	*Virgin with Saints*	1507	Wood	285 × 189
Pisanello, Vittore (1397-1450)	Bergamo	Accademia Carrara	Portrait of Leonello d'Este			
	London	National Gallery	St Jerome			
	London	National Gallery	*The Virgin with St Anthony and St George*			
	London	National Gallery	*St Eustace*			
	Paris	Louvre	Portrait of Ginevra d'Este			
	Verona	Sant' Anastasia	*St George taking leave of the Princess of Trebizond*		Fresco	
Pollaiuolo, Antonio (1432-1498)	Berlin	Kaiser-Friedrich-Museum	*Annunciation* (with Piero)		Wood	150 × 174
	Berlin	Kaiser-Friedrich-Museum	*David*		Wood	96 × 34

Name	Town	Museum	Title	Year	Type	Size (cm)
	Florence	Uffizi	*Hercules fighting the Hydra*		Wood	15.5 × 9.5
	Florence	Uffizi	*Hercules and Antaeus*		Wood	15.5 × 95
	Florence	Uffizi	*Three Saints* (with Piero)		Wood	
	London	National Gallery	*St Sebastian*	1475	Wood	285 × 198
	Turin	Museo	*Tobias and the Angel* (with Piero)		Wood	187 × 118
Pollaiuolo, Piero (1443-1496)	Florence	Merca-tanzia	*Faith, Prudence, Charity, etc.*	1469-1470	Wood	
	San Gim-ignano	Collegiate Church	*Coronation of the Virgin*	1483	Wood	
Signorelli, Luca (*About* 1441-1523)	Borgo San Sepulcro	Museo	*Christ crucified*		Canvas	190 × 135
	Cortone	Museo	*Institution of the Eucharist*	1512	Wood	290 × 290
	Florence	Uffizi	*Madonna*			
	London	National Gallery	*Circumcision*		Wood	255 × 177
	Loreto	Chapel of Church of Santa Casa	*Calling of St Peter; Incredulity of St Thomas; Conversion of St Paul*	*About* 1480	Fresco	
	Milan	Brera	*Flagellation*		Wood	80 × 60
	Monte Oliveto	Monastery	*Life of St Benedict*	After 1497	Fresco	
	Orvieto	Cathedral	*Last Judgement; Signs of the End of the World; Preaching of Antichrist; Resurrection of the Flesh; Hell*	After 1499	Fresco	
	Perugia	Cathedral	*Madonna with Saints*	1484		200 × 183
Squarcione, Francesco (1394-1474)	Berlin	Kaiser-Friedrich-Museum	*Madonna*			
	Padua	Museo	*Glorification of St Jerome*			
Tura, Cosimo (1432-95)	Berlin	Kaiser-Friedrich-Museum	*Virgin in Glory*			
	Ferrara	Cathedral	*Organ panels; St George; The Annunciation*	1468	Fresco	

Name	Town	Museum	Title	Year	Type	Size (cm)
	Ferrara	Palazzo Schifanoia	Fresco decoration with help of Francesco Cossa	1469-1470		
	London	National Gallery	*Virgin enthroned*		Wood	239 × 102
	London	National Gallery	*Primavera*		Wood	116 × 71
	Paris	Louvre	*Pietà*		Wood	132 × 267
	Rome	Galeria Colonna	*Bishop Lorenzo Roverella protected by St Maurello and St Paul*		Wood	101 × 57
Uccello, Paolo (1397-1475)	Florence	Cathedral	Equestrian portrait of Sir John Hawkwood	1436		
	Florence	Sta Maria Novella	*Creation*	1431	Fresco	
	Florence	Sta Maria Novella	*The Flood*	1445	Fresco	
	Florence	San Miniato	*Desert Fathers*		Fresco	
	Florence	Uffizi	*Battle of San Romano*	1456-1457	Wood	182 × 323
	London	National Gallery	*Battle of San Romano*	1456-1457	Wood	182 × 317
	Oxford	Ashmolean Museum	*The Hunt*		Wood	65 × 165
	Paris	Musée Jacquemart-André	*St George and the Dragon*	*About* 1440	Wood	52 × 90
	Paris	Louvre	*Uccello, Giotto, Donatello, Manetti, Brunelleschi*		Wood	43 × 210
	Paris	Louvre	*Battle of San Romano*	1456-1457	Wood	180 × 316
	Urbino	Museo	*Miracle of the Sacrament*	1469	Wood	32 × 342
	Vienna	Lanckoronski Collection	*St George and the Dragon*	*About* 1440	Wood	57 × 73
Veneziano, Domenico (*about* 1400-1461)	Berlin	Kaiser-Friedrich-Museum	*Adoration of the Magi*		Wood	84 in diameter
	Florence	Uffizi	*Sacra Conversazione*	Between 1445-1448	Wood	209 × 213
Verrochio, Andrea del (1435-1488)	Florence	Uffizi	*Baptism of Christ* (with Leonardo da Vinci)		Wood	115 × 80
	Pistoia	Duomo	*Madonna*		Wood	58 × 74

Dictionary

Fra Angelico
Annunciation
Madrid, Prado

Antonello da Messina
Portrait of an Unknown Man
Pavia, Galleria Malaspina

Angelico, Fra (Giovanni da Fiesole)

Known as Fra Beato or Fra Giovanni. Born at Vicchio, Tuscany, in 1387; died in 1455. Little is known of his childhood, but Vasari says that his talent showed itself at an early age. When he took his vows at the age of twenty, he was already known as a painter. He began by painting miniatures under the guidance of a Dominican friar in his monastery. His gentle mysticism brought him the nickname of "Angelico". His order fled to a brother foundation in Fiesole to escape the disorder current in Italy and from 1418 onwards he was occupied with a series of paintings in fresco or distemper. He had taught himself this technique by studying the work of Giotto. Then in 1436 he started work on the decoration of the Convent of San Marco in Florence and also undertook a number of commissions for Cosimo de' Medici in the SS. Annunziata; next, he was invited to Rome by the Pope and was asked to decorate the papal chapel in the Vatican. He painted scenes from the lives of St Stephen and St Lawrence, but these are now in a poor state of preservation. In 1447, Pope Nicholas V asked him to undertake the decoration of a chapel in Orvieto Cathedral and in return wanted to make him a bishop. Fra Angelico, who was a man of great humility as well as a great painter, begged the Pope to appoint instead one of his brothers in religion better able to fulfil such a heavy charge. He started work on the dome, but it was Signorelli who completed the Orvieto frescoes. The title of "magister magistrum" indicates with certainty that Fra Angelico supervised the work involved in the project. He returned to Rome to finish the decoration of the chapel of Pope Eugenius IV. He died there in 1445 and was buried in Santa Maria sopra Minerva.

Antonello, Antonio di Salvadore

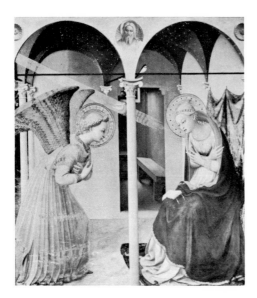

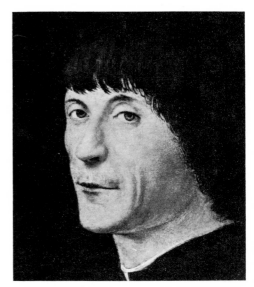

Known as Antonello da Messina. Born about 1430, died in 1479 (?)

The son of a sculptor, he completed his studies in Naples, where he may have studied the new techniques in oil painting which were being used by Flemish artists. Most of his life was spent in Sicily and Southern Italy, though he may have visited Rome. But in 1475 and 1476 he worked in Venice, where he was much in demand as a portrait painter. Antonello was a generous artist and never sought to conceal the secrets of his skill. On the contrary, he was glad to share with all who were interested in the special techniques of Flemish art.

Apartments of Alexander VI in the Vatican

When Rodrigo Borgia became Pope as Alexander VI in 1492, he commissioned Pinturicchio to carry out the decoration of his private apartments in the Vatican. Apart from the Sala dei Pontifici which was to be rebuilt in 1500 after a structural collapse and repainted by Giovanni da Udine and Perino del Vaga, the other five rooms are still as Pinturicchio painted them and are in a perfect state of preservation. The rooms are decorated on the following themes: I. the Virgin and Christ; II. the lives of the saints; III. the liberal arts and the sciences; IV. the Creed; V. the Sybils. In the first room, the artist portrayed Alexander VI with brilliant intensity, kneeling, hands joined in prayer, at the foot of the tomb of the Risen Christ. But the Pope's true nature is brilliantly conveyed—the sloping forehead, the small, cruel eyes, the sensual mouth. In the second room, the finest of the five, the artist gave full rein to his fine pictorial skill and his vivid imagination. The saints he chose to depict include Saints Catherine, Susanna and Barbara. The vaulted roof is decorated with the myth of Isis and Osiris, the triumphal procession of the bull, Apis, and the legend of Io, turned into a heifer by her lover Jupiter. The two latter objects were an allusion to the heraldic device of the Borgias, a bull. It was Pinturicchio's custom to work with a number of assistants and it is not difficult to pick out some unevenness of execution and certain differences of technique. The unity of the work, however, is evident throughout; everything was carefully planned by the master himself. In payment, Pinturicchio was given a twenty-nine-year lease of two plots of land in Perugia, his annual rental being a mere three pounds of white wax.

Baldovinetti, Alesso (1425-1499)

Probably born in Florence. Painter, worker in mosaic and stained glass. Baldovinetti started his painting career in 1448.

It is probable that he took part in the decoration of the churches of Sant' Edigio and Santa Maria Novella where Domenico Veneziano (1439-45) and Castagno (1451) were working. He completed the work left unfinished by Domenico Veneziano: a painting of the Virgin Mary for the main altar. In 1454, Castagno employed him to paint a picture of Hell for the Servites.

Between 1460 and 1462 Baldovinetti painted a *Nativity* for the church of the Santissima Annunziata and some frescoes for the chapel of the Cardinal of Portugal at San Miniato (1446-73), as well as an altar-piece for the sacramental reliquary at Sant'Ambrogio.

Only a few fragments remain of the frescoes he painted on the chapel roof in the Santa Trinita.

He was a man of learning and founded a school of painting. Ghirlandaio, Verrochio and Pollaiuolo were his principal pupils.

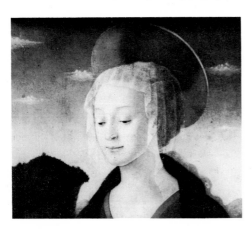

Most of Baldovinetti's painting had a short life on account of his constant experimentation with new chemical compounds for his colours.

Battle of San Romano

This battle took place in 1432. Under the command of Niccolo Maurucci da Tolentino, the Florentine forces defeated the Sienese army which had been devastating the land around Florence under their general Bernardino della Carda, a soldier of fortune who had previously been in the pay of Florence before passing to Siena by way of the Duke of Milan. Uccello's three paintings hung in a room in one of the Medici palaces. They depict the three main events of the battle. The panel now in the National Gallery, London, hung on the left; it shows Niccolo da Tolentino directing the attack, followed by his standard-bearer and a page carrying his helmet. In the centre hung the panel now in the Uffizi; in it, Bernardino della Carda is dismounted by a Florentine knight, an incident which settled the outcome of the battle. On the right hung the Louvre panel which shows Michelotto da Cotigno, another Florentine leader, attacking the Sienese rearguard and scattering them in disorder.

Bellini, Gentile (1429-1507)

Venetian school.

Eldest son of Jacopo Bellini, he was naturally much influenced by his father. He also worked in close collaboration with his brother Giovanni. In 1466, he worked at the Scuola San Marco, where his father

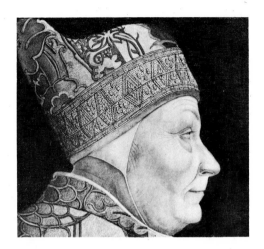

he went on to collaborate with him. In 1453 he made the acquaintance of Mantegna and spent some time in Padua. In his youth, he painted a number of Madonnas and Pietàs. He was essentially a religious painter. In 1470, he worked with his brother Gentile on the decoration of the Scuola Grande di San Marco. In 1479, he took over his brother's post as painter in charge of the restoration of the frescoes in this church; he was appointed official painter to the Signoria; his studio was one of the busiest in Venice. In 1496, he was offered a commission for a mythological picture but felt unable to meet the demands of such an innovation. Instead he painted (1504) a *Virgin with the Child Jesus, the Infant St John and St Joseph.* Faced with successful competition from Titian and Giorgione, he altered his style. In 1505, he was visited by Dürer, who considered him one of the greatest painters of the time.

Giovanni Bellini died in 1516, leaving unfinished a *Martyrdom of St Mark at Alexandria* destined for the Scuola di San Marco. He produced only a very few paintings which were not religious in theme, amongst them a portrait of the Doge Loredano.

and Francesco Squarcione had carried out some paintings. In 1469 the Emperor Frederick gave him the ranks of knight and count palatine. In 1471, he and his brother started teaching drawing.

In 1474, he was appointed to the task of restoring the paintings in the Sala del Maggior Consiglio, originally painted by Gentile da Fabriano and Pisanello. In 1479 he was sent to Constantinople as court painter to the Sultan. There he painted the portrait of Mahomet II and a view of Venice. Honours were heaped upon him and he returned to Venice a year later. He painted portraits of many of the Doges. In 1504 he was commissioned to paint a large *St Mark preaching at Alexandria* for the Scuola di San Marco. He wrote his will in 1506 and asked his brother to complete certain paintings he had left unfinished. He died in 1507.

Bellini, Giovanni (c. 1430-1516)

Venetian school.
Originally a pupil of his father, Jacopo,

Bellini, Jacopo (1400-1470)

The son of a pewterer, he became the pupil of Gentile da Fabriano when the latter came to Venice with Pisanello to paint the Sala del Maggior Consiglio of the Doge's Palace. In 1420, he and Gentile went to Florence and visited the studios of the great painters working there. He was back in Venice in 1437 and became associated with the Scuola di

149

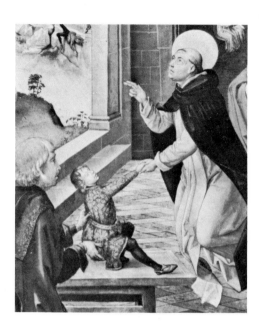

San Giovanni Evangelista. Niccolo III d'Este invited him to his court at Ferrara, where he became acquainted with humanist teachings. He was in Padua some time before 1460 and whilst there painted a reredos for the Basilica of St Anthony. During his stay, the family friendship with Mantegna ripened. Mantegna married Nicolosia Bellini, his daughter, in 1454. Most of Jacopo Bellini's paintings have now disappeared, but the Louvre and the British Museum have very fine collections of his sketchbooks. He may be counted as one of the founders of the Venetian school.

Berenson, Bernard

Art critic and historian of Lithuanian origin (born near Vilna in 1865). His work is written in English. He studied first at Boston and then at Harvard, where he worked under William James. He next took courses at the universities of Berlin and Paris and settled in Florence in 1920. His main works are *Venetian Painters of the Renaissance* (1894), *Italian Painters of the Renaissance* (1931), *Sassetta* (1946) and his autobiography (1955).

Berruguete, Pedro

Born at Paredes de Nava (Castilla la Vieja) about 1450; died in 1505.
This artist was court painter to Ferdinand and Isabella. In 1483, he settled in Toledo, but previously he had worked in Ávila, where he had painted the reredos of the high altar in the cathedral with the assistance of Santo Cruz and Juan de Borgona. Next in 1483 he worked with another artist on the frescoes of Toledo Cathedral. In 1495 he and his son-in-law Beceril painted several works for the cloister of the cathedral (all have now disappeared). The Prado has ten large paintings from the monastery of St Thomas in Ávila which are generally attributed to Berruguete. It is thought that he spent some time working at Urbino and the portrait of Federigo da Montefeltro, which forms part of the Brera altar-piece, is believed to be by him, though most of the work is by Piero della Francesca. The series of paintings in the Ducal Palace in Urbino showing twenty-eight figures of Philosophers has been attributed to Berruguete or to Joos van Gent with whom he collaborated. In Italy he was influenced by Perugino.

Borgia, Rodrigo (1431-1503)

Otherwise Pope Alexander VI, elected on the death of Innocent VIII in 1492. So

150

many romantic additions have been made to the basic historical facts in his life that it is hard to separate legend from truth. The entire Borgia family enjoyed a terrible reputation, much of it based on supposition. Alexander VI lived at a time when the prevailing moral standard was astonishingly low and in a Rome notable for the profound corruption in both its secular and ecclesiastical life. He was not especially well educated, had little interest in architecture and cared more for law than humanism; he was educated at Bologna and, thanks to the favour of his uncle Calixtus III, was made cardinal and vice-chancellor before actually taking holy orders. His income was enormous and he led the kind of life typical of the corrupt nobility of the time. He lived openly with Vanozza de Cattanei, who bore him several children, amongst them Cesare and Lucrezia, and later lived with Giulia Farnese. In 1492 he became Pope. A temporal rather than a spiritual leader, he strove to subdue the turbulent Italian nobles of the Papal States and played an important part in politics. When Charles VIII of France invaded Italy, Alexander contented himself with mere hostility, but when France lost the kingdom of Naples he came out strongly against them. Later, however, he allied himself with Charles' successor, Louis XII. In 1500 there was a great Jubilee year in Rome. Alexander tried in vain to organise a crusade against the Turks. In 1493 he had acted as arbiter in the division of the territories of the New World between Spain and Portugal. Savonarola denounced him as the worst spiritual leader in Christendom and was promptly excommunicated. In 1503, Alexander VI died of malaria.

Botticelli, Sandro (1444-1510)

His real name was Alessandro di Mariano Filipepi. Born and died in Florence. He was originally apprenticed to a goldsmith, but when he was fifteen went to work in the studio of Fra Filippo Lippi, where he seems to have stayed until about 1467. He then became a follower of Antonio Pollaiuolo, who represented all that was new and exciting in painting. The earliest authenticated work by Botticelli is dated as late as 1470: this is the *Fortezza* panel which he painted for the Mercatanzia; many other splendid paintings followed. From 1472 onwards, Botticelli was considered by his contemporaries one of the finest painters of the Florentine school. The dying Filippo Lippi asked him to undertake the education of his son Filippino. In 1480, Lorenzo the Magnificent chose him to paint the allegorical picture of *Pallas overcoming the Centaur* which symbolised the diplomatic victory of the Medicis over Naples. He painted a number of pictures, mainly Madonnas, for Giuliano de' Medici. In about 1483, he was summoned to Rome by Sixtus IV and was commissioned to paint some frescoes in the Sistine Chapel, along with Ghirlandaio and others. On his return to Florence he illustrated Dante's *Divina*

Comedia for his protector. Then in 1491 he met Savonarola and fell under his spell. He abandoned his painting and was one of those who gladly threw their works into the famous "Burning of the Vanities" in 1497. After Savonarola's tragic death, Botticelli lost heart in his work though he still went on painting. He suffered a decline in popularity and painted little towards the end of his life. In the years that followed, his pictures were more or less ignored until Ruskin "discovered" him and revealed his art to the Victorians.

Brancacci, Felice

Felice di Michele Brancacci was a man of considerable importance in Florence. He was a wealthy silk merchant, born in 1382, who filled various official positions in the Republic and undertook many confidential missions abroad. His most important embassy was his visit to the Sultan of Egypt in 1422 and he has left a full and detailed account of this. Before he left for this long and dangerous journey, he made a will which showed his close links with the Carmine church; he expressed a wish to be buried in the tomb of his ancestors and left the chapel he owned there half to his son and half to the other members of the Brancacci family. On his return from Egypt, he was honoured as highly as possible and he commissioned Masolino da Panicale to decorate his chapel in the Carmine with scenes from the life of St Peter taken from the *Acts of the Apostles* and *The Golden Legend*. When Masolino left the work uncompleted to go to Hungary early in 1426, Brancacci entrusted what remained to be done to Masaccio.

Brancacci Chapel

Masolino's frescoes:

These are to be found in three compartments on a part of the wall to the left of the altar, the upper row visible on the right on entering the chapel. First, *Original Sin* with the rather stiff figures of Adam and Eve; next, two episodes joined in one single composition: the *Curing of the Cripple* and *The Raising of Tabitha*, a somewhat Giottesque fresco with a superb Florentine décor; all the figures wear contemporary clothing.

Masaccio's frescoes:

Six of the frescoes in the chapel can be attributed to Masaccio with complete certainty: *The Expulsion, The Tribute Money, St Peter and St John curing the Sick with their Shadows, St Peter distributing Alms, The Raising of Theophilus' Son* (not fully completed).

At the entrance to the chapel on the left is the *Expulsion*, a sober and dramatic composition. The avenging angel hovers, sword in hand, in the sky above the roughly sketched gate of Paradise. He points his finger towards the desolate country where Adam and Eve must live from now onwards, a landscape of half-suggested grey rocks. The unhappy couple slowly walk away. Their differing attitudes magnificently express their suffering and anguish. It is noticeable that Eve's hands are held in approximately the same position as those of the *Venus pudica* of classical antiquity: the best known of these was the Medici Venus. However, it is probable that knowledge of the classical period influenced Masaccio only indirectly.

It is more than likely that he copied the general attitude of the figure from the statue of *Prudence* which decorated the pulpit of Pisa Cathedral, a piece of sculpture from the hands of Pisano, who did in fact copy *his* statue from a classical work (Masaccio had been in Pisa in 1426 to paint a polyptych for the Carmelite Church there). The bodies of Adam and Eve are living bodies painted with a perfect knowledge of anatomy; the use of light sets them in proper relief. They brought the nude and the beauty of the human body back into painting.

The Rendering of the Tribute Money illustrates an apocryphal miracle from the life of St Peter. Jesus is painted in the midst of his disciples asking Peter to take a drachma from the mouth of a fish to pay the customs official so that they may enter the town. The disciples in their draped togas are tremendously individualised and each depicts a particular type of human being. The sombre background of mountains and tall, slender trees gives a simple grandeur to the atmosphere of the scene. Following the custom of the time, two ancillary episodes of this legend appear on either side of the main theme: on the left, St Peter kneels at the edge of the lake to remove the obol from the fish, and on the right he gives the money to the customs official.

In the *Baptism of the Neophytes* the well-known "trembling nude" balances the figure of St Peter standing rock-like and firm in his cloak.

In *St Peter and St John curing the Sick with their Shadows* Masaccio reacts against the current ruling which gave equal value to each detail in the composition and removes from the picture every meaning-less accessory so that everything is centred on the figure of St Peter. Moreover, he introduces into this picture an element of directly-observed reality—a group of sick and crippled people in rags and tatters. He does the same in *St Peter distributing Alms*.

Filippino Lippi's frescoes:

Half a century later, Filippino Lippi finished the decoration of the chapel. He was working there between 1482 and 1487. In his largest fresco, he combined two subjects in the same way as his predecessor: *St Peter and St Paul before Nero* and *The Crucifixion of St Peter*. The two episodes are separated by a door which opens on to a landscape. Here—and in the other frescoes too—Filippino tried to restrain his natural style and follow Masaccio's as closely as he could. He borrowed Masaccio's calm disposition of figures and monumental concept of presentation together with the ample, draped garments and solemn, noble attitudes of his characters. The profile of the Emperor is taken directly from an ancient coin and among the bystanders can be seen several contemporaries—Antonio Pollaiuolo, Botticelli and Filippino himself, for instance. He put the finishing touches to the half-completed *Resurrection of the Son of Theophilus*. He added the young man who has been restored to life and who now kneels before St Peter, the group of men on the left under the porch and a few other figures. The paintings which give the most personal impression of Filippino are those on the pilasters on the right and left of the entrance: *St Paul visiting St Peter in Prison* and *The Angel*

153

delivering St Peter from Prison, where the heavenly messenger has a distinctly Botticellian look.

Brunelleschi (or Brunellesco Filippo)

Born in Florence in 1377; died there in 1446.

After refusing to follow his father in his profession of notary, Brunelleschi began studying art at an early age. He started by serving his apprenticeship to a goldsmith and in the period 1401-2 took part in the famous competition for the doors of the Baptistery in Florence. He withdrew in favour of Ghiberti who was judged of equal merit. This did not make him give up sculpture entirely and he did a superb *Christ crucified* to teach his friend Donatello a lesson. This work showed that his mind was slanted towards mathematical construction and abstraction. He and Donatello went to Rome together to study the classical remains and he spent some ten years measuring the ruins of the ancient city. His astonishing talent for assimilation brought life to the slowly degenerating Gothic style of architecture. He alone was responsible for the great new developments. He popularised the use of perspective by combining his mathematical knowledge with his artistic talent.

He was particularly eager to solve one special problem which as a Florentine was close to his heart: the completion of the dome for the cathedral Santa Maria del Fiore. This occupied him for close on thirty years and taxed not only his artistic genius but also his patience, energy, obstinacy and every bit of his skill. In spite of its deficiencies, the dome of this church became a model for thousands of others. Brunelleschi's main religious buildings are: the basilica of San Lorenzo and the adjoining sacristy, built for the Medici family, the basilica San Spirito, finished many years after his death; the Pazzi chapel, a wonder of elegance and splendour; the Badia at Fiesole, that is the interior of the church and the monastery; and the circular church of Santa Maria degli Angeli (1434).

The largest public building designed by Brunelleschi in the town of his birth is the Ospedale degli Innocenti (1421-44). Cosimo de' Medici, friend and admirer of Brunelleschi, had always longed to have a palace built to his design. Accordingly, Brunelleschi set to work and produced a plan of admirable beauty and proportion. The careful Cosimo judged it too lavish a project. The artist smashed his model and it was Michelozzo who eventually built Cosimo's palace. Another local aristocrat, Luca Pitti, asked Brunelleschi to design him a palace and the result was a vast building which combined grandeur with strictest simplicity: the severity of the Pitti Palace is magnificent—every ornamental detail is rejected throughout. One should also notice the more elegant design of the Palazzo Pazzi, the cloister of Santa Croce, the Palazzo Larione dei Bardi, the Palazzo della Parte Guelfa and the Villa Petraia. Brunelleschi was also outstandingly talented in the building of forts; he invented various types of machinery—ferries, windlasses, pieces of stage equipment for opera productions.

His influence was considerable, not only in connexion with the evolution of architecture itself, but also in the development of painting.

is the finest that has come down to us, thanks to his spontaneity, strength of feeling, exquisite technique and the clear, precise arrangement of his figures.

"Calumny" of Apelles, The

Botticelli's painting for the financier Antonio Segni developed the theme of calumny from the description Lucan gave of the lost work by Apelles. The famous Greek artist had painted this picture as an act of revenge for the calumnies poured out against him by his rival Antiphilus into the ears of King Ptolemy. The idea of using this allegory had been suggested to artists in 1435 by Leon Battista Alberti in his *Treatise on Painting*. "In this great painting," he wrote, "there was a man with large ears and alongside him stood two women, one called Ignorance, the other Superstition. Calumny walked towards them: she was an exceptionally beautiful woman, but her face was somewhat crafty; in her right hand, she held a lighted torch; with the other hand, she dragged a young man by the hair. He raised his arms to heaven. There was another man, pale, ugly and wild-looking; he was Calumny's guide and his name was Envy. Two other women accompanied Calumny and arranged her hair and clothes; one was Perfidy and the other Deceit. Behind them came Remorse, a woman wearing mourning and rending her garments; she was followed by a shy, modest young girl representing Truth;" Over a dozen versions of this famous allegory were painted in the course of the 15th and 16th centuries: by Botticelli and other well-known artists—Mantegna, Raphael, Dürer were among those who were anxious to try their hand at painting the subject originally illustrated by the great classical painter. Botticelli's version

Cambio in Perugia (The)

When Perugino was at the height of his fame he went back to Perugia and in 1499 started decorating the Cambio, that is the money changers' headquarters. Inspiration for the paintings was provided by Francesco Maturanzio, the humanist professor of rhetoric at Perugia University. First, Perugino painted a *Transfiguration of Christ* and an *Adoration of the Shepherds* accompanied by two other very fine frescoes showing the allegorical figures of Virtues together with heroes of classical antiquity. In the first fresco, *Strength* appears with Lucius Sicinius, Leonidas and Horatius whilst *Temperance* is shown with Scipio, Pericles and Cincinnatus. In the second fresco, *Prudence* protects Fabius

Maximus, Socrates and Numa Pompilius, whilst *Justice* looks after Camillus, Pittacos and Trajan. The heroes' names are carefully written alongside each, but Perugino made no attempt to bring local colour into the painting. Their garments are imaginary creations and the characters are totally unwarlike in appearance. On the contrary, they look somewhat timid and their bearing is even a little feminine and drooping. They seem lost in a dream and completely out of touch with their surroundings. Harmony of colour with a general predominance of blue combined with the freshness and poetry of the fresco make this painting one of Perugino's most engaging works.

Camera degli Sposi at Mantua

The "camera degli Sposi" (marriage room) in the castle at Mantua was decorated by Mantegna; it is a ceremonial room where the princes of Mantua were married. Apart from two window openings, every bit of the huge quadrangular room is covered from top to bottom with paintings. The ceiling vaults are covered in *trompe-l'œil* decoration simulating grisaille bas-reliefs and medaillons of Roman emperors. In the centre, Mantegna painted a cupola opening on to a beautiful cloudy sky. A group of women, including a negress and some small *putti*, or baby angels, lean over the parapet wall and watch what is happening in the room below. Above the entrance doorway, the same charming little *putti* with their butterfly wings hold up a cartouche bearing a Latin inscription which tells us that the Paduan

Andrea Mantegna finished this work in 1474 in honour of the excellent Prince Lodovico, Marquis of Mantua, and his glorious wife Barbara. The door separates one fresco into two sections, one showing Cardinal Francesco Gonzaga arriving at his father's home whilst the other part has his servants holding the horses and dogs. The solemnity of the scene is lessened by the half-real, half-imaginary landscape crowded with buildings in the classical style. The unbroken wall shows Lodovico Gonzaga and his family. In the middle, his wife watches her husband who has just finished reading a letter and who is turning towards his secretary to give him some instructions. Around them stand their children and their household, amongst them the elderly court astrologer and the Marchesa's favourite dwarf. The decoration of the room was completed in 1474.

Campo Santo of Pisa
(Frescoes by Benozzo Gozzoli)

The registers of the Council of Pisa Cathedral show that Benozzo worked on the decoration of the Campo Santo for more than sixteen years, that is from 1468 to 1485. The Campo Santo is a cemetery whose soil was brought from the Holy Land on the instructions of Archbishop Ubaldo in no less than fifty-three ships over the period 1188-1200. The polished marble surround which encloses it was not completed by Giovanni Pisano till 1283. A covered gallery looks through open-windowed arcades on to a roofless inner court which houses the remains of the dead. When Benozzo came to Pisa in the

Benozzo Gozzoli
The Prude of Pisa
Pisa, Campo Santo

first place, three-quarters of the enclosing wall had already been covered in a vast series of frescoes in superb colours, offering a great vivid panorama of the beliefs and customs of the Middle Ages. All the great painters from the schools of Pisa, Siena and Florence had left their mark there in the course of the 14th century. Gozzoli took up the story at the end of the Flood, the place in the Old Testament where Pietro di Puccio, the artist working there before him, had stopped painting.

Carpaccio, Vittore

Born in Venice about 1455, died in 1526. From his youth, he worked with a certain Lazzaro Bastiano, who Vasari thought was his brother. As we have no biographical documentation at all, we can only follow his life through his works. First of all, he worked with a team of painters in SS. Zanipolo in Venice. Between 1490 and 1496 he worked on the *Legend of St Ursula* for the Scuola di Sant' Orsola. In 1494, Carpaccio was invited along with Mansueti, Diana and Lazzaro Bastiani to decorate the Scuola di San Giovanni Evangelista. Between 1504 and 1508 he painted nine small pictures and an altar-piece for the Dalmatian members of the Scuola degli Schiavoni. In 1510 Carpaccio was at the height of his artistic power and widened his scope. He painted a variety of works in the Sala del Maggior Consiglio. In 1511 he started a vast undertaking for the confraternity of St Stephen. In about 1514, the church of San Vitale commissioned an altar-piece showing the saint with his wife St Valeria and other saints. In 1519 he painted two pictures for the Cathedral of Capo d'Istria and the church in Pozzolo near Cadore. These works marked the end of his career as an artist, though Lanzi mentions a portrait of himself which bore the date 1522.

Cassone

"Cassoni" were chests given to couples on the occasion of their wedding. They were often decorated with paintings on the side panels. The great masters of the Quattrocento were not too proud to decorate these items of household furniture.

Castagno, Andrea del

Born in 1423, died in Florence in 1457. Andrea was the son of a peasant who owned a small plot of land. He was left poor and orphaned at an early age. A letter he wrote in 1430 shows that he owned two patches of ground and a hut in his father's village. Shortly before he died, he owned a house in the Via Fib-

157

Andrea del Castagno
Farinata degli Uberti
Florence, Sant' Apollonia

Signorelli
Testament of Moses (detail)
Rome, Sistine Chapel

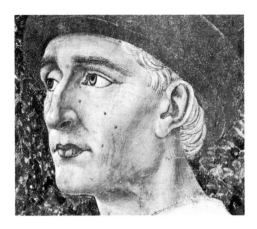

biai in Florence and led a steady, organised existence. It is said (quite wrongly) that he caught the attention of Bernardetto de' Medici by his crude drawings of people on walls and stones and that Bernardetto took him to Florence to apprentice him to Masaccio. He had a strangely fierce artistic talent and this brought him the curious commission of drawing the members of the Pazzi plot in the guise of hanged men on the walls of the Podesta: it won him the nickname of "Andreino degli Impiccati". His first major work was the *Last Supper* for the refectory of Sant' Apollonia in Florence. In 1451 he decorated a villa near Soffiano with a series of *Famous Men and Women*. Vasari wrote that Andrea del Castagno murdered Domenico Veneziano, but this is totally false. An irrefutable document proves that Veneziano did not die until 1461, some four years after the death of his alleged murderer.

Castiglione d'Olona

Masolino da Panicale's frescoes cover the chancel of the church. On the vault: *The*

Life of the Virgin; on the walls: *Stories of St Stephen and St Lawrence*. He also painted the inside of the baptistery with *The Story of St John the Baptist*. The first fresco shows *The Birth of the Saint and his Presentation to Zacharias*, but it is now almost totally effaced. Next comes his fine *Baptism of Christ*. Below, a series of rather narrow paintings show: *St John preaching, St John before Herod, The Beheading of the Saint*. On the ceiling: *The Evangelists* and *The Doctors of the Church*. These frescoes more than justify Vasari's appreciation of Masolino: "I find his manner very different from that of the painters who went before him, for he gave his figures a certain majesty and made his drapery supple instead of stiffly folded. And he understood light and shade and studied his models. He painted a number of foreshortenings very well; he also started giving his female figures more softness and put his young people into more elegant clothes than the old masters had done and he composed his perspectives with care and skill."

Cathedral of Siena

In 1504, Cardinal Francesco Piccolomini (the future Pope Pius III) commissioned Pinturicchio to paint a room adjoining the left aisle of Siena Cathedral. His idea was to make it into a "libreria", or library, for the books and manuscripts which had belonged to his uncle, the famous humanist Aeneas Sylvius, who had been pope under the name of Pius II. The artist took a good ten years, including interruptions, to finish the project. They show various episodes from the life of the Pope and are set inside a series of *trompe-l'œil* arcades with pilasters covered in riotously ornamented grotesques. The entire work is painted with masterly casualness and gives a superb picture of life and manners in the early Renaissance.

Cennini, Cennino di Drea

Born in Colle di Valdesa (Tuscany) about 1370, died in Padua in 1440.
He was a pupil of Agnolo Gaddi, with whom he collaborated on a number of frescoes in Florence and other towns in Tuscany, in particular in the church of San Francesco, Volterra, where he painted a cycle on the theme of *The Childhood of Jesus*. Later he went to Padua, where he entered the service of the great patron Carrara. Cennino Cennini is best known as the author of a treatise on painting which contains a host of odd details on the techniques in use at the time. The manuscript entitled *Il Libro dell' arte* is held in the Laurentian Library in Florence and is dated 1437. It was published for the first time at the beginning of the 19th century.

Chiaroscuro

Literally: "light-dark", from the Italian. This word refers to the use of the tones between black and white to model form in painting. Light falling on objects produces highlights and shadows which enable us to understand their shape. In the fourteenth century chiaroscuro was hardly used, but only pure colour. It is with Masaccio and a few followers who were particularly interested in the problem of describing solid objects that the technique was introduced.

Condottiere

This word, which means "leader", was used to describe the leaders of mercenary bands who served the best-paying princes during the Italian wars in the Renaissance period. The word was extended to include in its meaning all the soldiers so occupied. The condottieri played an important part in the wars which constantly broke out between the different Italian states and principalities in the 15th and 16th centuries.
Venice had mercenary troops in her pay from 1143 onwards: the laws of the Republic forbade its citizens to carry arms and refused to allow foreign generals to bring their troops within the city confines; Venice feared the ambitions of its citizenry but at the same time did not wish to waste their lives. It was really on account of the great rivalry between the Guelphs and the Ghibellines that the condottieri spread all over Italy. With mercenaries in your pay, you were always prepared if war broke out; governments did not need to recruit their own subjects and once peace

had been signed all war expenditure ceased, for the condottieri were disbanded. Machiavelli described the horrors that arose from the mercenaries' activities all across Italy—looting and fighting wherever they went. In the course of the 14th century, these roving bands became more or less permanent in their structure. They passed nonchalantly from the service of one state to another, always willing to perform the act of treachery; never particularly anxious to actually die for their employers. Some condottieri became famous: Attendolo Sforza founded the dynasty which ruled Milan till 1535, Faccino Cane was sent to reduce Alessandria in 1403 and stayed in control of the city till his death, Federigo da Montefeltro won and ruled Urbino, Sigismondo Malatesta held Rimini and Sir John Hawkwood (Giovanni Acuto to the Florentines) founded the famous White Company. The condottieri disappeared in the course of the 16th century as more and more permanent armies were set up with the help of the Swiss mercenaries and the Landsknechts.

Cornaro, Caterina

Born in 1454, died in Venice on 10 July 1510. She was one of the most famous women of the Renaissance. Brought up in the Convent of San Benedetto in Padua, she was married by proxy to Jacques de Lusignan in 1468. He had managed to get himself acknowledged ruler of Cyprus by the Sultan of Egypt and it was to win the support of Venice that he married the young Caterina. The Senate took the island under its protection and gave Caterina a substantial dowry—but prudently insisted on holding Famagusta and Kyrenia as mortgages. In 1472, Caterina joined her husband, but he died soon afterwards, leaving her pregnant. With the help of her uncle Andrea Cornaro, she took over the government, but her son Jacopo died in 1475. The Venetians then decided to make a formal annexation of the island and lest Caterina should marry Alfonso of Naples sent her brother Giorgio to make sure things went to plan. In 1489 she abdicated and returned to Venice where she was received with the greatest honours. She was given the seignory of Asolo, at the foot of the Alps near Bassano. There she kept a magnificent court, surrounded by men of learning. Her cousin Bembo sang her praises in his dialogues, *Gli Asolani*. She was buried in S. Salvatore where Contino built her a splendid monument in 1580.

Corvinus, Matthias (1443-90)
King of Hungary.

Son of the hero John Corvinus of Hunyadi. He was proclaimed king at the age of fifteen by a Diet meeting at Rakos. The early days of his reign were surrounded in difficulties, but he had considerable help from his father-in-law, the King of Bohemia. As allies of the Pope and of Venice, the Hungarians fought against the Turks who had besieged Belgrade a second time in 1464. The fight was soon transformed into a struggle against the Christian heretics in Bohemia. Matthias conquered Moravia and part of Silesia. During the second half of his reign, he won victories against the Turks and the Austrians.
Matthias was a great administrator and an outstanding Renaissance ruler. It was during his reign that printing was intro-

Francesco Cossa
Virgin and Child
Paris, Musée Jacquemart-André

duced in Buda by German workers, and he encouraged the new study of ancient writers from the fine manuscripts brought to Hungary by Italian scholars. The Corvina Library was reckoned to be the finest in Europe at the time.

Cossa, Francesco (about 1438-77)

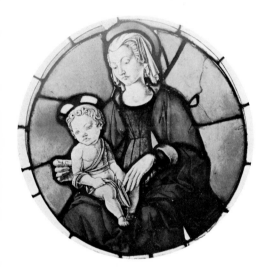

A petition signed by Cossa dated 1470 indicates that at that time he was working on the Palazzo Schifanoia frescoes in Ferrara. He then moved to Bologna, where he worked for the Bentivoglio family. In 1472 he restored a 14th-century fresco in the Barrocano oratory and added to it a fine landscape and two angels, both still visible today. In 1474 he painted a number of religious pictures for the Bologna Mercatanzia. Then, he and Ercole de Roberti painted the great altar-piece of St Vincent Ferrer. One of his last works was the decoration of the Garganelli chapel which remained unfinished at his death. He died of the plague in 1477. Lorenzo Costa and

Francesco Francia were his pupils; in addition he had considerable influence on Ercole Roberti, Ercole Grandi, Lodovico Mazzolino and Timoteo Viti.

Costa, Lorenzo

Born in Ferrara about 1460, died in Mantua in 1535.
This artist was a follower of Francesco Cossa and Cosimo Tura. He painted various works at Ravenna and Ferrara before settling in Bologna where he became official painter to Giovanni II Bentivoglio. He ran a school of painting in Ferrara between 1492 and 1497 and then returned to Bologna; he later went to Mantua where he worked for the Gonzaga family. His great masterpiece was the decoration of San Giacomo Maggiore in Bologna.

Crivelli, Carlo

Born between 1435 and 1440 in Venice, died after 1493.
Crivelli worked in Venice until 1457, when he left there for ever and settled first in Fermo (until about 1470) and then in Ascoli, where he stayed for fourteen years. From there he went back to Fermo and in 1488 he was in Camerino. His last known work is dated 1493—*The Coronation of the Virgin* painted for the church of San Francesco in Fabriano. In 1490, the Prince of Capua (the future Ferdinand II of Naples) gave him the rank of "miles" which he never forgot to add to his signature on his paintings. He was also awarded the title of "eques laureatus". The exact date of his death is unknown and so is the place.
Crivelli seems to have been a pupil of Vivarini, but he was very much influenced

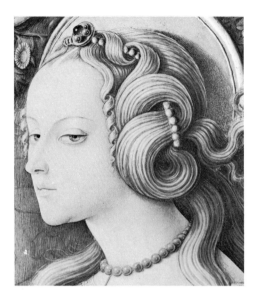

by the Paduan school, as we know it from the studio of Squarcione. Crivelli's style had a great influence on art in the Marches and the neighbouring provinces. Amongst his pupils and followers were his brother, Vittorio Crivelli, Pietro Alamanno, who signed some of his pictures, and a large number of anonymous painters who worked with him on his larger altar-pieces.

Crivelli, Vittorio

Born in Venice, worked in the Marches from 1481 onwards, died in 1501 or 1502. He imitated his brother's style but was much inferior to him. Like Carlo, he painted a number of *anconae*, but his line was always rather weak and his expressions insipid. His largest works are the altar-piece of *The Coronation of the Virgin* in the Palazzo Communale at Sant' Elpidio a Mare and another altar-piece at San Giovanni, Torre di Palme.

Diamante, Fra (1430-98)

Born in Terranova. Member of the Carmelites in Florence.

He was Filippo Lippi's uncle and went with him to Prato, where he was chief assistant in the decoration of the cathedral choir. When he was later confined to his monastery in Florence on his superior's orders, the Prato council wrote and pleaded for his release in a series of letters still in existence. He went next to Spoleto, where he worked with Fra Filippo on the frescoes of the Duomo, an undertaking which he had to finish alone after Fra Filippo died and for which he received a payment of 200 ducats. From Spoleto he went back to Prato, where in 1470 he painted a portrait of Cesare Petrucci in the portico of the Palazzo, the only work for which he was entirely responsible. As this has now been destroyed, it is difficult to assess the value of his art.

Donatello (Donato di Niccolo Betto Bardi)

Born in Florence in 1386, died in 1466.

Donatello was first apprenticed to a goldsmith; then, if we are to believe Vasari, he worked for the painter Lorenzo di Bicci. It was, however, to sculpture that he decided to dedicate his tremendous talent. He worked as a journeyman in Ghiberti's studio when the latter was making the Baptistery doors (1401). But it was not until he had made his fateful journey to Rome and seen the marvels of antiquity that his true genius was awakened. His real career started when he was about twenty with his sculptures for the Cathedral and Orsanmichele in Florence. After

fairly modest beginnings, he worked on a series of monumental marble statues and produced two masterpieces: *St John the Evangelist* for the façade of the cathedral and *St George*, finished in 1416 for a niche in Orsanmichele. Another statue which should be mentioned is one of a prophet known as Zuccone and carved between 1415 and 1425. It was during this period that Donatello sculpted the lion which guards the foot of the staircase in the *palazzo* where Pope Martin V stayed in Santa Maria Novella.

His fame soon reached far beyond the bounds of Florence and many commissions reached him from other towns; he began to work in bronze. From 1425 to 1433 Donatello worked in collaboration with Michelozzo. From this close contact came the tomb of Pope John XXIII. In 1433, Donatello left for Rome; his genius was now in its finest flower. He

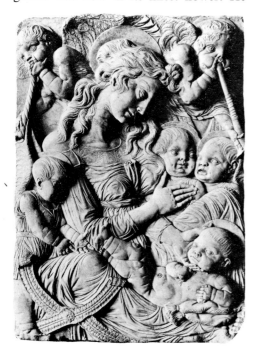

produced the tabernacle of St Peter's, the *Entombment*. On his return from Rome (he was now forty-eight), he began producing one masterpiece after another, thanks to the patronage of the wealthiest connoisseurs of the time. He designed the pulpit of Prato Cathedral and moved on to the Cantoria of the Cathedral in Florence which he finished in 1483. This tremendous burst of productivity reached its finest moment when he sculpted a series of *Prophets*. His friend and protector, Cosimo de' Medici, gave him the task of making for the church of San Lorenzo a bust of the saint, some bas-reliefs and two bronze doors. He followed this with the restoration of some antiquities. Donatello was invited to Padua in about 1444. He produced the first large equestrian statue erected since the classical period: that of the Venetian condottiere Gattamelata (1447). Between 1446 and 1450, he worked on the rebuilding of the high altar of the Basilica of St Anthony, an enormous undertaking unfortunately demolished in the 17th century and only partly rebuilt since. Donatello returned to Florence in 1456; he was seventy years old. The last part of his artistic career brought its surprises: after the bronze group of *Judith and Holofernes* and the *St John the Baptist in the Desert*, he produced the extraordinary and marvellous statue of the *Magdalene* for the Baptistery in Florence. He was not able to complete the two bronze pulpits in San Lorenzo. His long career was ended by paralysis three years before his death at the age of eighty. His influence was of the first importance, not only by virtue of its tremendous effect on the development of sculpture but also because it made a great impact on painting.

Ercole de Roberti (Grandi Ercole d'Antonio)

Born in Ferrara in 1450, died in 1496. From 1479 onwards he often worked with his brother as painter and gold-beater. His teachers were Francesco Cossa and Cosimo Tura, with whom he worked on the Palazzo Schifanoia.

One of his main works was the decoration of the Garganelli chapel in San Pietro de Bologna which was finished in 1483. In 1494, he completed a portrait of Ercole I which he signed. He was the court painter to the Duke of Ferrara and on this account had to fulfil a number of minor duties such as painting the Duke's triumphal chariot and the Duchess's loggia.

Este (Borso, Marchese d')
Duke of Ferrara and Modena.

The natural son of Niccolo III, he succeeded to the dukedom in 1453. Like his predecessor Leonello, he had a distinct taste for scholars of all kinds, granting them enormous sums of money and extremely flattering marks of favour. It was thanks to this generosity that Borso won the honours and titles which he passed on to the house of Este.

The Emperor Frederick III was so delighted with the reception Borso gave him when he passed through Ferrara that on 18 April 1452 he granted him the title of Duke of Modena and Reggio and Count of Rovigo and Comacchio. Borso was unable to get the state of Ferrara included in these investitures, for it belonged to the Church, but he approached Pope Pius II in the hope that it could be raised to the state of a duchy. His negotiations with the Vatican were unsuccessful for a long time, but on 14 April 1471 Paul II granted him his wish. But the new duke did not enjoy his position for very long: as he was returning from Rome where he had received the ducal coronet from the Pope, he fell ill and died (20 August 1471).

Fabriano, Gentile da

Born in Fabriano about 1370, died in Rome in 1450.

Son of a painter called Niccolo da Fabriano, he worked first of all with Allegreto Nuzi di Gubbio. This association did not last long, for his teacher died at the end of 1385. Vasari says that he was also taught by Fra Angelico, though this is a disputable fact; he certainly imitated Fra Angelico and may well have been a follower of this artist.

In 1421 he was included in the register of Florentine painters and was described as a "Magister magistrorum" in the list of artists working on the Cathedral at Orvieto in 1425. He went to Venice with Pisanello to paint frescoes on the walls of the Sala del Maggior Consiglio in the Doges' Palace. At that time, one of his pupils was Jacopo Bellini.

Amongst Fabriano's most outstanding works are the reredos for the altar of the Virgin in the church of San Niccolo in Florence and the decoration of the church of St John Lateran in Rome. Gentile had

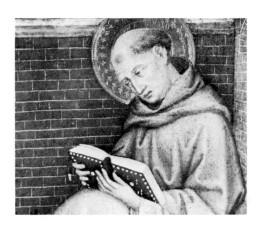

a son called Francesco and many pupils. During his lifetime he enjoyed a very high reputation and deserves to be classed with the finest artists of the Umbrian school at the beginning of the 15th century.

Ficino, Marsilio

Theologian and neo-Platonician born in Florence in 1433, died at Carreggi in 1499. He was the son of Cosimo de' Medici's principal doctor and studied at Bologna. Whilst there, he devoted himself to the study of Plato and indeed spent the rest of his life reading and working on this philosopher's writings. Once he was back in Florence, he imparted his enthusiasm for Plato to his protector Cosimo de' Medici and in due course was made president of the Academy. At the age of forty-two, Ficino took holy orders and became a canon of San Lorenzo. His new duties did nothing to impair or prevent his philosophical activities. In the period 1483-84 his Latin translation of Plato was completed; this was the greatest work of his career. He brought out several translations of works originally in Greek and wrote many studies in which he set out his own philosophical doctrine. He believed that where the teachings of the New Testament contained the perfect revelation of the love of God for his creatures, those of the Greek philosophers revealed God as Wisdom and Truth. They served to support dogmas relating to reason and provided speculative minds with indispensable material for every kind of serious discussion. Ficino could see only harmony and agreement between Platonism and Christianity. For this reason, he considered Plato a true precursor of Jesus

165

Christ. He taught Platonism with great success and one of his pupils was the future ruler of Florence, Lorenzo the Magnificent.

Filippino Lippi

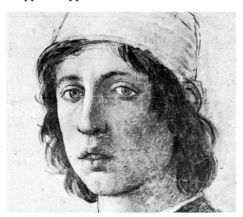

Born in Prato in 1457, died in Florence in 1504. Son of Fra Filippo Lippi. The dying Fra Filippo asked his uncle Fra Diamante to take care of him. He was then two years old. His real master was Sandro Botticelli. He was every bit as gifted as his father and in 1487 started painting for the Badia church in Florence a picture which is an unchallenged masterpiece: *The Vision of St Bernard.*

This excellent start to his career brought him the signal honour of being invited to finish the frescoes in the Brancacci chapel in the Carmine, left incomplete by Masaccio and Masolino. Next, after starting the series of frescoes for the Strozzi chapel at Santa Maria Novella on the subject *The Life of St John,* he went to Rome to decorate Santa Maria sopra Minerva and produced the famous frescoes on *The Life of St Thomas Aquinas.* A heart attack carried him off at the height of his career.

Foreshortening

Known as *scorcio* in Italian when seen from in front and *di sotto in su* when seen from underneath. It is basically perspective applied to a single object in such a way that it appears to recede from view, often very dramatically. The artist achieves this result by presenting the eye with a carefully judged series of ever-retreating planes; as they recede from view, they allow the eye to appreciate distance or length, which may be greater or less according to the narrowness of the angle separating the planes. Any object which is looked at either from top to bottom or from bottom to top, or which we see presented to us lengthwise is in fact a foreshortened object—a hand pointed towards the spectator or a road disappearing towards the horizon are typical examples. Painters made foreshortening a particular technique in which the rules of perspective and the art of chiaroscuro were of equal importance. Its merit as a feature of painting technique is really little more than a demonstration of a particular artist's skill in showing objects in a specially difficult position and sometimes in a manner in which we are not accustomed to see them: Mantegna's *Cristo Scorto* is perhaps an extreme example of this. Foreshortening is particularly popular as a device in decorating ceilings when we are shown objects as they appear when seen from below.

Francia, Francesco (Francesco Raibolini)

Born in Bologna in 1450; died there on 5 January 1518. Italian painter and goldsmith.

He was originally apprenticed to a gold-smith and never completely severed his relationship with his first craft. More-over, whenever he signed his pictures he always added the word "aurifex" or "aurifaber" to his name. He studied painting with Lorenzo Costa. Between 1483 and 1489 he held the position of head of the Goldsmiths' Corporation. The Bentivoglio family appointed him Master of the Mint, a position he held all his life. He engraved type for the famous Venetian printer Aldus Manutius and was himself a printer in Bologna under the name of Francesco di Bologna.

His first pictures apparently date from 1495. In about 1499 he was commissioned to decorate the Bentivoglio chapel in San Giacomo Maggiore. Francia kept a record-book in which he noted all the main events which occurred in his studio. We know that he had a new pupil called Timoteo Viti in 1490 and this pupil served as a link between Francia and Raphael. Francia and the latter were always very close.

In 1507 a political upheaval drove the Bentivoglio family from Bologna and Francia lost his patron. However, the new ruler, Julius II, was well-disposed towards artists and Francia kept his posts. When the Bentivoglio returned to Bologna, Francia was elected one of the people's magistrates. In 1516, Raphael sent him his famous *St Cecilia* and he took charge of the hanging of the picture in San Giovanni del Monte.

Born about 1410, he was illegitimate, like so many of his contemporaries. During his youth he was taught by the great educator Vittorino da Feltre and became one of the most outstanding princes of Renaissance Italy by virtue of his learning, eloquence, wit and candour. In his ducal capital, he raised splendid buildings and founded an excellent library; his court was filled with the best scholars and artists of the day, he appreciated learning and beauty above all things. As a fighting-man, he had an adventurous life and led many bloody campaigns against his great enemy Sigismondo Malatesta. Then in 1467 he led the Florentine army against the condottiere Colleone, who was in the service of Venice. In 1472, the Florentines hired him to subdue Volterra, which was in open revolt. He could not prevent his troops looting and pillaging, but he took for himself only a magnificent Hebrew Bible which he put into his library in Urbino. On the marriage of his daughter to Giovanni della Rovere, nephew of Pope Sixtus IV, he was given the title of Duke of Urbino (1474). Four years later, he took command of an army sent into Tuscany by the Pope to subdue Lorenzo de' Medici. He had just been appointed to lead an army raised by the Duke of Milan, the King of Naples and the Republic of Venice to defend Ferrara against attack from Venice when he died (1482).

Frederick, Duke of Urbino (Federigo da Montefeltro)

167

Ghiberti, Lorenzo (1370-1455)

Born and died in Florence. Sculptor.
The work which represents for posterity the greatest achievement of Ghiberti is found in the two bronze doors for the Baptistery in Florence. In 1401, the merchants of Florence decided to provide the Baptistery with a new bronze door to match the one already in position which had been made by Andrea Pisano; it was suggested that there should be a competition to see which artist could produce a bas-relief to match the spirit of the existing door. The subject chosen for the test panel was the sacrifice of Abraham. A year was allowed for the work to be carried out and at the end of this time, only the work of Ghiberti and Brunelleschi seemed good enough. Brunelleschi stepped down at his own wish. The great door is made up of twenty-eight medallions carved inside quadrilobate squares and gives the story of the New Testament. Throughout this long undertaking, Ghiberti produced other interesting pieces of work. As an architect, he entered the various competitions for the completion of the Duomo at the same time as Brunelleschi. He was named chief architect for the fabric and the façade of the great church.
In 1427 Ghiberti returned to the same subject that he had carved on the Baptistery door when he produced some baptismal fonts for Siena. In 1425 he was commissioned to make a third door for the Baptistery. He decided to abandon the twenty-eight compartments for a vaster form of composition. Each panel was composed of five sections and within this framework he gave a vivid representation of the Old Testament.

168

Ghirlandaio (Domenico Tommaso Bigordi)

Born in Florence in 1449, died in the same town in 1494.
There were four artists in this family and Domenico was known by the same nickname as his father, Tommaso. He did a great deal of work with his brother David and it is often difficult to distinguish between their styles. Domenico was first of all set to work in a goldsmith's studio, then learnt painting and mosaic work under the guidance of a notable teacher, Alesso Baldovinetti, an exponent of naturalism in painting. At the same time, Ghirlandaio studied Masaccio's frescoes in the Carmine.
In 1475 he painted a *Story of Saint Fina* for the Collegiata of San Gimignano; in 1480, he did a *Last Supper* and a *St Jerome* for Ognissanti; then he went to S. Trinita to paint the frescoes in the Sasseti chapel which he finished in 1485 (*Life of St Francis*). In

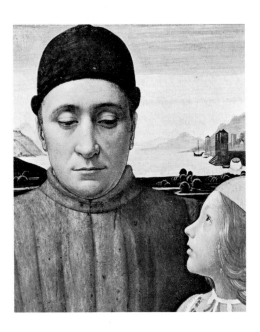

1481 he signed a contract for the frescoes in the Sistine chapel in Rome and whilst there he met the Florentine Francesco Tornabuoni, who became his great patron. It was Tornabuoni who was responsible for one of the great masterpieces of the 15th century: the frescoes in Santa Maria Novella in Florence which Ghirlandaio painted between 1485 and 1490—*The Life of the Virgin* and *The Life of St John the Baptist*. Michelangelo was almost certainly engaged on this work as Ghirlandaio's apprentice and he was very much influenced by it. In 1494, Ghirlandaio died, leaving several works unfinished; his two brothers and his pupils were commissioned to complete them.

Giotto, Ambrogio Bondone (1266-1336)

Born at Colle di Vespignano in Tuscany. According to Ghiberti and Vasari, the child Giotto was working as his father's goatherd when the great painter Cimabue discovered him drawing on a stone with a piece of charcoal and took him to train in his studio, convinced that he had found a genius.

Ghiberti and Vasari attribute to his early career some paintings which have now disappeared but which decorated the choir of the Badia in Florence. It is not easy to distinguish fact from fiction in these matters. In general terms, what Giotto did for art was to bring back to western painting the appreciation for truth as found in the heart of nature. There was already in the early 13th century a distinct effort to discard the traditional hieratism of pictorial art (as seen in Ravenna, for example) and to replace it with something less inflexible, probably under the influence of St Francis of Assisi, for it was this saint who brought humanity back to art.

The first authentic work which can be attributed to Giotto consists of the twenty-eight frescoes he painted in Assisi for the upper basilica of St Francis. In them, we see a complete break with Byzantine tradition. For the first time, an artist broke with conventional themes always painted according to the same set of rules to seek inspiration in popular tales and contemporary customs. Simplicity, charm, gentleness and purity, these are the new features which Giotto introduced into painting. The Assisi frescoes must have been finished by 1298 because at that time Giotto was in Rome engaged on some paintings which are now lost. However, we can still see in St Peter's the famous mosaic *Navicella* (the Ship of the Church) and the reredos for the high altar preserved ever since the 16th century in the canons' sacristy. This important work marks an important date in Giotto's development. He brought his fresco technique to altar-painting. It is thought that Giotto and Dante met in Parma and it is certain that Giotto kept the memory of the great poet alive in Florence by painting his portrait on the walls of the little chapel in the Palazzo del Podestà. He was next summoned to Padua by Enrico Scrovegni in 1303 in order to decorate a chapel dedicated to the Virgin. There, he divided the wall of the nave into wide quadrilateral sections, three rows one above the other. Giotto painted *The Life of the Virgin and of Christ*. The chapel is a masterpiece of perfect harmony between the building itself and its internal decoration and is the most striking example of the best Italian art of

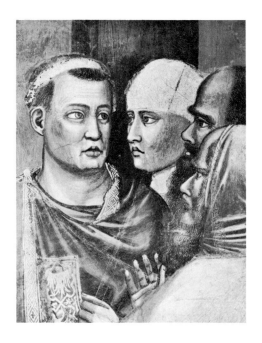

He died in Florence and was buried with great pomp in the cathedral for which he had designed the campanile. His subsequent influence on painting was enormous: all the schools of painting which grew up in the centres of Italian civilisation spring from him: Masaccio, Fra Angelico, Ghirlandaio and Raphael were proud to acknowledge their debt to his art. Vasari considered him the ancestor of all Quattrocento painting.

Gonzaga, Lodovico (Marquis of Mantua)

Nicknamed "the Turk", sixth Lord and second Marquis of Mantua, son and successor of Gianfrancesco I.
He reigned from 1444 to 1478. The Gonzaga family always supported the Ghibelline faction. At the start of his reign, Lodovico left the service of the Duke of Milan to ensure an alliance with Venice and in 1448 launched an attack on Milan. He was the rival of his brother Carlo and this rivalry meant that they frequently changed allegiances, faithful only to their mutual hatred.
Lodovico was one of the foremost soldiers of Renaissance Italy, but he was also outstanding for his passion for elegance and the arts, as well as for his constant patronage of poets, scholars and artists. A particularly brilliant epoch for Mantua opened with the congress of Christian princes summoned there by Pope Pius II in 1459 and 1460 to discuss the defence of Christianity against the Turks. In the course of this meeting of Italian princes and ambassadors from other countries, many noble resolutions were passed: but not one was ever put into execution.

the period: there is no more perfect union of art and architecture anywhere in the world.
Then, according to Vasari, Giotto went back to Assisi to work in the lower church. When he returned to Florence he decided to settle there. In 1317 he was asked to decorate the apse and the chapel in Santa Croce. It is tragic that the passage of time and the carelessness of human beings have done so much to rob us of Giotto's masterpieces. Much of his work has disappeared without trace. Some was found during the 19th century underneath a thick layer of whitewash, but restoration techniques have never been able to reproduce the brilliance of his line and colour. Amongst those found were *The Resurrection of Drusina*, *Herod's Feast* in the Peruzzi Chapel and the famous *Vanante*, etc., in the Bardi Chapel. Giotto was also an architect and

a sculptor.

Gozzoli (Benozzo di Lese di Sandro Alessio)

Born in Florence in 1420, died in Pistoia in 1497.

He first learnt about painting in Fra Angelico's studio and soon became his assistant. Later, he is mentioned as Ghiberti's assistant during the making of the Baptistery doors. In 1447 he went to Rome with Fra Angelico and helped him paint the two papal chapels of Eugenius IV and Nicholas V in the Vatican. Later in that year he went to Orvieto with Fra Angelico. From there he went to Montefalco where he stayed two years; painting for the church of San Francesco a cycle of

frescoes on the life of St Francis which won him considerable fame. In 1459, he was offered the opportunity for a work of great scope and size: the frescoes in the Medici-Riccardi chapel showing the *Procession of the Magi*. In 1463 he was painting frescoes in the church of San Gimignano in Valdesa (Tuscany) on the theme of the life of St Augustine. In the years between 1468 and 1484, Gozzoli was occupied in his greatest project: the decoration of the Campo Santo in Pisa with stories from the Old Testament. In 1484 he built and decorated a niche in a tiny church in Castelfiorentino. In 1489, he painted some frescoes of rather less merit than usual for the monks of San Michele in Borgo. He also produced a number of works of secondary importance: banners; paintings on wood or canvas . . . He died at the age of sixty-eight, probably of plague. He left a modest fortune to his seven children. He had many collaborators: Mezzastris de Foligno and Giusto d'Andrea di Giusto. He had Cosimo Rosselli as one of his pupils.

Grotesques

During the 15th century in Rome when the first real archaeological excavations got under way, many classical remains were uncovered. The underground rooms that they discovered particularly in Nero's Golden House looked like 'grotte'—that is caves. Consequently, they called the antique paintings that they discovered on the walls, along friezes and all over the pillars, "grotteschi" because they came, as it were, from "grotte". In this technical sense, the word has nothing to do with the normal modern usage. The paintings were made up of arabesques which coiled and curled and sprang into human forms, or animal forms, sometimes real, sometimes imaginary; sometimes disparate shapes were joined together, sometimes there were clusters of

171

fruit or flowers, sometimes extraordinary and unexpected objects. The Renaissance artists were fascinated by them and eagerly incorporated them into their paintings. It seems likely that Pinturicchio was the first to use them when he put them into the decorative scheme of the Piccolomini Library at some time after 1512.

Hawkwood, John (otherwise Giovanni Acuto)

Famous English condottiere from the 14th century. For over thirty years he commanded a band of English soldiers of fortune under the name of the White Company and served in swift succession all the Popes, princes and republics of Italy. Like the other condottiere of his time, Hawkwood served the man who paid the most money and was willing to change sides whenever a better offer came along. It was on account of his victory at Cascina on 28 July 1364 that the Florentines commissioned Paolo Uccello to paint the equestrian figure of the condottiere in the nave of the Duomo.

Hieratism

The system of having all forms in painting and sculpture fixed by religious tradition according to precise rules. These forms became rigid and lifeless because they were not susceptible of change in any way.

Joos van Gent

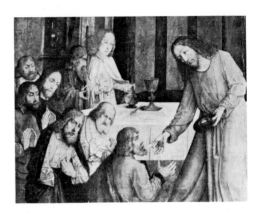

Probably born in Ghent in about 1440, died after 1475.

In 1460 he is given as a member of the Guild in Antwerp. He is mentioned from 1473 to 1480 as working at Urbino for Federigo da Montefeltro where he was engaged on his principal work: *The Last Supper*, still to be seen in the Palazzo Ducale. A variety of pictures from the castle of Urbino have been attributed to him, as have the twenty-eight portraits of philosophers and poets of classical antiquity and modern times now on view in the Palazzo Barberini in Rome and in the Louvre in Paris. They were originally painted for the Duke of Urbino. Amongst the works he painted before going to Italy were *The Adoration of the Magi* and a triptych of *Calvary*, the latter now to be seen at the church of St Bavo in Ghent.

Legend, The Golden

Written by Jacopo da Voragine, born in Varazze in 1230, died in Genoa in 1298. Jacopo da Voragine entered the Dominican order at the age of fourteen; he was appointed provincial of Lombardy in 1276. In 1287, Honorius II sent him to Genoa to pacify the town after it had been rent by factions hostile to Charles of Anjou. Even though his success in this direction was superficial, he was nevertheless appointed archbishop of Genoa in 1292. He wrote a great many sermons, but he is best known as the author of *The Golden Legend*. This is an enormous compilation of stories which in the main are somewhat fantastical; they are taken sometimes from other books and sometimes from popular tradition. The peculiar etymologies which the compilation gives for proper names throws an instructive light on this aspect of 13th-century scholarship. The Middle Ages adored the book and as late as the 16th century the Sorbonne insisted that Claude Despence retract a statement in which he referred to the collection as "The Iron Legend". *The Golden Legend* was one of the main sources of inspiration for the painters of the Quattrocento.

Legend of St Ursula
By Carpaccio.

Ursula, as beautiful as she was pious, was —according to *The Golden Legend*—the daughter of Maurus, King of Brittany. One day ambassadors came to Maurus to ask him to allow his daughter to be married to Conan, son of the King of England. It is this scene which we see in the first episode painted by Carpaccio. Ursula intends to convert her new husband to Christianity and asks her father to accept the marriage proposal on condition that the young man be baptised (2nd episode). In the course of a solemn audience, Maurus gives Ursula's reply to the ambassadors (3rd episode). When they are back in England, they give the message to their king (4th episode) and Conan, anxious to meet Ursula's wishes, says goodbye to his father (5th episode). He and his fiancée set out for Rome, with the blessing of King Maurus (6th episode). During the journey, Ursula has a dream in which an angel tells

her that she will soon be martyred (7th episode). The couple arrive in Rome, accompanied by the eleven thousand virgins forming Ursula's suite and are received by Pope Cyriax (8th episode). They set out for England, together with the Pope, with the intention of converting the country (9th episode). But whilst at Cologne, they are attacked by the Huns, who murder Conan, the Pope, Ursula and every one of her eleven thousand companions (11th episode). Next comes the solemn funeral procession of the saint (11th episode) and her apotheosis. In the 12th episode we see St Ursula in glory, adored by the eleven thousand virgins and received into Heaven by the Heavenly Father. One of the charms of these pictures is to be found in their delightful scenes of family life, Ursula talking with her father in her bedroom, furnished with touching simplicity with a plain canopied bed, a statue of the Virgin and a fat book of devotions. Another scene shows the angel messenger carrying the martyr's palm to Ursula as she lies in bed, her head resting on her hand in a great four-poster bed with her little dog on guard at the foot. Scenes like this are typical of Carpaccio, who loved to paint them.

Leonello and Ginevra d'Este

Leonello, natural son and successor to Niccolo III, Marquis d'Este, reigned from 1441 to 1450. His reign saw no conquest, no revolution and no outstanding political event. He was adored by his subjects for his pleasant nature and his personal charm. He rendered great service to art and literature and encouraged trade and industry. He was himself something of a scholar and spoke both Latin and Italian with a deep appreciation of linguistics. He corresponded with all the great Italians of the time—letters from him appear in collections of correspondence by Poggio, Francesco Barbaro, Ambrogio the Camaldolite and his teacher Guarino. He lived in splendid harmony with his court of artists and men of letters. In 1435 he married the daughter of Gianfrancesco Gonzaga, Marquis of Mantua; he had one son, Niccolo, who was still very young when Leonello died on 17 October 1450. His brother Borso succeeded him. His sister Ginevra d'Este married Sigismondo Pandolfo Malatesta.

Lippi (Fra Filippo di Tomaso)

Born in Florence in about 1406, died in Spoleto in 1469.
An orphan, he entered the Carmine at the age of eight. We know that he very early showed little inclination towards study but great aptitude towards painting and drawing. He copied the Masaccio frescoes in the Brancacci Chapel. He seems to have already taken orders when he left the monastery in 1431, for the Carmelite brothers in Florence never stopped thinking of him as one of themselves, in spite of subsequent events.
Once outside the monastery, he embarked on a wild and adventurous life; Vasari says he was even carried away by Barbary pirates sailing off-shore from Ancona. After eighteen months in captivity, he returned to Florence and became absorbed in painting. However, when he was working on a picture

for the nuns of Santa Margherita at Prato he used one of the young novices as a model and it was not long before they were in love. They ran away (in spite of Fra Filippo's fifty-one years) and Lucrezia refused to return to the convent. She gave birth to a son in 1457, Filippino, destined to become a great painter like his father. Filippo Lippi carried on painting in Prato Cathedral notwithstanding and the work was finished in 1464—a vast *Life of St John the Baptist* and *Story of St Stephen*. In about 1467 the magistrates of Spoleto asked him to paint a large *Life of the Virgin* in the cathedral. He was not able to finish this and his pupil Fra Diamante was commissioned to complete it. Fra Filippo was buried in Spoleto Cathedral, where Lorenzo de' Medici had a superb tomb built for him.

Lodovico il Moro

Born in Vigevano in 1451, died in 1508. Nicknamed the Moor on account of his dark complexion.

He was the son of Francesco Sforza, Duke of Milan. Lodovico became Regent of Milan on behalf of his young nephew Gian Galeazzo and promised to keep the ducal title for him. He was a man of considerable cunning and profound immorality. He was one of those who summoned Charles VIII of France to invade Italy. Soon after Charles had passed through Milan, Gian Galeazzo opportunely died and Lodovico was proclaimed Duke in 1494. This brought a change of heart. He was now seriously worried by France's claims to Milanese territory and on 31 March 1495 formed a league against France with Alexander VII, the Emperor Maximilian I and the King of Spain, Ferdinand V. After the siege of Novara he obtained Genoa and Novara through the Treaty of Verceil (1495). However, Louis XII decided to make the most of his ancestor Valentina Visconti's claims to the Duchy of Milan and began to press his advantage. Lodovico was captured in 1500, taken to Lyons and then imprisoned at Loches, where he died in a small unlighted underground cell. His politics were atrocious but he was nevertheless a great patron of the arts.

Malatesta, Sigismondo Pandolfo (1417-68)

The Malatesta family were of condottiere stock. They settled in Rimini in the middle of the 12th century and by the 14th had spread over the Ancona Marches and parts of the Romagna.

Sigismondo was only fourteen years old when he succeeded his brother Galeotto Roberto. In 1433 he married Ginevra d'Este, daughter of Niccolo III, Marquis of Ferrara. In the same year, he received the Emperor Sigismond in Rimini. In 1435 Eugenius IV called him to command the armies of the Church. In 1437 he entered the service of the Republic of Venice and fought the Milanese at Reggio. In 1439 he joined the league of Venice, Genoa, Florence and Ferrara against the Duke of Milan, Visconti, and fought the Duke of Urbino on several occasions. He spent the years between 1438 and 1446 fortifying his capital by building a large citadel, the "Rocca Malatestiana". In 1447, when the question of the succession to the Duchy of Milan became of vital importance, he changed sides and left Florence for Venice. This was not enough to prevent the recognition of Francesco Sforza as Duke of Milan. In 1452 he joined battle with Federigo da Montefeltro, Duke of Urbino. In 1460 he was excommunicated by the Pope. When he was abandoned by his own town of Fano, he and his brother Novello were obliged to do penance before the papal legate and lost everything except the single town of Rimini. In 1464, he entered the service of Venice to lead an expedition to the Morea. Humbled yet again by Pope Paul II, supplanted by his arch enemy Montefeltro, he died in 1468.

Mantegna, Andrea

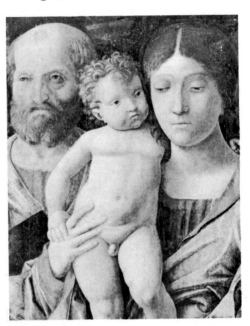

Born in Isola di Cartura near Padua in 1431; died in Mantua in 1506.

His initial training took place in Squarcione's Paduan studio, but he was deeply impressed by the works of Andrea del Castagno, Paolo Uccello and Donatello. In 1454, he went to Venice to marry the daughter of Jacopo Bellini. Between 1454 and 1459, he was in charge of the assistants painting the Ovetari Chapel in the Eremitani, Padua (nominally the work of Squarcione). From 1460 till his death, he lived in Mantua. He decorated the Camera degli Sposi in the Castello del Corte in Mantua for the Marquis of Gonzaga. In 1488 he went to Rome to decorate the Belvedere Chapel for Innocent VIII. On his return to Mantua, he painted *The Triumph of Julius Caesar*, a frieze thirty feet long, intended for the decoration of a theatre. At the end of his life, Isabella d'Este asked

him to paint *Wisdom overcoming the Vices* and *Parnassus*. A great antique collector and archaeologist, Mantegna was also an engraver and sculptor.

Masaccio (Tommaso di Ser Giovanni di Simone)

Born in 1401, died in 1428.
He was the son of a poor notary from Castel San Giovanni near Florence. In 1422 he was registered with the Corporation degli Speziale in Florence and in 1424 with the Guild of St Luke. He was associated with Brunelleschi, who taught him perspective, and with Donatello. Vasari thought that Masolino was his teacher, but this now seems not to be so.

His first works still bore the Gothic imprint—*Virgin and Child* (Uffizi) and another *Madonna and Child* (National Gallery). In 1426, when Masolino stopped painting the frescoes in the Brancacci Chapel, Masaccio began working there in his place. What he painted there was to give new life to western art. It was completely opposed to the Gothic concept and because of this, Masaccio may be said to have started the Renaissance in Italy. In 1428 he suddenly left the frescoes unfinished and went to Rome; he had barely arrived there when he fell ill and died.

Medici Family

This famous Italian family played a vital part in the history of Florence and Tuscany. It originated in Mugello, but left this country-place very early to settle in Florence. From the 13th century onwards, they gradually became richer and more powerful.

Cosimo (1389-1464)
Son of Giovanni de' Medici, he succeeded his father as *gonfaloniere* (city magistrate). He had an enormous fortune, acquired through commercial enterprise, and was virtual dictator in Florence from 1434 onwards. He was an ardent patron of art, literature and scholarship. He died with the title *Pater Patriae*.

Piero I (1414-69)
In 1464, he succeeded his father, Cosimo. He kept his hold on Florence till his death, in spite of various plots.

Lorenzo the Magnificent (1449-92)
One of the really great men of the Renaissance. A man of firm character and a skilful diplomat, he strengthened the power and the reputation of the Medici. His love

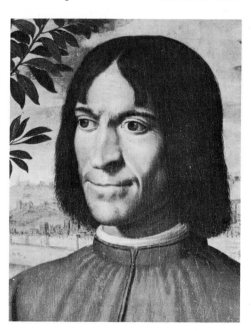

177

of luxury and his generosity led the family to bankruptcy, carrying the state with it. He then gave up banking and invested his money in land.

In 1466 Lorenzo travelled around the various courts of Italy and in 1469 married Clarissa Orsini. His prodigality provided him with the means to win over his great enemy King Ferdinand. Reconciled with the Holy See, he persuaded the Pope to make his son Giovanni (the future Leo X) a cardinal, even though he was only thirteen years old. He ended his days in his country-seat at Careggi. His library—the Laurentian Library—is well known. He was a writer of talent and distinction. His poetry was very fine: the main works are *Stanze bellisime, Poesie volgare, Rime sacre, La Nercia da barberino, L'Ambia, De Conti Carnascialeschi.*

He left three sons:
Piero the Gouty (1471-1503)
He succeeded his father in 1492. He was an invalid and somewhat indolent; in 1494 he was expelled from Florence by angry citizens. He tried to return but in 1503 was drowned in the Garigliano.

Giuliano (1478-1516)
Brother of Piero. He was restored by Spanish troops in 1512, but abdicated in favour of his nephew Lorenzo II in 1513. He took the title of Duke of Nemours.

Giovanni
Pope under the name of Leo X from 1513 to 1521, successor to Julius II. He was hostile to France and continued the policy of his predecessors in seeking to drive "the barbarians" out of Italy. The sale of indulgences which he organised to raise money for the building of St Peter's in Rome precipitated Luther's attack on the Church. Leo X was an ardent patron of arts and letters.

Melozzo da Forlì
(or Marco degli Ambrosio)

Born at Forlì in 1438, died 8 November 1494 in the same town.

Melozzo was deeply influenced by Piero della Francesca, whom he seems to have known personally. He was also a close friend of Giovanni Santi, Raphael's father. It seems that it was through Santi that he met the Duke of Urbino, Federigo da Montefeltro. He in turn introduced Melozzo to Pope Sixtus IV, the great patron of the arts who built the Sistine chapel (1473). As official painter to the Vatican, Melozzo was commissioned to paint a large picture of *Platina appointed Director of the Vatican Library, paying homage to the Pope surrounded by his Cardinals.* Later, he painted a fresco in the SS. Apostoli for Cardinal Giuliano della Rovere, nephew of Sixtus IV, on the subject of *The Ascension of Christ.* In 1485 he worked at Loreto for another nephew of the Pope, Cardinal Girolamo Basso della Rovere. He decorated the so-called Treasure Chapel of the cathedral. Melozzo then settled in Loreto, but only one of his later works remains: the *Pestapepe,* a grocer's sign.

Mercatanzia

The Florentine Mercatanzia was the merchants' tribunal where six magistrates sat to settle disputes and differences between members.

Michelozzo Michelozzi

Born in Florence in about 1396, died there in 1472. Architect and sculptor.

He started life by engraving seals, then went on to study with Donatello; later he became his collaborator. He worked with him on the tomb of Pope John XXIII in the Baptistery in Florence, then on the Brancacci tomb in Naples and the Aragazzi tomb in Montepulciano.

He soon spent more of his time on architecture than on sculpture. He carried on the work and the teachings of Brunelleschi. In Venice, he built the library of San Giorgio Maggiore for Cosimo de' Medici; in Milan, he extended the palace given by Francisco Sforza to the Visconti family and built for Pigello Portinari the chapel of St Peter Martyr at San Eustorgio. He built extensively in Florence for his patrons, the Medici: the convent of San Marco, the Medici chapel at SS. Annunziata, the Careggi and Coffagginolo villas and the Palazzo Medici (now the Palazzo Medici-Riccardi). This *palazzo* has a *cortile* or inner courtyard which served as model to almost all Italian palaces in the 15th century. Florence also owes a debt to Michelozzo for his fine restoration of the Palazzo Vecchio, the building of the novitiate of Santa Maria Novella and a great many other buildings which came into existence in the glorious dawn of Renaissance Italy.

Miracle of the Sacrament

When Uccello was almost seventy-one, he went to Urbino to paint for the church of the confraternity of the Corpus Domini a six-compartment predella destined to serve as base to a reredos painted at a later date by Joos van Gent; the predella is now in the Museo nazionale delle Marche at Urbino. The series of tiny panels illustrates a mediaeval legend telling the story of a profaned sacrament and a subsequent miracle. The story is split up into several episodes, for all the world like a modern comic strip.

The scenes occur in the following order: 1. A woman goes into a Jew's shop to sell him a consecrated wafer; 2. In his home, the Jew throws this into the fire, but it does not burn—instead a stream of blood pours from it and passes beneath the door; a passing band of soldiers sees it and breaks the door down; 3. The Pope solemnly places this miraculous sacrament in a special monstrance on an altar; 4. The woman is condemned to be hanged, but as she repents, an angel helps her bear the agony of execution; 5. The Jew and his family die at the stake; 6. The body of the woman lies before an altar and possession of her soul is sought by two angels and two devils.

Mirandola, Pico della

Italian scholar born in 1463 in the Duchy of Ferrara; died in Florence in 1494.

He belonged to a wealthy family of aristocrats who claimed descent from Constantine. Even as a child he was known for his brilliant memory. His ambition was to delve deep into nature's secrets and to enjoy full knowledge of the universe. He travelled for seven years, visiting the most famous universities of France and Italy and, apart from Greek and Latin, also learnt Hebrew, Chaldean and Arabic.

In 1486, he went to Rome, where he arranged a public discussion with learned men of all kinds on nine hundred propositions "de omni scibili" (of all things it is possible to know), taken from all fields of philosophy and theology. No one was willing to risk debating with such a renowned scholar. Some of the propositions, however, were denounced as heretical to Pope Innocent VIII and were condemned by a special commission. For his defence Pico della Mirandola wrote his *Apologia* dedicated to Lorenzo de' Medici, a masterpiece of subtle argument. It was not until 1493 that a bull from Alexander VI acquitted him of heresy. He left Rome for Florence to join his friends Poliziano and Marsilio Ficino. His last years were spent in the exercise of piety. He died prematurely at the age of thirty-one. Pico della Mirandola left a great number of works which revolved around his efforts to reconcile theology and philosophy. He defended Neo-Platonism and used the methods of the Hebrew Kabbala (*Heptaplus*, 1489; *De Ente et Uno Opus.* 1491).

Monte Oliveto Maggiore (Monastery of)

In 1497 the prior of the Benedictine monastery of Monte Oliveto Maggiore commissioned Luca Signorelli to decorate the cloister walls. Luca painted eight frescoes, now unfortunately very damaged, on the theme of the life of St Benedict, the founder of the Order. In the paintings, the artist tried to to convey the movements of the body and gestures made for their own sake rather than for expressing some moral purpose. The best scenes are: *The Sin of Two Monks eating outside the Convent, St Benedict's Meeting with Totila's Squire* and *Totila, King of the Goths before the Saint*. The first is an amusing composition: two young brothers who have been unable to resist the temptation of a well-served meal, are sitting at table in an inn in the middle of a crowd of women. The two latter paintings allowed Signorelli to paint energetically and expressively, as he loved to do. The Goths all look like Renaissance mercenaries and undoubtedly were painted from life. Their attitude is truculent, the garments picturesque. Here, as always in Signorelli's paintings, we see his infinitely careful delineation of anatomical detail.

Nicholas V (Thomas Parentucelli or de Sarzana)

He was elected Pope on 6 March 1447. Platina speaks highly of his intelligence, gentleness and generosity. His aim was to pacify war-torn Italy so that all Christian princes could join together in a crusade against the Turks, whose ever-growing military success alarmed the whole of Europe. By the intermediary of Charles VII of France, Nicholas procured the abdication of the Antipope Felix V and thus ended the papal schism which had divided the Church for so many years. He gathered a considerable amount of money from

German Catholics to finance the League against the Turks, but rumour had it that these funds were being used to fight the Milanese and the King of Naples. German generosity dried up accordingly. He made the Greeks accept the decisions of the Council of Florence, but all in vain. In 1451, Constantinople was captured by the Turks in spite of the support he had sent —all too late.

He crowned the Emperor Frederick in Rome with great pomp and ceremony. Whilst he was Pope, he built many beautiful buildings in Rome, collected the most superb Greek and Roman manuscripts for the Vatican Library of which he was the true founder. The letters of indulgence he gave to the kingdom of Cyprus shortly before his death are among the oldest known examples of typographical art, since they bear a printed date.

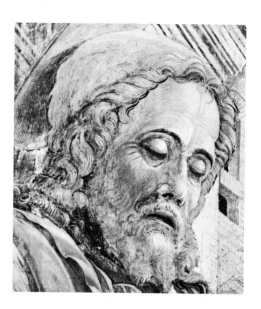

Ovetari Chapel, Padua

A certain Antonio Ovetari who owned a chapel in the church of the Eremitani (Hermit Brothers) left 700 ducats to his heir to pay for the decoration of his chapel with stories of St James and St Christopher. The commission was given to Squarcione. As always, he gave the job to his pupils to carry out in his place and the work was done by Mantegna with the help of other pupils of less talent: Niccolo Pizzolo, Bono da Ferrara, Ansuino da Forlì, etc. It seems likely that the project as a whole was directed by Mantegna, for even though the frescoes bear the signatures of these different artists, there is a definite sense of unity about the project. Mantegna was responsible for six of the compartments: *The Baptism of Hermogenes, St James before the Emperor, St James on the Way to Execution, The Martyrdom of St James, The Martyrdom of St Christopher* and *The Carrying-off of St Christopher's Body.* In the St Christopher cycle, Mantegna gave a picture of contemporary life, but in the St James cycle, he gave full rein to his passion for archaeology. For the first time, an artist painted a minutely detailed reconstruction of the monuments and costumes of ancient Rome. He combined this with a perfect knowledge of the science of foreshortening and of architectural perspective. These frescoes dating from the period 1454 to 1459 show that Mantegna was already in full possession of his great artistic skill.

P

Pacioli, Fra Luca

Born about 1445 in Borgo San Sepolcro,
died some time after 1514. Italian mathe-
matician.

Originally a private tutor in Venice, Rome
and Florence, he entered the Franciscan
Order in 1470 and taught mathematics
in Perugia, Naples, Milan, Pisa, Bologna,
Venice and Rome. His *Somma de Arith-
metica, Geometrica, Proportioni e Propor-
tionalita* (Venice 1494) is a résumé of the
mathematical knowledge of his time. An-
other work, *De divina proportione,* for which
Leonardo da Vinci did the figures, had a
considerable influence on Renaissance ar-
tists. In it, Pacioli studied the "golden
section" and its importance in various
geometric constructions. He showed its
role in nature and in the proportions of
human bodies.

Palazzo Riccardi, Florence

In 1459, Piero de' Medici commissioned
from Benozzo Gozzoli the decoration of
the chapel in the Palazzo Medici (now
known as the Palazzo Medici-Riccardi
because Grand-Duke Fernando sold it in
1659 to the then Marchese Riccardi) which
Cosimo had had built by Michelozzo
Michelozzi in about 1430.

The room is narrow and is lighted by
means of one small window. There was
already an altar-piece in position—Filippo
Lippi's *Nativity*. The three main walls
remained untouched. The theme suggested
to the artist was the adoration of the Magi.
The way the room was built imposed a

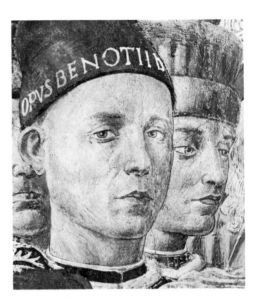

particular form on him and this led to a
unique composition: he set the procession
of the Wise Men in movement around the
three walls, travelling slowly towards the
Infant Christ whose birth was pictured
above the altar. In this way, Benozzo's
painting formed a magnificent introduc-
tion to Fra Filippo's picture and, by the
same token, the picture was a superb con-
clusion to Benozzo's fresco. The circum-
stance was purest accident, but it led to
this unusual and successful method of treat-
ing a subject normally confined to a single
canvas or a single stretch of wall.

Palazzo Schifanoia, Ferrara

The principal work of Cosimo Tura and
Francesco Cossa, carried out jointly be-
tween 1465 and 1470, is the decoration
of the main room of the Palazzo Schi-
fanoia (i.e. *Freedom from Care*), the
summer residence of the d'Este princes.
The frescoes were cleared of whitewash

in 1840, having been hidden for centuries. It was possible to save only those on the eastern and southern walls. These two walls (one 80 feet long, the other 34 feet long, each 24 feet high) have three rows of paintings one above the other, each row divided into compartments. They depict the months of the year. In the top row, we see the triumphal chariots of the pagan divinities who presided over the months with a whole crowd of different scenes around them. In the central row are the signs of the Zodiac surrounded by allegorical figures and in the bottom row the outstanding events in the life of Duke Borso d'Este. The allegories and symbols were no doubt suggested to the artists by the many scholars at court, all fascinated by astrology and the enigmas of fate. According to the ancient science of astrology, the astral powers which secretly govern the life of the year's seasons are analogically associated with human activities. Cosimo Tura, in association with several other artists, was in charge of the undertaking. It is only in the months of March, April and May that the style of Francesco Cossa can be clearly seen. Other outstanding scenes are the triumphs of Lust (September) in a chariot drawn by monkeys and surrounded by small Cupids and cyclops forging breast-plates, of Ceres (August), with peasants working in the fields and merchants arguing about the price of corn, of Venus (April), whose triumphal boat is drawn by two swans on a lake around which knights and ladies kiss in a garden. The bottom row shows Duke Borso full of bonhomie, paternal and reassuring. But the smile on his thin lips has a cunning look. He is dispensing justice in the midst of his ministers and courtiers, he goes hunting, rides, receives petitions, talks with scholars, rewards his jester with a coin. All around, the people of Ferrara prune their vines, argue and work in the fields.

Palazzio Vecchio, Florence

Florence is dominated by this great building with its sinister crenellations and its tower, serving both as belfry and donjon, made for look-out and defence. It is a colossal fortress built in the Middle Ages, begun in 1298 by the architect Arnolfo del Cambio. There are few windows, and on the ground floor these are protected by grilles, as well as set high up in the wall; they are typical of a well-designed fortress. Under the Republic the Palazzo Vecchio was the seat of government; today it is the town hall. The Sala del Maggior Consiglio, the Capella dei Priori, the Medici apartments and the fountain of Verrocchio are the most interesting parts.

Pallas and the Centaur (Botticelli)

This painting was commissioned by Lorenzo the Magnificent to celebrate one of his political victories. By a bold diplomatic coup, Lorenzo had broken the coalition of his enemies in 1480. He had gone to Naples—not entirely without risk —to negotiate peace with Ferdinand and returned to Florence to be hailed by the populace as the saviour of the Republic. Botticelli's picture was meant to be an allegorical souvenir of this great event in the history of the Medici family. Set against a background which looks like

183

an idealised view of the Bay of Naples, Pallas, goddess of wisdom, tames the Centaur, symbol of the spirit of violence and strife. On the white gown of the goddess the triple ring of the Medici is embroidered and this emblem is an allusion to the Medici role in the peace settlement (an allusion made even stronger by the olive branches twined in her hair and around her arms).

Panicale (Masolino di Cristoforo, Fino da)

Born in Florence in 1383, died in 1440. He was much influenced by Gentile da Fabriano and Fra Angelico and worked at Empoli. His early works include *The Madonna and Child* (now in Bremen), the Empoli frescoes of *Piety*, the ceiling paintings in the choir of the Collegiata of Castiglione d'Olona (about 1435). Two paintings for Santa Maria Maggiore in Rome followed these.

In 1423, he was working on the Brancacci Chapel in Florence (*The Curing of the Cripple*, *The Resurrection of Tabitha*), though the frescoes had to be taken over by Masaccio when Masolino was invited to Hungary in 1426 by Pippo Spano (otherwise Filippo Scolari, soldier and general adviser in the service of the King of Hungary). Most of the pictures due to this visit are now lost. In 1431, Masolino painted some frescoes for S. Clement in Rome.

Perspective

Perspective is the change of shape and dimension which the appearance of objects seems to undergo according to their position in relation to our eyes; it is the result of the various changes of angle formed in the eye by the light rays reflected from the object we look at, according to our distance from it and our position in relation to it. At the Renaissance interest in perspective increased as it provided a certain basis for representing what we see. There are in fact two sorts of perspective in so far as artistic definitions are concerned: *linear perspective* which is positively established and which can be demonstrated by geometrical lines and *aerial perspective* which deals with changes in tone and colour as objects recede from the spectator, becoming muted and bluish. The artists of the Cinquecento were particularly absorbed by this form of perspective. Linear perspective became a quasi-mathematical science and was closely related to optics. The science of perspective determines at what point an object should be placed in a picture and within what area a collection of objects should figure in a spatial sense in order to give the eyes of the spectator the impression that he is seeing something exactly as it would be in reality. This is a positive science: the distance and the shape of a body being known, geometry can determine with complete certainty what height and what measurement it should be given on a picture so that it will appear to have the same size, shape and proportion as in nature.

Perugino (Vannucci Pietro)

Born in 1450 at Castello della Pieve, near Perugia; died at Fontignano in 1524.

He was apprenticed to a Perugian painter very young. Possibly Bontigli was his teacher. Some art historians claim that this is so; others think his master was Fiorenzo di Lorenzo; still others believe that he worked in Piero della Francesca's studio and that later he went to work with Verrocchio where he studied at the same time as Leonardo. In 1472 he is mentioned on the list of painters working in Florence. In 1475, he was commissioned to paint a series of frescoes in the Palazzo Publico in Perugia. In 1478, he worked in the chapel of Cerqueto. By 1480 he had the reputation of an outstanding artist, for he was one of those invited by Sixtus IV to paint the Sistine chapel (*The Charge to St Peter*).

He was back in Florence in 1486. A period of intensive activity started for him. He had two studios, one in Perugia and one in Florence, and a large number of assistants were in his employ. In 1495 he finished an altar-piece for the magistrates' chapel in Perugia and began his *Crucifixion* at Santa Maria Maddalena de' Pazzi which he finished in 1496. In 1497 he was invited, together with Benozzo Gozzoli, Rosselli and Filippino Lippi, to appraise a painting by Baldovinetti in Santa Trinita in Florence. In 1499, he started the decoration of the Cambio in Perugia: it was completed in 1500.

In Perugia, in 1499, he took a new pupil —Raphael Santi, aged sixteen. Under his teaching, Raphael's talent developed. In 1501, his fellow-citizens of Perugia invited him to serve as one of the city magistrates. In 1504 he was one of the committee charged with the task of finding a proper site for Michelangelo's *David* in Florence. In 1512 he bought two farms and a house in Perugia. He loved travelling and between 1512 and 1523 went all over Italy to execute various commissions. His last work was painted at Fontignano in 1523. He seems to have died of plague in 1524.

Piero della Francesca (Piero di Benedetto de' Franceschi)

Born between 1410 and 1420 at Borgo Sepolcro; died in 1492.

He came to Florence in about 1430 to start his training. He started by studying mathematics, a branch of science which he always

185

liked, then when he was about fifteen, turned to art. He might well have been a pupil of Domenico Veneziano and it is likely that he accompanied him on his various journeys through Umbria and the Marches. He worked with Veneziano on the frescoes for Sant' Egidio in Florence in 1439.

His first truly personal work dates from 1442: the *Madonna della Misericordia*. He painted in many places: Rome, Rimini (*Pandolfo Malatesta* and *St Sigismond*), Urbino (*Flagellation*, *Virgin and Child*), Ferrara, Perugia and Arezzo. In 1452 he started his great masterpiece, the decoration of the San Francesco chapel in Arezzo (*The Story of the True Cross*). These frescoes seem to have been finished in 1459. Towards the end of his life he wrote two outstanding works on mathematics: *Treatise on Perspective*, illustrated with his own sketches and diagrams, and a study on *The Five Regular Bodies*. He retired at an advanced age to Borgo San Sepolcro, where he became blind and died in 1492.

Piccolomini (Aeneas Sylvius, Pope Pius II)

Born at Cosignana; near Siena, in 1405; died 16 August 1464.

He was one of the finest Latinists of his time, a lover of learning, an eloquent speaker, a skilful negotiator. When he was young, he tried hard not to take holy orders so that he could enjoy worldly pleasures without remorse; he wrote erotic poetry and an extremely frivolous novel, *Euryalus and Lucretia*. He took part in the Council of Basle, then Nicholas V appointed him Bishop of Trieste and later, bishop of Siena. During the next pontificate, Aeneas

Sylvius worked skilfully to calm the discontent of German Catholics. Calixtus III made him a cardinal-deacon of the parish of St Eustace, then moved him to St Sabine. After his election, Pius II sought to restore the power of the Papacy to its former greatness and to organise and direct a coalition of Christian princes against the Turks, who had just captured Constantinople.

The Archduke Sigismond brought the attention of the Church to the contradiction between the opinions of Pius II when he was Aeneas Sylvius Piccolomini, secretary of the Council of Basle, and those which he now held as Pope. To annul this contradiction, Pius II published a solemn bull on 26 April 1463 retracting his old opinions, giving his youth as excuse. His adversaries retorted that the chief factor in this conversion was the benefit resulting from a change of position. Pius II decided to fit out a fleet at the Church's expense and send it to Asia Minor. Unfortunately, he fell ill and died as it set sail. His principal achievement as humanist was the opening of the College of Abbreviators (i.e. drafters of Papal briefs) for scholars from all countries. This institution was suppressed by his successor Paul III. His writings on history, geography and rhetoric were published in Basle in 1551. His *Letters* give a fine picture of the history of his time.

Piero di Cosimo (Piero di Lorenzo)

Born in 1462 in Florence, died there in about 1521.

He was the son of a goldsmith, Lorenzo Chimenti, and was probably also his pupil. We know for certain that he was the assistant of Cosimo Rosselli and from him

he took his nickname of Piero di Cosimo. He worked with his teacher in the Sistine Chapel in Rome and in fact painted some of the most difficult parts of the frescoes. One of them—*The Destruction of Pharaoh's Armies crossing the Red Sea*—is almost entirely from his hand. On his return to Florence he was frequently busy organising carnival festivities and he decorated *cassone*. He painted some religious pictures (*The Conception of the Virgin*), but he was more interested in mythological and symbolic works: *The Death of Procris, Mars, Venus and Cupid, The Story of Perseus and Andromeda* and *Simonetta Vespucci as Cleopatra*. He was much influenced by Neo-Platonism and by the artists Botticelli, Leonardo da Vinci and Signorelli. He taught Andrea del Sarto and Pontormo.

Pinturicchio (Bernardino di Betto)

Born in Perugia in 1454; died in 1513.
Originally a pupil of Fiorenzo di Lorenzo like Perugino, he was much influenced by the latter when they were both in Rome working on the Sistine Chapel. There, he painted almost all *The Journey of Moses in Egypt* and *The Baptism of Christ*. Shortly afterwards, the Buffalini, a Perugian family, commissioned him to paint their chapel in the church of Santa Maria in Aracoeli in Rome (*Life of Saint Bernardino*). Pinturicchio became the favourite painter of the papal aristocracy and worked on a great many decorative schemes in their palaces (the Palazzo Sciarra Colonna, for example). He started one of his masterpieces in 1492: the decoration of the apartments of Alexander VI, the Borgia Pope, in the Vatican.

In 1501 he started the decoration of the Baglioni chapel in the church of Santa Maria Maggiore in Spello. Three years later, he painted a room in Siena Cathedral which was one of his finest achievements: the famous *Episodes in the Life of Pope Pius II* (known as a humanist by the name of Aeneas Sylvius). Ill and abandoned by his wife, he died from neglect in 1513.

Pisanello

Born in Verona in 1397; died in Pisa, after 1450.
Pisanello probably got his early training from his visits to the studios of Domenico Veneziano, Paolo Uccello and Donatello in Florence. At the beginning of his career he went to Venice with Gentile da Fabriano to paint some frescoes (now lost) in the Sala del Maggior Consiglio of the Doges' Palace. Other paintings he did for St John Lateran

187

in Rome and in Pavia have also disappeared. His great masterpiece is in St Anastasia in Verona: *St George taking leave of the Princess of Trebizond*. He also painted some easel-pictures: *St Eustace*, portraits of *Ginevra d'Este* and *Leonello d'Este*, *St Jerome*, *The Virgin appearing to St Anthony and St George* and some extraordinary drawings of animals. In addition, Pisanello was the greatest medallist of his time.

Platina (Bartolomeo de Sacchi)

1421-1481, Italian historian.

After starting life as a soldier, he entered the College of Abbreviators, opened in Rome by Pius II to edit public records. He became a member of the Roman Academy founded by Pomponius Laetus for encouraging the study of the monuments and works of classical antiquity. After unfortunate episodes with the ecclesiastical authorities, torture and imprisonment, he was appointed Vatican Librarian by the next Pope, Sixtus IV (1475). He died of plague. One of the most learned men of his time, he was above all a lucid and sensible commentator and critic. He wrote a history of the Popes and a history of Mantua.

Poliziano, Angelo Ambrogini

Called Poliziano from the name of his birthplace. 1454-94. Italian poet and humanist.

A pupil of Marsilio Ficino, he was famous from the age of fifteen for his learning and his poetic skill. He was a fellow-student of Lorenzo de' Medici, who later entrusted him with the education of his sons Piero and Giovanni (the future Leo X). In 1480 he became professor of Greek and Latin rhetoric at the Studio of Florence and his classes were followed by the most eminent scholars of the time. When he was secular prior of San Paolo, he was appointed canon of the metropolitan church of Florence. Only his premature death prevented his elevation to the rank of cardinal. He translated the *Iliad* into Latin and followed this by translating Moschus, Callimachus and various Greek prose-writers. He was best known in the literary field for his works on textual criticism and he can be considered as the true precursor of modern philology. The introductions (*Praelectiones*) which he gave to his academic lessons are especially interesting for the history of literary criticism. Poliziano was also a poet and wrote a mythological drama in Italian—*Orfeo*—and some *Stanze* to celebrate a tournament in which Giuliano de' Medici particularly distinguished himself, a number of sonnets, songs and ballads which show that he was one of the finest poets of his time. He used popular Tuscan themes for his inspiration and in his poetry he preserved their freshness and charm, whilst at the same time clothing them in the aristocratic garments of formal verse.

Pollaiuolo (Antonio di Jacopo d'Antonio Benci de)

Born in Florence in 1432, died in Rome in 1498.

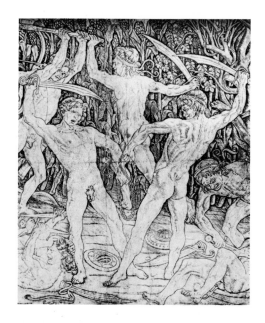

sculpture. The chronology of his works is difficult to establish. Some fine examples are *Hercules suffocating Cacus*, the bust of a young warrior and a superb bas-relief, *The Battle of the Naked Men*. At some time before 1483 he went in for the competition for an equestrian statue of Francesco Sforza.

In 1489 he settled in Rome, where he began work on the tomb of Sixtus IV. This was completed in 1493 and he then started the mausoleum of Innocent VIII in the Vatican which he did not finish till 1498, a few months before his death. He had gone back to Florence in 1496 to put the finishing touches to the cupola in the sacristy of Santo Spirito. His body was buried in the church of St Peter-ad-Vincula near that of his brother Piero (1443-96), who collaborated with him in the execution of a great many of his works.

His father was an ordinary poultry-seller, whence his nickname. He was known as a sculptor, goldsmith, painter and engraver. He first learnt to be a goldsmith in the studio of Bartoluccio, Ghiberti's father-in-law; Ghiberti allowed him to execute some of the details on the second Baptistery door. Shortly afterwards, Antonio set up in business on his own account and two large commissions came his way very quickly: one was from the Merchants' Corporation and the other was for a silver helmet (1472). At the same time, he started doing some enamelling as well. As a painter, he continued the trend of Florentine realism and to this tradition he joined his special knowledge of anatomical science. He was working on three large canvases in 1460: *The Labours of Hercules* was one and another was a *St Sebastian* for the Pucci family, painted in 1475.

Pollaiuolo was equally successful in his

Prato (Cathedral of)

Fra Filippo Lippi settled in Prato in about 1452, when he was nearly forty-five years old, and started the work of painting the frescoes in the cathedral. They show the story of St John the Baptist (on the right) and that of St Stephen (on the left). He made no attempt to impose any unity of action on the work and set several scenes inside the same framework without the slightest effort to show transition from one to the other. But in the work "there is a sensuousness new to Italian art in the supple, sinuous figure of Salome dancing before Herod—possibly inspired by the Salome of Donatello on the baptismal fonts in Siena." (A. Pérat.é)

189

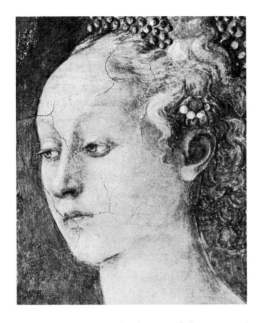

On the other wall, the fresco of the *Funeral of St Stephen* offers a striking contrast to that of Salome in its awe-inspiring solemnity, its sober emotion, its deeply-felt religious feelings. The architecture of the church with its coffered ceiling and its two rows of columns with Corinthian capitals was inspired by that of Brunelleschi's San Lorenzo. All the figures standing around the body of the martyr are portraits of real people. The priest standing on the left reading a missal is probably Donato de' Medici, Bishop of Pistoia; the stout gentleman in the front row of the group opposite is Carlo de' Medici; the rest of the bystanders are magistrates and notables of Prato.

Predella

Lower part of an altar-piece, usually divided into small sections and giving a series of scenes.

Rosselli, Cosimo (Cosimo Lorenzo, also called Filippino)

Born in Florence in 1439; died there in 1507.

He was the pupil of Neri de Bicci and possibly of Bennozo Gozzoli too. In 1476 he painted a fresco in SS Annunziata in Florence. In 1480, he was summoned to Rome by Pope Sixtus IV to take part in the decoration of the Sistine Chapel. Vasari informs us that Rosselli's paintings pleased the Pope very much, but it was his pupil Piero di Cosimo who was almost entirely responsible for the large fresco *The Destruction of Pharaoh's Armies crossing the Red Sea*. On some date impossible to specify exactly, Rosselli went to work in Lucca and then in Florence. His pupils, who also acted as his assistants, included Piero di Cosimo and Fra Bartolomeo.

Benozzo Gozzoli
St Augustine arrives in Milan
San Gimignano, San Agostino

S

Sacra Conversazione

The *sacra conversazione* (holy conversation) is an iconographic theme invented by the Quattrocentists in which various sacred personages, usually the Madonna and Child with Saints, seem to meet and talk together. It does not refer to any particular biblical or legendary happening and the painters link together saints who have no actual historical or geographical connexion. The only justification for their presence in company with one another is their role as patrons either of the donor of the picture or of the church for which the painting has been commissioned.

Sant' Agostino in San Gimignano

Gozzoli's frescoes on the subject of the life of St Augustine are divided into seventeen compartments: 1. The saint's parents, Patricius and Monica, bring their small son to the schoolmaster in Thagaste; 2. The second fresco is almost completely destroyed, like the third and fourth (but repainted in the 17th century); 5. Augustine lands on the Italian coast; 6. Augustine in his professorial chair; 7. He goes from Rome to Milan; 8. On his arrival in Milan, he is greeted first by the Emperor Theodosius, then by St Ambrose; 9. He discusses philosophy with St Ambrose; 10. Augustine, seated in a garden, reads the Epistles of St Paul; 11. St Ambrose baptises Augustine; 12. St Augustine in the garb of a monk questions a child on the solution of the mysteries; 13. St Augustine is present at the deathbed of his mother; 14. St Augustine, now a bishop, blesses the faithful; 15. He argues with Fortunatus; 16. The saint at his desk; 17. Death of this learned doctor of the Church.

In this ensemble, Gozzoli achieves a perfect harmony of thought and composition. Where the Palazzo Riccardi frescoes are like a shortened version of the elegant life of the 15th century, the San Gimignano cycle describes the way the intellectuals and scholars lived at the same time.

San Francesco at Arezzo

It was in 1452 that Luigi Bicci, a wealthy citizen of Arezzo, a small town in the upper valley of the Arno, commissioned Piero della Francesca to complete the decoration of the church of San Francesco; this had originally been started by a traditionalist painter, Bicci di Lorenzo, who had just died. Piero gave up seven years to this vast undertaking. The frescoes form a long cycle. They are divided into ten compartments and cover the lateral walls of the choir with *The Story of the True Cross*, as found in Jacopo da Voragine's *Golden*

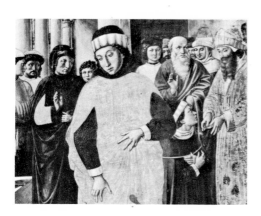

Legend. The story starts at the top of the right-hand wall with 1. *The Death of Adam.* Seth, the son of Adam, places in his dead father's mouth a branch of the tree of life which the angel guarding the gates of Paradise has given him. From this branch will grow the tree from which the cross of Christ will be made. Next comes 2. *The Visit of the Queen of Sheba to King Solomon.* The branch has grown and is now a magnificent tree. Solomon has had it cut down and has used it as the main beam in the building of a bridge. Balkis, the Queen of Sheba, who has to cross this bridge to reach the king, experiences a moment of revelation as she crosses it and kneels in adoration before the sacred wood; 3. King Solomon has the bridge destroyed and one of the workmen, whose attitude foreshadows that of the Saviour carrying the cross, bears the beam away to bury it; 4. *The Annunciation.* This marks the beginning of the events leading up to the Passion. Piero della Francesca did not paint a scene showing how the beam which Solomon had buried was dug up by the executioners of Christ but indicated this event in an elliptical manner; 5. *The Dream of Constantine.* The night before the battle in which Constantine hopes to defeat the usurper Maxentius, he is awakened by an angel and sees shining in the sky a cross which announces his victory; 6. *The Victory of Constantine over Maxentius.* The usurper and his forces who carry a standard bearing a dragon, the symbol of evil, flee before the small white cross which the Emperor holds on high. On the opposite wall of the choir the story carries on as follows: 7. *The Torture of the Jew.* St Helena, who has been searching for the True Cross, asks a Jew named Judas who knows where it was buried after the Passion to tell her where this is. When he refuses, he is thrown into a dried-up well. After ten days in the well, the Jew is brought up dying of hunger. This is the moment shown in the fresco. He says he will reveal the hiding-place. Later, he is baptised and becomes Bishop of Jerusalem; 8. *The Finding and Identification of the True Cross.* When the cross has been dug up, it is brought before the Empress and shown to a young man who has just died: he revives instantly; 9. *The Defeat of Chosroes by Heraclius.* Thirty years after the discovery, Chosroes, the heretical King of Persia, steals the Cross and has it built into his throne. To avenge this sacrilege, Heraclius declares war on him and defeats him after a terrible battle; 10. *Heraclius returns the Cross to Jerusalem.* Barefoot, clad simply and with no imperial regalia, followed by Greek priests, the Emperor carries the Cross whilst the crowd kneels to adore it before the ramparts of the city.

Piero put the very best of his talent into this vast philosophical epic which unfolds

its story with slow majesty across the walls of San Francisco. The characters he paints have a genuine nobility and dignity. Their sculptural beauty is in perfect harmony with the strictly geometrical basis of the over-all composition of the pictures. Piero had the altogether admirable gift of imparting life to his figures by the skilful use of light which he drew from the colours he used. This great artist produced in these frescoes a disturbing synthesis of inertia and dynamism.

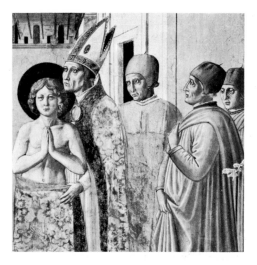

San Francesco in Montefalco

Montefalco is a tiny town in Umbria between Assisi and Spoleto. It has a Franciscan monastery which Benozzo Gozzoli decorated. It was his first major undertaking. In the side-aisles of the church he painted the following murals: *The Crucifixion, Christ blessing, with Four Doctors, Virgin and Four Saints*. In the side chapel which is dedicated to St Jerome he painted *St Jerome leaving Rome, St Jerome taking a Thorn from a Lion's Foot*, etc. His full talent is visible in his work in the choir. In the vault he painted magnificent pictures of saints, amongst whom we see St Elizabeth of Hungary, standing graceful and majestic in the folds of her white garments. At the lower end, he painted *The Glorification of St Francis*: this is the centrepiece of the decoration. On the side walls, Benozzo painted twelve compartments showing the great moments in the life of St Francis. Below the frescoes and on the sides of them, he painted a sort of triumphal accompaniment to the "Poverello" of Assisi: ten medallions showing men of outstanding fame, the great men of the Franciscan

order, and under the middle window, the portraits of Giotto, Dante and Petrarch. These *Scenes from the Life of St Francis* are set inside a pretty foliage frieze and against the delightful countryside of Umbria; they were inspired by the poetry of Dante, who wrote superbly of the wandering saint and by the existing frescoes at Assisi painted by Giotto over a hundred years before. Inevitably the closeness of Assisi and Montefalco makes a comparison of the two great works almost inevitable, but the mastery of Giotto is matched to some extent by the verve and spirit of Benozzo, both qualities missing from Giotto's artistic concept of the story. In these frescoes, we see the beginnings of that marvellous talent for telling a story which will later appear to better advantage in the frescoes of the Medici chapel in Florence and in the Campo Santo in Pisa. The best episodes at Montefalco are possibly *The Meeting of St Francis and His Father, The Meeting with St Dominic* and *The Death of St Francis*. In the latter, the saint is lying in his coffin, his face transfigured by death. The brothers sur-

193

round him respectfully, both sad to lose him and happy to know that he has gone to eternal bliss.

San Miniato del Monte (Cloister of)

Uccello's frescoes date from a period before 1439. They are in a terrible state of dilapidation.

In the first scene, we see St Benedict and a monk—the saint is ordering him to pour away some poisoned wine; in the background, there is a bare pale violet landscape. The following scene has only a background landscape of mountains, lilac-coloured with green streams. In the third scene, a monk sitting on a bench raises his arms towards a young man who offers him a copper bowl. Further on, there is a kneeling saint with a long bushy beard and a hieratic angel with red wings. The décor is unreal: a mottled pink foreground scattered with bushes and bounded by buildings of lilac-grey or yellow or red with vertical streaks, all with grey and yellow openings. The last scene that can be seen properly is set in a pink landscape and has an old man and another figure running with a red vase. this is all that is left of Uccello's murals of the desert Fathers. However, enough remains for us to understand why Vasari chose to comment on Uccello's boldness in the use of colour, a boldness which shocked most of his contemporaries.

Sant' Apollonia (Monastery in Florence)

It was thanks to the decoration of the refectory in this monastery that Andrea del Castagno became so famous so quickly. In the lower part of this large fresco he painted the *Last Supper* and above it three episodes from the Passion—*The Crucifixion, The Entombment* and *The Resurrection.* Andrea del Castagno set the scene of the Last Supper in the dining-hall of a Renaissance palazzo. By the strictest use of perspective, he made this room appear to open off the wall it was painted on. It is sumptuously decorated with square plaques of porphyry, veined marble and serpentine, all minutely reproduced in *trompe-l'œil.* Judas is placed on the wrong side of the table, sitting all alone, and is thus singled out for censure. The artist chose to paint the moment of high drama when Jesus tells the disciples that one of them will betray him. The apostles react to these words in keeping with their different temperaments and their varying expressions are seized by the artist with an almost snapshot swiftness. The refectory of Sant' Apollonia has now been changed into the Andrea del Castagno Museum. It is specially important in that it houses the reconstituted frescoes on the subject *Famous Men and Women* from the Villa Carducci, near Soffiano.

Santa Maria in Aracoeli in Rome

In the Buffalini Chapel of Santa Maria Aracoeli in Rome, in a series of frescoes designed to glorify the memory of St Bernardino, the monk who brought about the reconciliation of the Buffalini family and their great enemies in Perugia, Pinturicchio painted the following pictures: *The Stigmata of St Francis* (because St Bernardino belonged to the Franciscan order),

The Taking of the Habit, The Retreat to the Desert, The Funeral and *The Glorification of St Bernardino.* The entire work is in the perfect Umbrian tradition with its over-all peace and the tender, gentle expression of the faces.

What is particular to Pinturicchio is the picturesque vivacity he imparts to the characters. It is easy to see that he felt a genuine religious emotion whilst painting these frescoes, for St Bernardino was his patron saint and it was with real feeling that he painted the drawn features and mystical ardour of the saint.

Santa Maria Novella (Cloister of)

The frescoes painted by Paolo Uccello for the cloister of Santa Maria Novella are in a poor state of preservation. In 1431 he painted *The Creation of Man and the Animals* in green monochrome (hence the name "The Green Cloister"). In 1445 he added to this his famous *Flood.*

Santa Maria Novella

Frescoes in the choir by Ghirlandaio.
The four Evangelists are painted on the vault with their traditional attributes. On the walls are painted the following scenes: Left-hand wall (from left to right, for each successive row): 1. *Joachim driven from the Temple*; 2. *Birth of Mary*; 3. *Presentation of Mary in the Temple*; 4. *The Marriage of Mary*; 5. *Nativity and Adoration of the Magi* (this last fresco is almost completely destroyed); 6. *Massacre of the Innocents* (very damaged); 7. (lunette) *The Assumption.*

Right-hand wall (from right to left for each successive row): 1. *The Angel appearing to Zacharias in the Temple*; 2. *The Visitation*; 3. *Birth of St John*; 4. *His Father gives Him the Name of Jesus*; 5. *The Preaching of St John*; 6. *St John baptises Christ*; 7. (lunette) *Herods's Feast.*

Their harmony and clarity, their colourful mixture of realism and classical elegance make these frescoes a perfect expression of one of the most delightful art forms to develop from the civilisation of the Renaissance.

Santa Maria sopra Minerva (Rome)

The life of St Thomas Aquinas, a favourite theme for the Dominican order, is the general subject of the frescoes painted by Filippino Lippi for the Caraffa chapel in the great Dominican church in Rome. The paintings have been heavily restored and show an *Annunciation*, an *Assumption, The Vision of the Miraculous Crucifix* and *The Triumph of St Thomas.* Filippino introduced into the background of the pictures some interesting pieces of architecture inspired by the buildings of Rome which seem to have greatly impressed him. He uses his crowd movements very skilfully and avoids over-exaggeration in the ener-

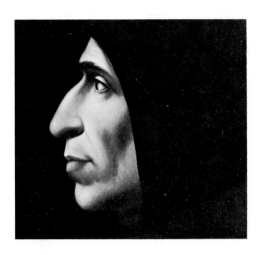

getic expressions of his characters' faces, but it is clear that he had trouble controlling his increasingly exuberant imagination. *The Assumption* displays many characteristics signifying the end of the well-balanced art of the 15th century, especially in the dancing ring of angel musicians who leap and prance in uncontrolled bliss around the Virgin in Glory.

Savonarola, Girolamo

Born in 1452 and died in Florence in 1498. Preacher.

He joined the Dominican order when he was twenty-two and started preaching in Florence in 1481, not with any great success. Soon afterwards he started believing that he had been divinely inspired to prophesy and whilst preaching at Siena in 1485 he prophesied for the first time the forthcoming punishment of the vices of the Roman Catholic church, to be followed by a swift rebirth. In 1490, he returned to Florence, where he preached with the most astonishing success. For the next eight years, the city was profoundly influenced by this extraordinary monk. He became prior of San Marco and preached in the Cathedral. The arrival of Charles VIII in Italy seemed to be the fulfilment of his prophecies and Savonarola's power increased accordingly. He wanted to reform the general way of living in Florence and without condemning literature and art completely sought to exclude paganism from them. Artists like Botticelli and Lorenzo di Credi adopted his ideas. Alexander VI, who was displeased to see that Savonarola continued to be a partisan of the French troops, summoned him to Rome on 25 July 1495 to give an account of his prophecies; on 15 October he forbade him to preach. However, as soon as he got back to Florence he started preaching again and during Lent in 1496 unleashed an attack of unheard-of violence against the vices of Rome. He started again in the following year. On 12 May 1497, Alexander VI excommunicated him. Savonarola replied by attacking the Church in Rome even more vigorously. However, the threats from the Vatican frightened the Florentine Signory and Savonarola's enemies joined together. He was arrested, tortured and condemned to death. On 2 May 1498, he was hanged and then his body was burned.

Scolari, Filippo (Pippo Spano)

Born in 1369, of an old Florentine family; died in Lippa in 1426. General and statesman in Hungary.

Originally an ordinary shop-boy, he became the right-hand man of King Sigismond who made him Count of Temesvar. He is said to have conquered the Turks

eighteen times. This condottiere has always been famous as an outstanding example of the military bravery of Florence. He was interested in the arts and is supposed to have been a keen builder. One of his 15th-century biographers claims—surely with some exaggeration—that he had one-hundred-and-eighty chapels built.

Scuola

The *scuole* (schools) were a sort of mutual aid society occupied both with the economic and religious interests of their members. Wealthy craftsmen, merchants and other notables were members. Their vast financial resources allowed them to patronise the best artists in Venice.

Signorelli (Luca d'Egidio di Ventura)

Born about 1441 at Cortone; died there in 1523.

When he was ten years old, he was sent to work in the studio of Piero della Francesca, who lived in Arezzo at that time. He was also influenced by Verrocchio and Pollaiuolo. He worked first of all in the Marches. In about 1480, he decorated the cupola of the sacristy of Loreto Cathedral. In 1488 he became one of the magistrates at Cortona. In 1497 he worked on the frescoes of the Benedictine monastery of Monte Oliveto Maggiore (*The Life of St Benedict*). Then, in 1499, he started the most powerful of his masterpieces: the decoration of the St Brice chapel in Orvieto Cathedral (*The Last Judgement, The Signs of the End of the World, The Resurrection of the Flesh*). This undertaking made him the true precursor of Michelangelo. At the end of his life, Signorelli directed a studio in Corona and at the same time filled various official posts.

Sixtus IV, Francesco della Rovere, 219th Pope

Born on 22 July 1414 in the village of Albizolla; died 13 August 1484. Elected Pope 9 August 1471.

Some historians state that he came from a family of humble origins and that his father was a fisherman called Leonor Rovere. After he became Pope, the della Rovere aristocracy claimed him as a relation. When he was very young he entered the Order of Minorite Brothers and distinguished himself in all branches of knowledge. He soon climbed towards the very senior position of the Order. Next, Cardinal Bessarion had him created Cardinal by Pope Paul II. In 1471 he was unanimously elected Pope. He instantly made his two nephews cardinals, although they were extremely young. It was they who persuaded him into all sorts of risky undertakings, wars and complicated plots which made Italian anarchy worse and did nothing for the reputation of the Papacy.

Things were a great deal better when he concentrated on making efforts to fight the Turks, whose power had increased most menacingly since the fall of Constantinople, especially with regards to Italy. The Pope started asking Christian princes to form an alliance against the Turks in 1472, but met with no success. Even so, he fitted out a fleet under Cardinal Caraffa and sent twenty-four galleys to join with

ships from Venice and Naples; they sailed to Pamphylia, where they captured the town of Attalia. In 1476, the Turks had their revenge; they challenged the Venetian general, who was killed. The Turks progressively took over all the main ports and harbours in Greece. In 1480 they destroyed the town of Otranto in Calabria. Sixtus IV sent another twenty-four galleys to strengthen the Neapolitan fleet.

Sixtus IV wrote a variety of theological treatises. One of his greatest claims to fame is his building and decoration of the Sistine Chapel.

Spoleto

In about 1467, Filippo Lippi went to the small town of Spoleto with his son, Filippino, and his uncle Fra Diamante. He had been commissioned to paint some frescoes in the cathedral there, thanks to the recommendation of the Medici family. The subjects he painted best were those associated with the life of the Virgin: Annunciation, Nativity, Death and Coronation of the Virgin. These are what he painted at Spoleto. His Coronation was especially superb and in it he attains a breadth of conception and a power he had never previously reached. The painting covers the whole of the apsidal vault. His head surrounded by a halo of heavenly fire, God the Father, a majestic old man wearing a papal tiara, sits enthroned above the moon, sun and stars. He places a crown on the Virgin's head and raises his right hand in blessing in a noble gesture. All around stand angels, singing, playing the flute, the organ and the bagpipes, throwing flowers before the Mother of God. Below, the Blessed in Paradise, Adam

and Eve and even the Sybil who announced the coming of Christ stand watching the apotheosis of the Queen of Heaven. Unhappily, Filippo Lippi died on 8 October 1469 before he had been able to put the finishing touches to his work.

Squarcione, Francesco

Born in Padua in 1394; died there in 1474. Squarcione was the son of a notary who was probably fairly wealthy. He started life as a merchant; this we know for sure since he is mentioned as a tailor-embroiderer in 1423. It seems likely that he belonged to the class of rich merchants who travelled all over Italy and the rest of Europe, going from town to town to sell their gorgeous stuffs to the noble lords. This allowed him to bring back large collections of antiques from his travels. It was not until 1439 that he was mentioned as an active painter. From 1441 to 1463 he was included in the register of the Padua Confraternity of Painters. He opened a school and was the inspiration of every young artist in the town. He had as many as 137 pupils. Amongst the most important was Mantegna, whom he had adopted as his son. He and Mantegna signed a working contract when the latter was only seventeen years old, but he had been registered as a painter since 1441.

Is it true that Squarcione sought fame for himself by using the talents of his pupils? This is a question to be seriously considered, for in 1455 Mantegna brought an action against him demanding that their agreement be declared null and void on the grounds that he had been a minor when it was signed. It seems certain that Squarcione operated as a sort of painting

contractor since he signed similar contracts with other pupils—Pietro Calzetto, for instance. It is not difficult to see why the breaking of the contract with Mantegna brought the full force of Squarcione's hatred on to his adopted child and former pupil. There are few works from Squarcione's brush and these are of doubtful attribution. During his lifetime, his influence was considerable. He was an outstanding teacher whose speciality was making his pupils copy antiques. A great many important figures paid homage to his talents, including the Emperor Frederick and Cardinal Mezzarota.

Tondo

A *tondo* is a round picture, peculiarly Florentine, which started out as a *discho da parto*, or dish on which it was customary to take sweets or fruit or presents of some kind to women who had just had babies. It was customary to decorate the upper face with a picture of scenes from mythology or history or the Bible, according to the fancy of the donor. The underside would bear the coat-of-arms of the parents. Later, the *tondo* would hang on the wall as a form of decoration.

Treasure of Loreto, Chapel of

The decoration of the cupola of this octagonal chapel was carried out by Melozzo da Forlì at the invitation of Cardinal Girolamo Basso della Rovere and, when this was completed, the Cardinal asked Signorelli to carry on with the rest of the decoration, probably at Melozzo's suggestion. Luca painted on the cupola roof of the sacristy a number of angel musicians and below them the four Evangelists and four Fathers of the Church. On the walls, he painted the twelve apostles, rather stately figures but nevertheless full of life, and two scenes from the Bible—*The Calling of St Peter* and *The Incredulity of St Thomas*, in which Christ reveals his resignation and his compassion in a magnificently touching gesture. The largest fresco in which the artist's special talents are seen to best advantage is in a compartment over the door; it shows *The Conversion of St Paul*. The panic of the soldiers and the weird light of revelation are painted with remarkable intensity. The influence of Pollaiuolo is still to be noted in this composition, but there is much in it that anticipates the masterpiece that Signorelli was to paint later at Orvieto.

Tura, Cosimo (about 1432-95)

This artist worked in Ferrara and was influenced by the teaching of Squarcione. It seems likely that there was a contract between them, though the actual document no longer exists. Tura stayed only briefly in Padua, but nevertheless had the opportunity of admiring the work of Donatello and Mantegna. Moreover, many famous artists worked at Ferrara for the d'Este family—Pisanello, Bellini, Roger van der Weyden (in 1449), Piero della Francesca. A purely local style came into being.

Cosimo Tura
The Madeleine (detail)
Ajaccio, Musée Fesch

Paolo Uccello
Detail from *Battle of San Romano*
Florence, Uffizi

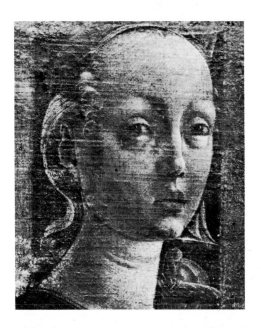

It was in 1458 that the name of Tura appeared for the first time in the accounts of the court at Ferrara, where he was employed on some minor decorative work. In 1468 he painted the organ doors for Ferrara Cathedral. From 1469 he collaborated with Francesco Cossa on the decoration of the Palazzo Schifanoia, his major work. Ercole I, the successor to Duke Borso, kept him on as court painter and once again set him to such insignificant tasks as making patterns for embroideries, tapestries and goldsmiths' work. He also carried out some commissions for the Ferrarese nobility, such as a reredos for the Roverella family (originally for the chapel of San Giorgio furoi le mura, the central panel, a *Virgin*, is now in the National Gallery and the upper part, a *Pietà*, is in the Louvre). Tura made quite a lot of money by financial speculation and is said to have paid for the building of a church.

U

Uccello (Paolo di Dono)

Born in Florence in 1397; died there in 1475.

He first of all served an apprenticeship with a goldsmith. A pupil of Lorenzo Ghiberti, he worked under him on the famous Baptistery doors. Manetti gave Uccello his first knowledge of geometry and Ghiberti taught him painting. He worked in Florence, Padua and Urbino. His nickname Uccello came from his passion for birds.

In 1436 he painted a huge equestrian portrait in *trompe-l'œil* of Sir John Hawkwood, the famous condottiere; this was on the wall of the Duomo. It was his first important work. Next, he painted the cloister of San Miniato del Monte (*Lives of the Fathers of the Church*). In 1445, he worked in the cloister of Santa Maria Novella (*The Flood*). Some years later, he produced his masterpiece *The Battle of San Romano*. When he was about seventy-one, he went to Urbino to paint his *Miracle of the Sacrament* for the Confraternity of the Corpus Domini. His last work, *The*

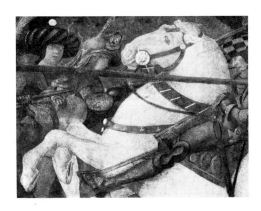

Giorgio Vasari
Leda and the Swan
Rome, Galleria Borghese

Hunt, is in the Ashmolean Museum in Oxford.

Many of Uccello's easel pictures have long since disappeared. Vasari tells us that he did not have a particularly happy old age. He was short of money and was not well. His best friends watched him persisting in his study of perspective to the detriment of the great talent they all knew he had. Donatello would say to him (according to Vasari): "Ah, Paolo, this perspective of yours makes you neglect what we know for what we don't know. These things are no use except for marquetry...". But Uccello went on and on working out his problems. He did not by any means invent perspective, but he gave greater impetus to the revolution which opened out space and dimension to the artist; more than this, he showed posterity exactly how to do it.

Vasari, Giorgio

Born in 1511 at Arezzo; died in Florence in 1574.

Both painter and architect, Vasari owes his fame mainly to his talent as a writer. He is generally considered as one of the

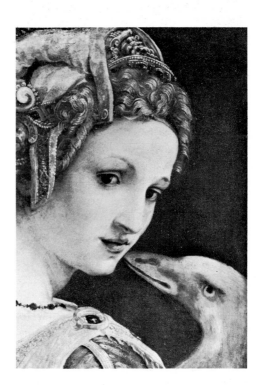

inventors of art history. In his *Vite de più eccelente Architetti, Pittori e Scultore*, he provided us with the finest collection of biographies of all the artists of the Italian Renaissance that it is possible to read; it is an irreplaceable document for a proper knowledge of one of the greatest and most fertile periods in the entire history of art. The collection of *Lives*, packed with factual information and ideas, com-

ments and quotations, is something very special in the literature of the world; it is a very personal document and it needed the perfect union of scholar and artist, if it were to be completely successful. At the present time, when many important works of scholarship have led to a better understanding and appreciation of the period, Vasari's many faults have been revealed: his chronology is weak, he is very ready to accept as gospel what turns out to be studio gossip, and he believes that everything Florentine is necessarily bigger and better. But the *Lives* had a very special charm which assures them a firm and permanent place in the history of art: this charm lies in Vasari's enthusiasm, vivacity and eagerness. The stories pour out, they are packed with actuality.

Veneziano (Domenico di Bartolomeo)

Born about 1400, died in 1461.
This painter is always referred to as Veneziano (the Venetian) but in fact he was living in Perugia in 1438. Cosimo de' Medici invited him to Florence and from 1435 to 1439 he worked in the Sant' Egidio chapel at Santa Maria Novella. He had Piero della Francesca as his assistant, but their work in the chapel no longer exists. Other pictures painted by him in Santa Maria Nuova are thought to have been painted in association with Andrea del Castagno, but there is no proof of this. Amongst his best paintings are the *Sacra Conversazione* in the Uffizi and the predellas in Cambridge, Washington and Berlin.
A recently discovered document refutes the legend that he was murdered by Andrea del Castagno (he died four years later than his alleged murderer). Domenico died in Florence in May 1461 and was buried in San Pier Gattolino.

Verrocchio (Andrea di Michele Cioni)

Born in 1435 in Florence; died in Venice in 1488.
He was sent as apprentice to the goldsmith Verrocchio, and in gratitude took his surname for his own. Only one work remains from this period of his working life—the bas-relief of *The Beheading of St John the Baptist*, engraved in silver for the Baptistery altar (1477-80). Next, he carried out experiments in metal-founding and made several statues for the city of Florence as well as a tomb for Cardinal Fortiguerra in Pistoia Cathedral.
It was in Venice that he found the most superb opportunity to show his skill. The Republic wanted to honour the memory of one of her most famous condottiere, Bartolomeo de Bergamo, known as Colleoni, and commissioned Verrocchio to make an equestrian statue of him. He started work in 1481, but the statue was not finished till after his death in 1488—by Leopardi. On this occasion, Verrocchio found himself once again inviting comparison with his great rival Donatello: Donatello had been the first sculptor to make a large equestrian statue since classical antiquity, that of the condottiere Gattamelata. Verrocchio had a famous studio where he taught several pupils, some of whom became famous: Botticelli, Lorenzo di Credi and best of all, Leonardo da Vinci. Verrocchio's studio was particularly important in the development of

Florentine art. There are only two paintings in existence which we know to be his: *The Baptism of Christ* and the *Madonna* in the Duomo at Pistoia. The young Leonardo is thought to have worked on the former.

Villa Carducci

The frescoes which Andrea del Castagno painted in the Villa Carducci (near Soffiano) have been taken to the cloister of Sant' Apollonia, now the Castagno Museum. They were probably painted about 1451 and they show *Famous Men and Women*. The artist made them look like statues set in rectangular niches bounded by pilasters. Amongst them are Filippo Scolari, better known as Pippo Spano, the famous Florentine soldier of fortune; Niccolo Acciaiuolo, who led the armies of the King of Naples; Farina degli Uberti, another warrior; the Cumaean Sybil, Queen Esther and Queen Tomyris, Dante, Petrarch and Boccaccio. The figures are painted in sharp colours and have a rough, dramatic outline.

Villa of Lorenzo Tornabuoni

In 1486, Lorenzo Tornabuoni, cousin of Lorenzo the Magnificent, was married to Giovanna degli Albizzi and to celebrate the occasion Botticelli was commissioned to paint their country villa with suitable frescoes. They were re-discovered in the course of the 19th century under a thick layer of whitewash and were taken to the Louvre. One of them, dedicated to Lorenzo, shows the young fiancé led before a gathering of the seven liberal arts. Another shows Giovanna receiving the homage of Venus and the Three Graces. These were possibly Botticelli's last pagan works, for soon after they were painted he became involved with the teachings of Savonarola.

Vivarini, Antonio

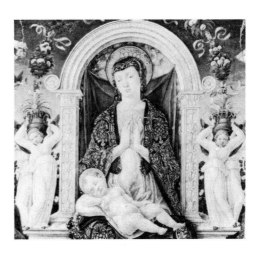

Born in Venice about 1415; died there between 1474 and 1484.
Brother of Bartolomeo Vivarini and father of Alvise. One of the most outstanding representatives of a school of painters, called the Murano school (they worked on the island of Murano in the Venetian lagoon). Until 1450 one of his collaborators was Giovanni d'Alemagna (also called Giovanni da Murano), a German artist active in Venice; then he worked with his brother. Richness of decoration is the outstanding characteristic of his art.

Printed in Italy

Table of Illustrations

206

Bibliography

J. Alazard: *Piero della Francesca*, Paris 1948.

J. Alazard: *Le Perugin*, Paris 1927.

G. C. Argan: *Botticelli*, Geneva 1957.

B. Berenson: *Quelques Peintures méconnues de Masolin da Panicale*, Gazette des Beaux-Arts, February 1902.

B. Berenson: *The Florentine Painters of the Renaissance*, New York 1904.

A. Blum: *Mantegna*, Paris, no date.

S. Bottari: *Antonella da Messina*, Milan 1953.

J. Cortwright: *Sandro Botticelli*, London 1904.

M. Crutwell: *Verrocchio*, London 1904.

M. Crutwell: *Antonio Pollaiuolo*, London 1907.

C. Diehl: *Botticelli*, Paris 1906.

G. Fiocco: *Mantegna*, Paris, no date.

H. Focillon: *Piero della Francesca*, Paris 1952.

C. Gamba: *Giovanni Bellini*, Paris, no date.

Gronau: *Die Künstlerfamilie Bellini*, Bielefeld 1909.

H. Haberfeld: *Piero di Cosimo*, Breslau 1901.

H. Hauvette: *Ghirlandaio*, Paris 1907.

F. Knapp, *Perugino*, Bielefeld 1901.

Mackowsky: *Verrocchio*, Bielefeld 1901.

G. MacNeil Rushforth: *Crivelli*, London 1900.

J. Mesnil: *Botticelli*, Paris 1938.

G. L. & P. Mohmenti: *Carpaccio*, Paris 1910.

T. Pignati: *Carpaccio*, Geneva 1958.

G. Ricci: *Pinturicchio*, Paris 1903.

Salmi: *Castagno, Veneziano, Uccello*, Florence 1938.

Schmarsow: *Masaccio-Studien*, Cassel 1895-1900.

Schmarsow: *Melozzo da Forlì*, Stuttgart 1886.

Steinmann: *Ghirlandaio*, Bielefeld 1897.

E. C. Strutt: *Fra Filippo Lippi*, London 1901.

Supino: *Fra Filippo Lippi*, Florence 1902.

Supino: *Les Deux Lippi*, Florence 1904.

L. Venturi: *Piero della Francesca* Geneva 1954.

R. Vischer: *Luca Signorelli und die italienische Renaissance*, Leipzig 1879.

W. Waldschmidt: *Andrea del Castagno*, Berlin 1900.

207

The Renaissance I

This volume in the series
History of Art was printed in offset
by the Officine Grafiche
Arnoldo Mondadori, Verona.

The text was composed in Times 10-point type;
the first and third parts were printed
on machine-coated paper and the second part on
blue cartridge paper.

The cover and lay-out of the inside pages
were designed by Jean-Marie Clerc of
Editions Rencontre.